To Hogans
from Naoko

Merry christmas !!
Thank you,
I thank you for having me.
I had really good time.

すべてのクリスマスがホーガン家に
　　　幸せをもたらしますように‥‥
　　　どうもありがとう!!

Christmas 2004

大場奈桜子

JAPANSCAPES

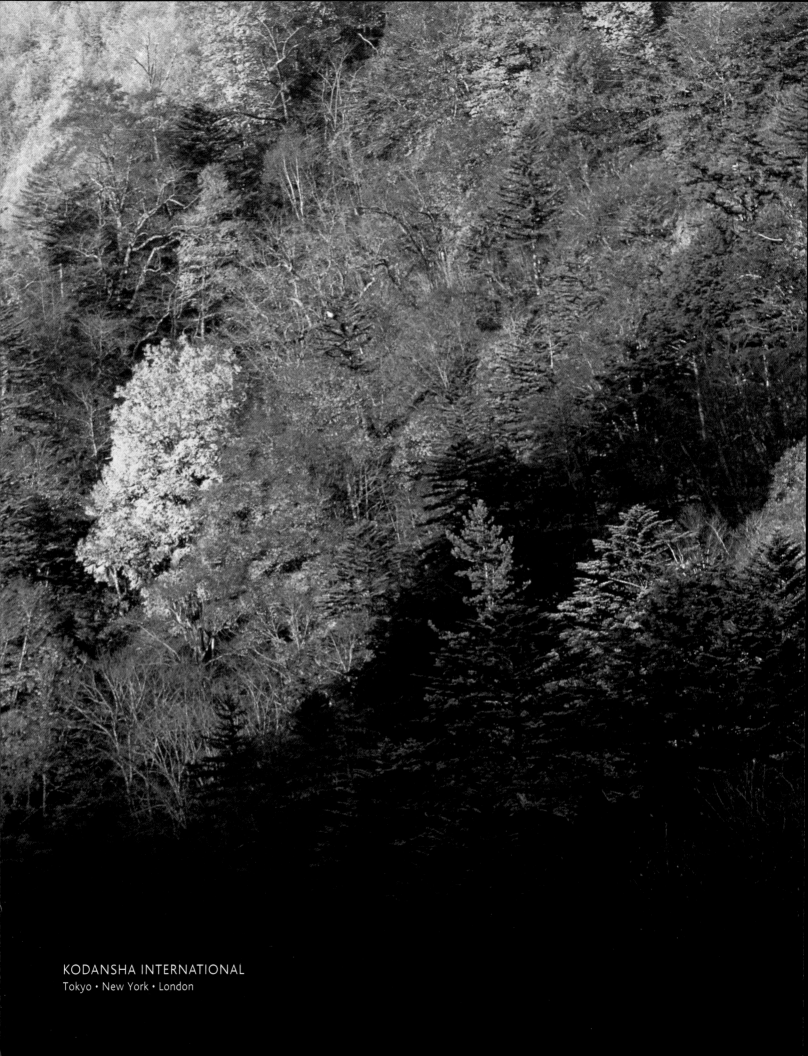

KODANSHA INTERNATIONAL
Tokyo · New York · London

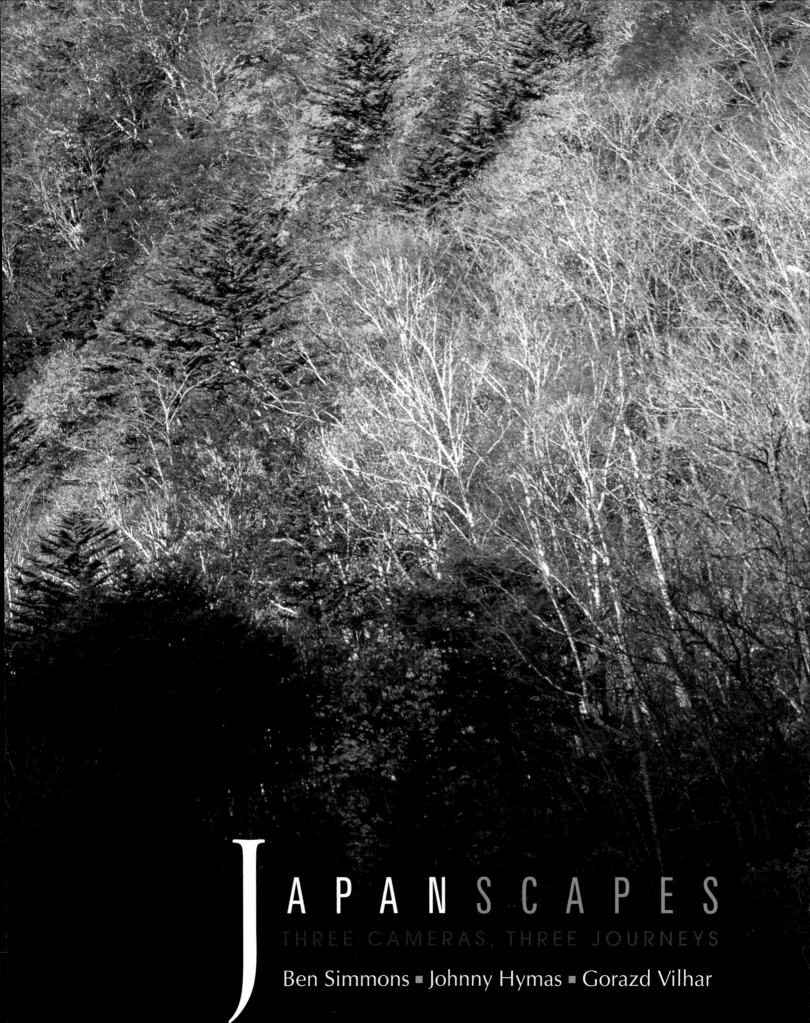

JAPANSCAPES
THREE CAMERAS, THREE JOURNEYS

Ben Simmons ▪ Johnny Hymas ▪ Gorazd Vilhar

CONTENTS

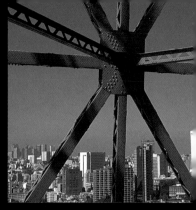

CITY 9
BEN SIMMONS
TEXT ■ Lucille M. Craft

INTRODUCTION Azby Brown 6

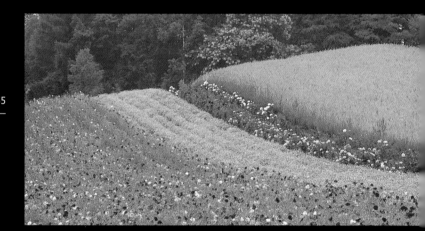

NOTE: Historical periods are listed at the end of the book.

FRONTISPIECE: *Taiko* drum, photo by Vilhar. TITLE PAGE: Fall colors in Norikura, Nagano Prefecture, photo by Hymas.

Published by Kodansha International Ltd., 17-14 Otowa 1-chome, Bunkyo-ku, Tokyo 112-8652, and Kodansha America, Inc. ■ Distributed in the United States by Kodansha America, Inc., 575 Lexington Avenue, New York, New York 10022, and in the United Kingdom and continental Europe by Kodansha Europe Ltd., 95 Aldwych, London WC2B 4JF.

1 2 3 4 5 6 7 8 9 05 04 03 02 ■ ISBN 4-7700-2876-8

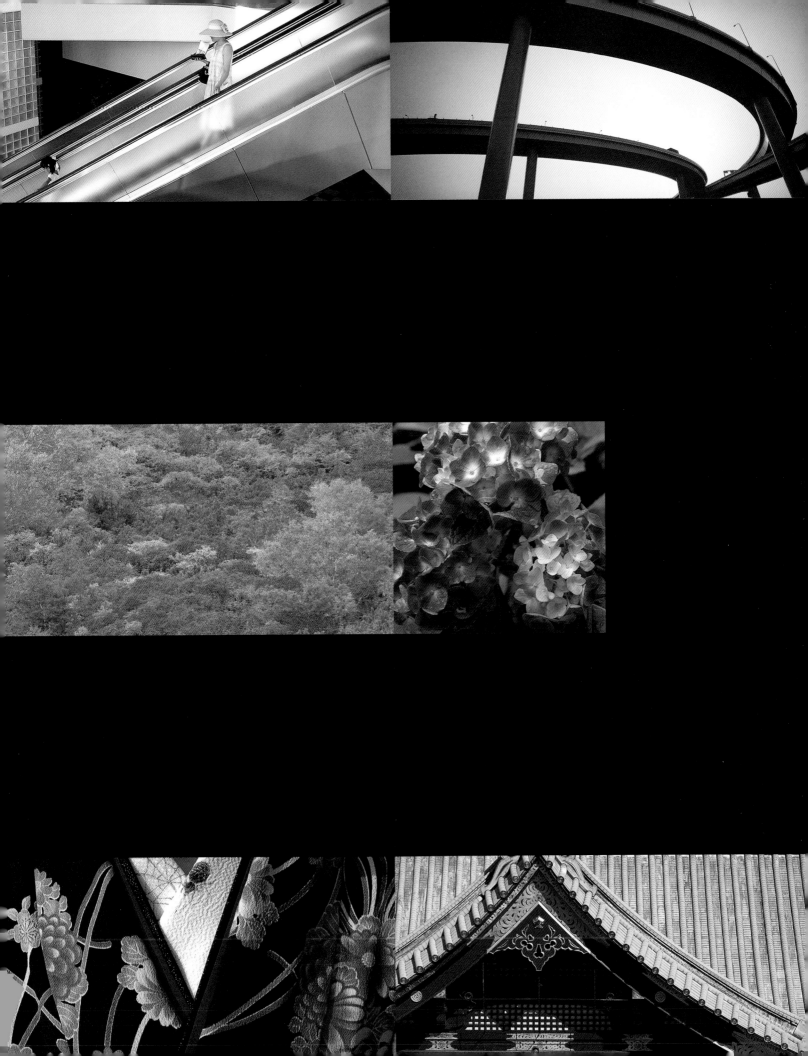

INTRODUCTION

Japan is a fascinating country. It can be exhilarating and shocking, engrossing and annoying, pleasing and baffling. The Japan of today assails the senses, like a shot of adrenaline in the eyeballs, a massive jolt to the ears, a throbbing jab in the olfactory bulb. And at the same time, one finds pockets of beauty everywhere, personal and reposeful spaces obviously tended with care, which exhibit not only an understanding and awareness of the delicate sensibilities of times past but a tangible desire to counter the dehumanizing and debilitating, if not to say culture-threatening, effects of life in a country where economic pragmatism is king.

It is impossible to encapsulate Japan in a text, however long. And one man's ear-shattering din is another's lovesong. Photographs, which render so much clear largely because they leave so much unsaid, are a wonderful way of presenting a place like this. If nothing else, one may examine the photographed reality and arrive at one's own conclusions. And yet there is more to be said. Because photographs are intentionally framed and selective, they leave a lot out; so when one discovers images of Japan that seem to present aspects of the place that are usually cropped out, it is both refreshing and enlightening.

Present-day Japan's vitality, and arguably its very existence, is based upon the often abrasive coexistence of opposing forces and ideas. It is, without a doubt, a technologically advanced nation whose citizens seem to be permanently smitten with gadget lust. And at the same time, these same citizens will line up in the hot sun for hours to get a glimpse of hand-thrown ceramic pots. It is an inordinately fashion-conscious society, whose young people measure clothing and hairstyle trends in weeks, while traditional formal dress—the incomparable kimono—has remained essentially unchanged for centuries.

One senses a nearly obsessive hunger for novelty, hope, and a bit of fresh air, all represented by ideas and images brought in from the outside world. This notion of "within," meaning "of and from us," and "without," meaning "theirs," poses an incredibly robust paradigm for value-assessment. But as the nation consumes its own soul and is smothered under "imported culture" with barely a glance backward, it is with the assumption that someone, somewhere, is carefully husbanding the Things That Really Matter: a teahouse here, a significant sword there, a garden vista elsewhere.

Japan is much more than the all-too-Occidental images first encountered at Narita Airport and the train ride into Tokyo. Yes, the ugly concrete structures and imported cultural icons are all on view—as well as the jittery insecurity this implies—but Japan is also beautiful, gentle, rich in observation and poetry, and possesses a unique and precious sense of the human place in the world and the possibilities for admirable restraint when interacting with nature. These are contradictory characteristics, yes. But those who spend time in Japan tend to come away with an awareness that harboring contradictory sentiments, far from being a sign of duplicity or some sort of mental imbalance, is in fact an eminently human, even desirable, psychic condition.

For these reasons and more, Japan is an extremely broad and challenging subject for photographers. The professionals whose work is featured in this book—Ben Simmons, Johnny Hymas, and Gorazd Vilhar—bring to it a combined experience of over sixty years of looking at and capturing Japan on film. These photographs are alternately entertaining, surprising, energetic, contemplative, and intriguing, and in this sense they capture the experience of being in and looking at Japan surprisingly well.

Throughout the three series presented here—urban Japan, rural Japan, and the traditional culture—the viewer can detect a searching quality, a surprise and wonder, that is palpably different than the investigations of self-identity—of inner conflict perhaps—one encounters when examining ostensibly "Japanese" images of Japan. Outsiderhood is a valuable position for a creator, a privileged perch so to speak, for it allows a more elastic degree of engagement and detachment, and here that privilege is put to good use. These are images of inquiry. Put another way, it is as if each of these three photographers directed his lens at a pregnant scene and made a simple request: "Tell me about yourself."

By suppressing the urge to impress their own personalities upon the Japanese scenes they examine, Simmons, Hymas, and Vilhar have given parts of the country the opportunity to speak for themselves. In this sense, most of the photographs contained here seem to acknowledge the different ways in which the country would like itself to be seen. Though only Vilhar's section bears the word in its title, these images are about Japanese culture. And if one were to characterize further, one might suggest that Simmons's work—on urban Japan—conveys the tremendous energy of Japanese cities; the

imagination and desires of the people; the color, grit, and irony of daily life. These are pictures that focus on the unavoidable sense of conflict the newcomer feels when first encountering cities like Tokyo or Osaka as well as the ease and clarity that the long-time resident may come to feel after coming to grips with the intriguing reality these cities represent. Hymas's images, focusing on rural Japan, show the incredibly varied natural landscape of the island nation in all its green wetness. Yet a closer look reveals that he is attuned to the astonishing degree to which the natural environment has been cultivated. This is nature as a cultural product, as the result of millennia of human intervention. These images document the constant tug-of-war between human will and the unruly natural generative process. Finally, Vilhar, in the section on culture, while seeming to observe the often superficial "stage-set" qualities that traditional culture in Japan tends to exhibit—all color and costume, all rehearsed and cleaned up for the public—penetratingly captures the core of tradition itself: the desire for continuity with the past, the sense of age. His series must implicitly be seen as bracketed by the other two, the rural settlements of the past on one side and the most astonishing cities on the planet on the other. Traditional culture keeps a foot in each era, one representing origins and original significance, the other serving to heighten the value of these ancient cultural practices and manifestations as they are gradually overwhelmed by an endless stream of the new, both imported and homegrown. This is culture enshrined as a beacon of identity, a set of guideposts for evaluating all that has come after.

However, it is not necessary to look at these photographs as essays in culture and outsiderhood, or as embodiments of ideas and relationships. For they are all excellent images, full of other photographic values as well: light, color, rhythm, texture, camera angle, timing. And yet it may be assumed that anyone who picks up this book and feels a glimmer of recognition in its pictures will in fact have had a button pushed: they will have seen something familiar, and a little chain of whys and wheres will have been set in motion. And in fact, the whys and wheres of it all is what this book is about.

Azby Brown

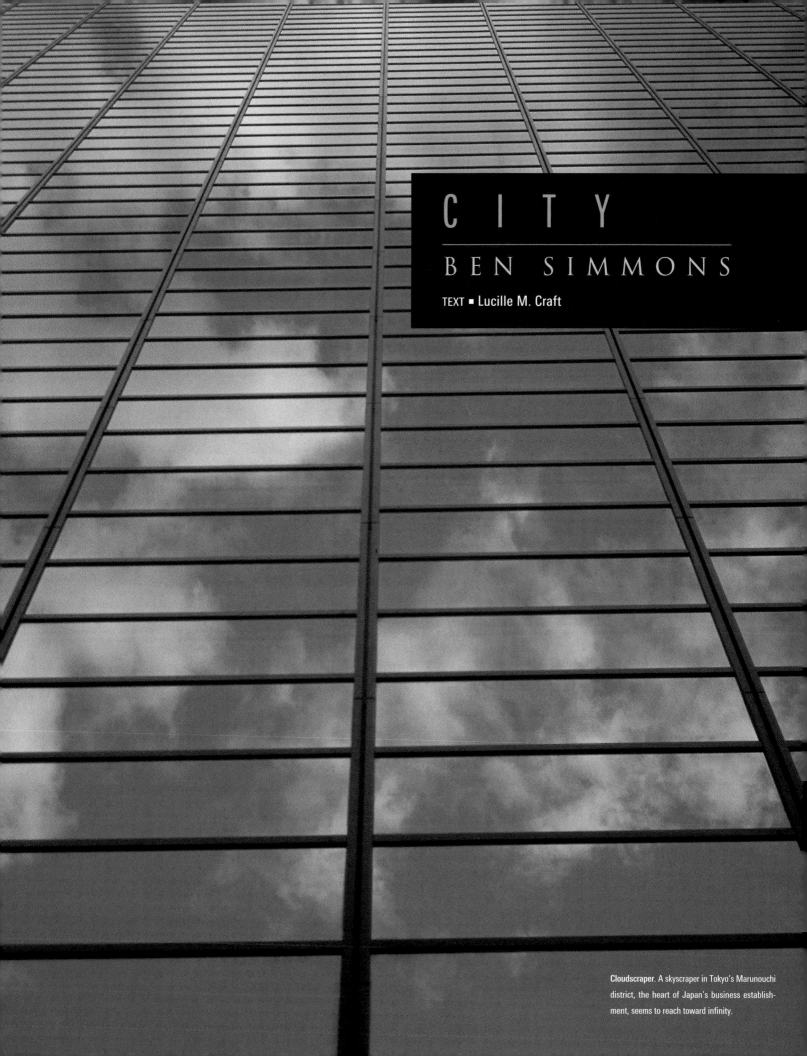

C I T Y

BEN SIMMONS

TEXT ■ Lucille M. Craft

Cloudscraper. A skyscraper in Tokyo's Marunouchi district, the heart of Japan's business establishment, seems to reach toward infinity.

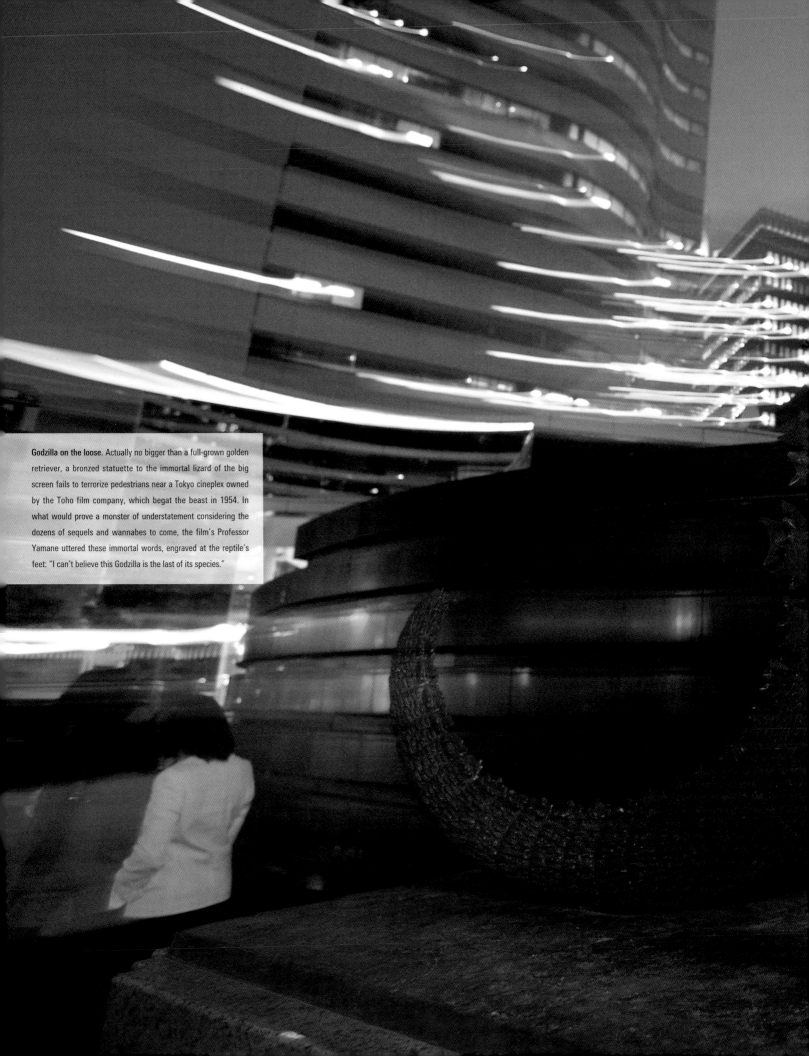

Godzilla on the loose. Actually no bigger than a full-grown golden retriever, a bronzed statuette to the immortal lizard of the big screen fails to terrorize pedestrians near a Tokyo cineplex owned by the Toho film company, which begat the beast in 1954. In what would prove a monster of understatement considering the dozens of sequels and wannabes to come, the film's Professor Yamane uttered these immortal words, engraved at the reptile's feet: "I can't believe this Godzilla is the last of its species."

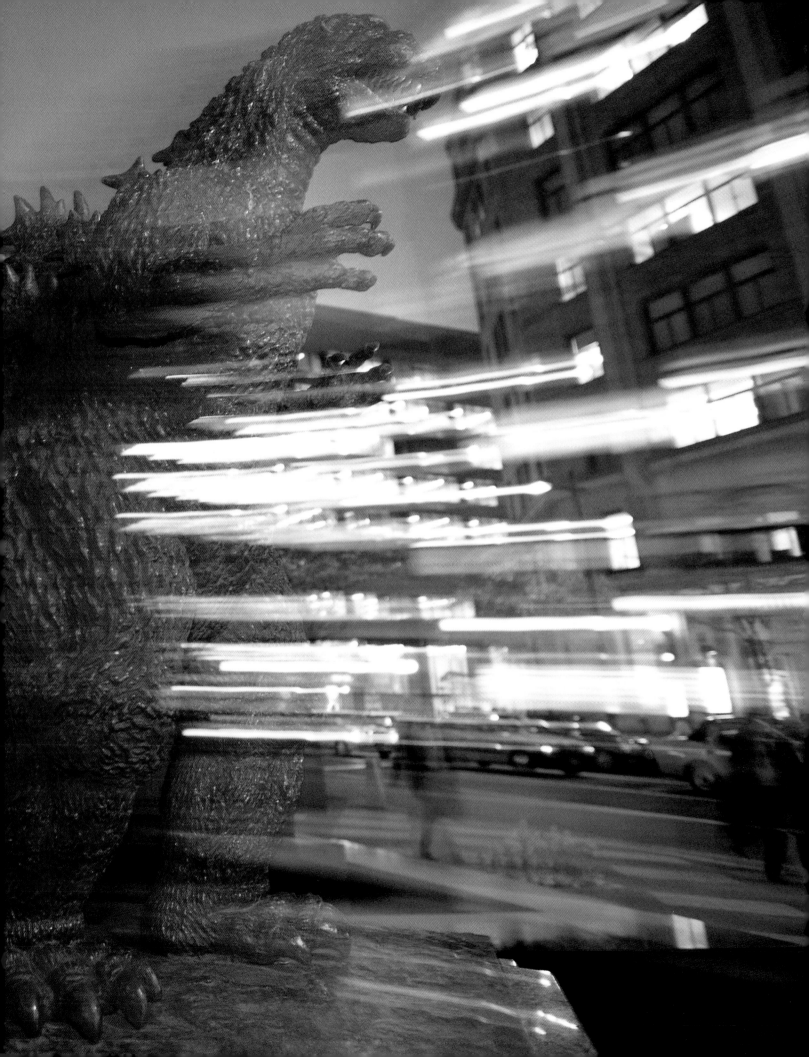

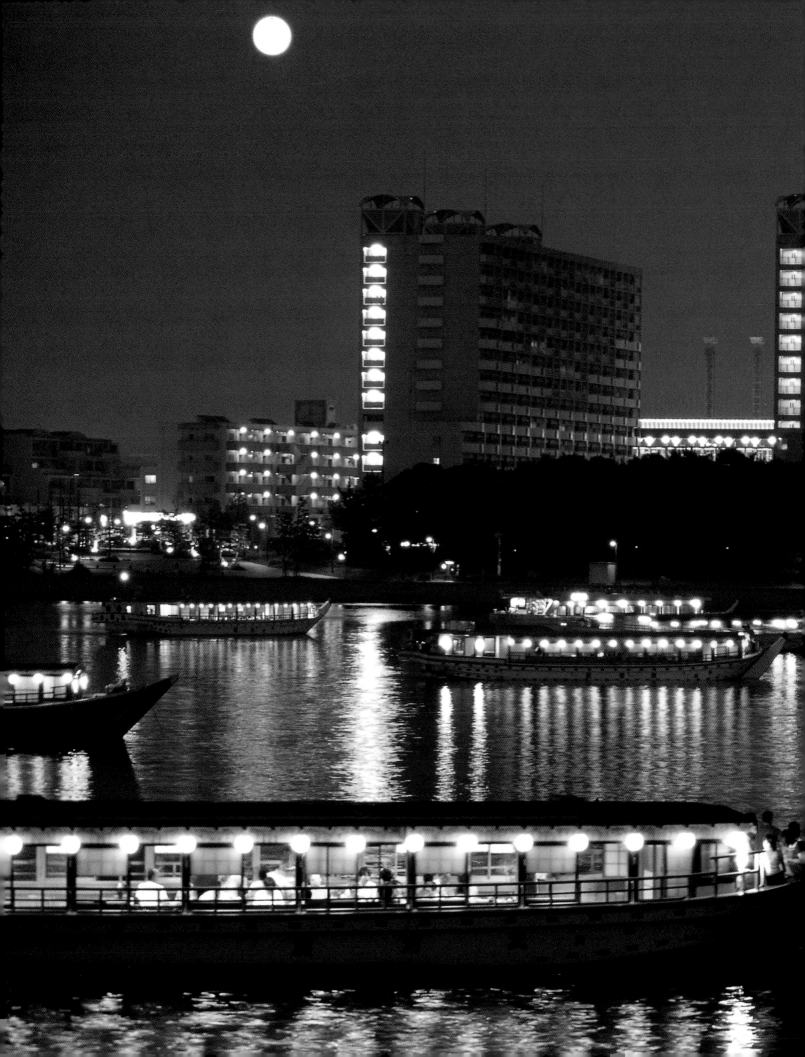

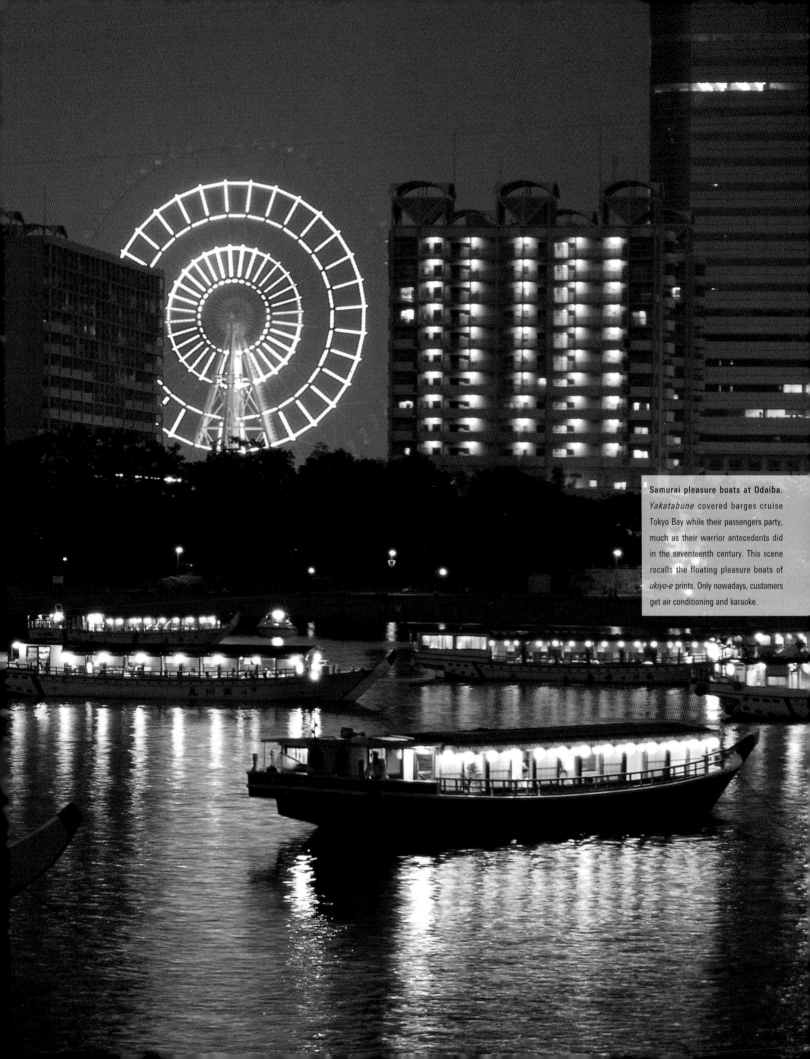

Samurai pleasure boats at Odaiba.
Yakatabune covered barges cruise
Tokyo Bay while their passengers party,
much as their warrior antecedents did
in the seventeenth century. This scene
recalls the floating pleasure boats of
ukiyo-e prints. Only nowadays, customers
get air conditioning and karaoke.

Morning rush hour at Tokyo Station. Foreigners wrinkle their noses at white-gloved train attendants cramming passengers into the cars, but considering the thousands of souls transiting Tokyo Station each workday, unscathed except perhaps for a missing button or scuffed loafer, the transport system is Japan at its technological best.

CLUB, A SLIGHTLY

BEWILDERED LAUREN

BACALL UNWITTINGLY

SUMMED UP THE

SENTIMENTS OF MILLIONS OF VISITORS

TO JAPAN'S CLUTTERED CAPITAL.

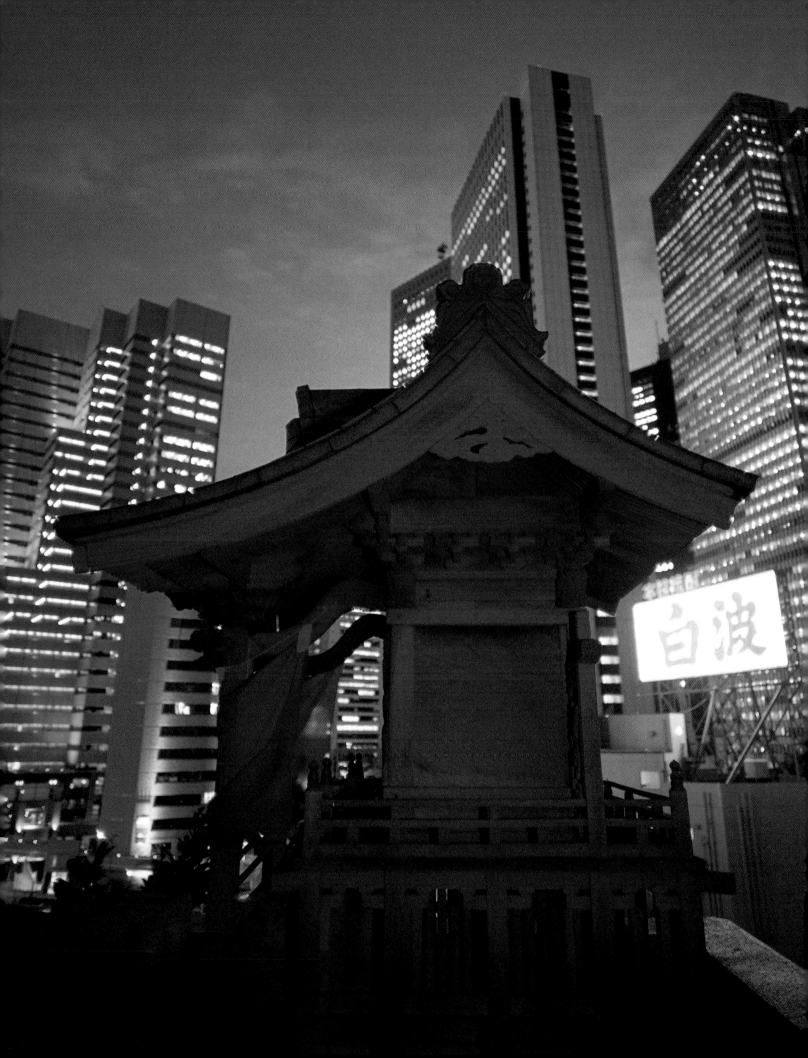

Casually but impeccably dressed, towering regally above the rumpled journalists like some kind of elegant giraffe who had wandered into a herd of livestock, the American actress was nonetheless plainly flummoxed. Despite having logged thousands of miles around the globe through dozens of cities, nowhere had she ever felt so nervous about stepping out of her hotel room, she confessed, as in Tokyo.

There are three points to be made here. First, the screen star and wife of Bogey was of course not referring to fear of bodily harm; Japanese citizens—like urbanites in the West, back in the innocent 1950s—continue to wallow in a placid soup of security so enviably peaceful, subway commuters carelessly stash their parcels on overhead racks while dozing, and pedestrians are able to stroll at all hours,

Interior, Tokyo Metropolitan Government Offices. Kenzo Tange's grandiose, postmodernist addition to the skyline in western Tokyo is unloved by many citizens but has helped the metropolis carve out an image distinct from the national government based downtown.

literally everywhere, designer bangles on display, and this, mind you, without having to affect a skulking, don't-mess-with-me "New York walk." The low rate of crime permits owners of ten-seat noodle shops and fifty-story skyscrapers alike to, if the muse strikes, gild their entrances with a fanciful array of fiberglass, plastic, old cars, a replica of the Statue of Liberty, you name it, much of it fragile grillwork that would not last a week in other urban jungles of the world.

The second point is the shorthand icons still lovingly used to describe "Japan"—the flimsy houses, the carp ponds, even sumo wrestlers—have little to do with the daily sights and sounds of a Japanese city today, to the chagrin of many disappointed tourists, who must sate their hankering for cultural

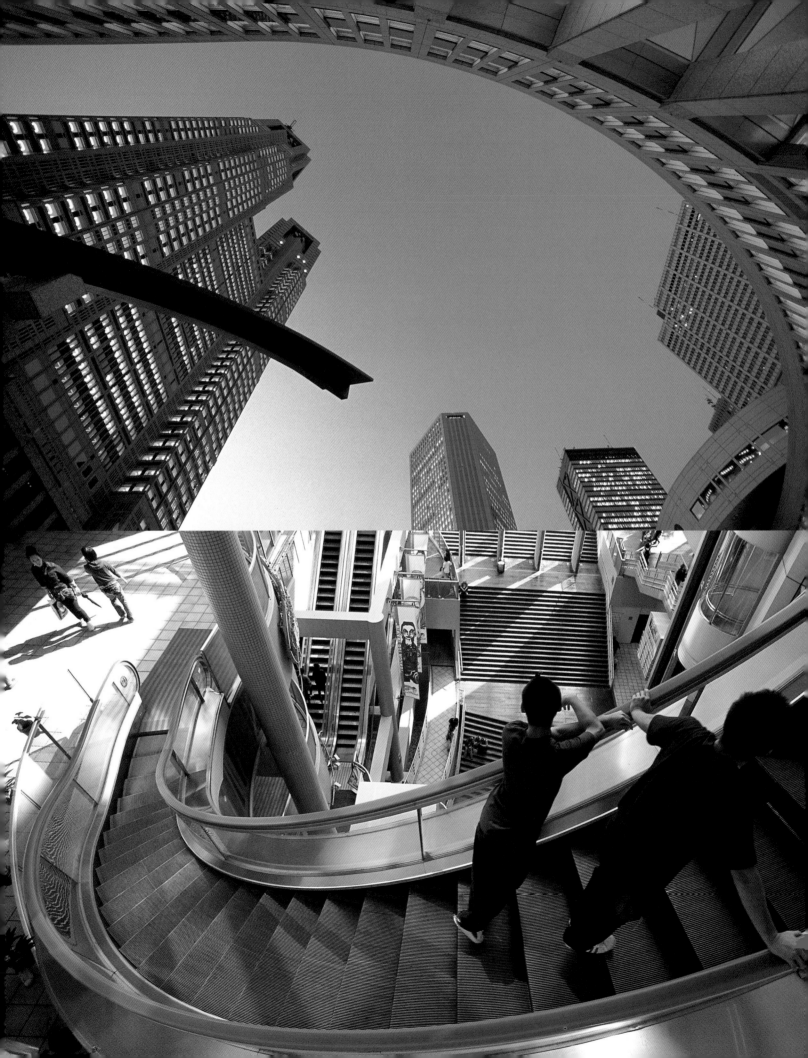

Gazing roofward at **Kyoto Station**. Opened in 1997 to commemorate the twelve hundredth anniversary of Japan's ancient city, Kyoto Station's abandonment of traditional design caused a sensation.

FAR LEFT, TOP: **Tokyo Metropolitan Government Offices, from Citizens' Plaza**. Modeled after the Campo in Siena, the semi-circular plaza is joined by a portico to the main building—48-story, gothic cathedral-style twin towers—and to the assembly hall of the city council.

FAR LEFT, BOTTOM: **Stepping down at Big Step**. A seven-floor beehive of boutiques and eateries, Big Step is a popular people-watching and pick-up haven of Osaka's "American Village," or simply *Ame-mura* to the locals. Weekends, over 200,000 young fashion victims have been known to descend on the area's 3,000 funky shops, which rival their cross-country counterparts in Tokyo in determining what's hot and what's not among the ripped-jean set.

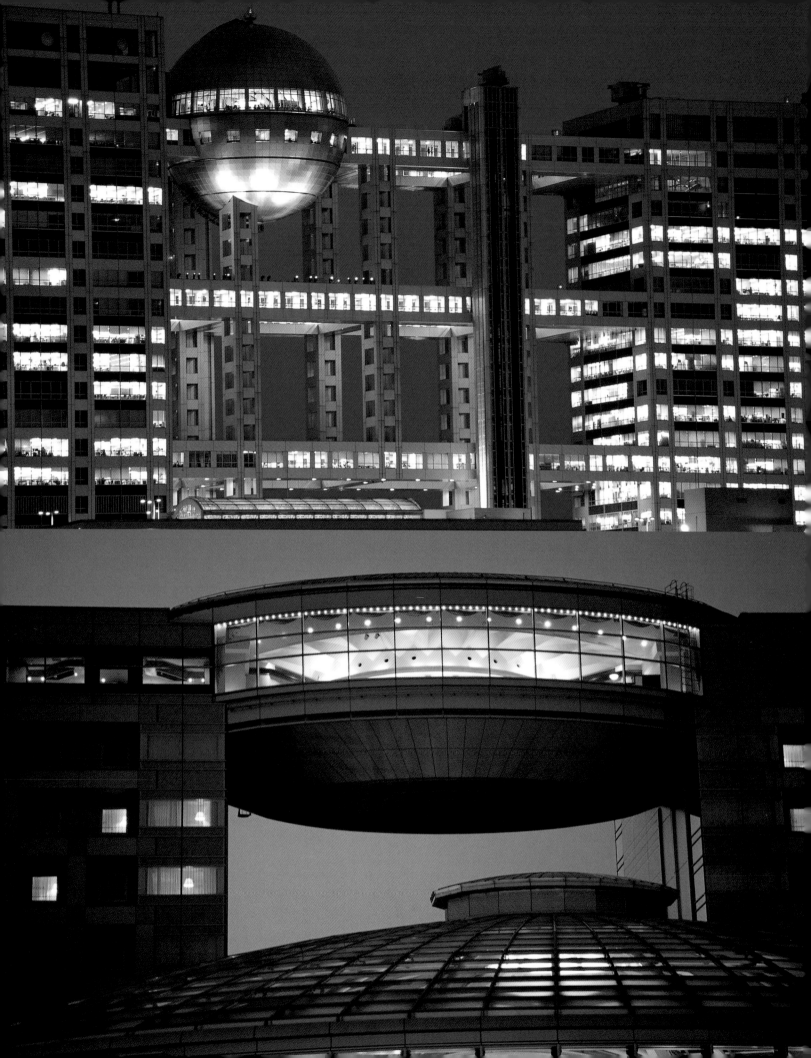

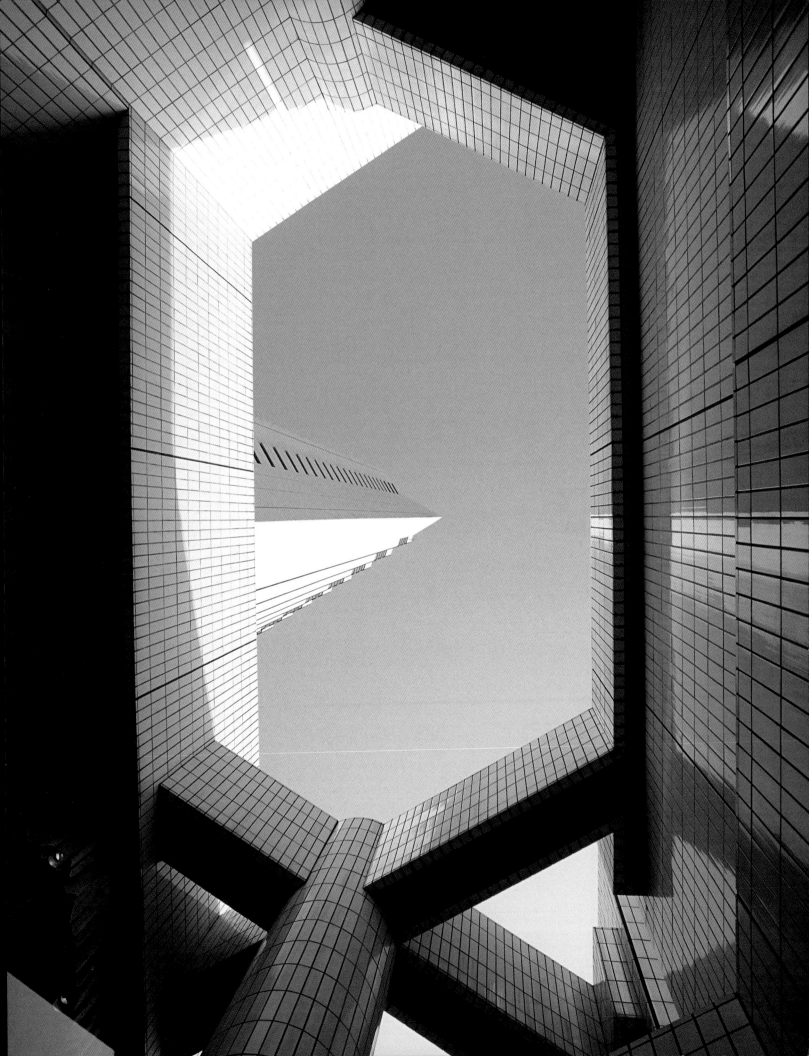

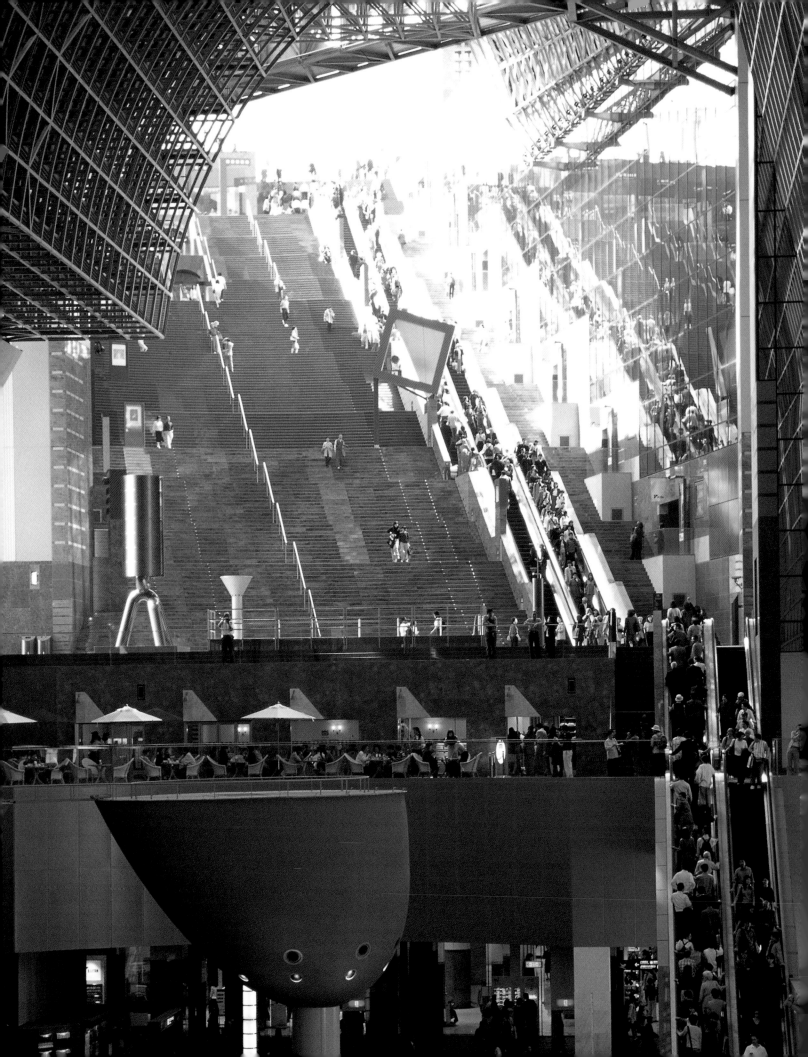

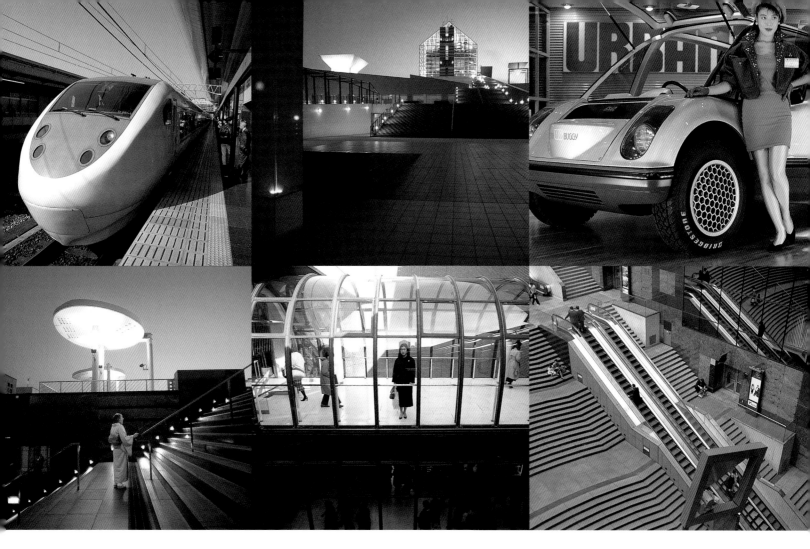

Transport and communications. PAGE 20, TOP; THIS PAGE, BOTTOM ROW, LEFT: Tokyo's Odaiba waterfront area created from landfill is as famous for being a fiscal sinkhole, as for its photogenic qualities. The artificial but sunny beach, fetching Rainbow Bridge, and 380-foot ferris wheel (a world contender; *page 13*) make it a magnet for those in search of romance, dining with a view, and locations for television soap operas, all of this convenient for the Fuji TV network, whose headquarters, with its embedded sphere, overlook the harbor. PAGE 20, BOTTOM: The Aeroplaza retail complex at Hotel Nikko Kansai Airport, a hotel-and-shopping extension of Kansai International Airport. PAGE 21: The ANA Hotel in Tokyo's Tameike area. PAGE 22; THIS PAGE, FIRST ROW, LEFT AND CENTER; SECOND ROW, LEFT AND RIGHT; AND BOTTOM ROW, RIGHT: Kyoto Station initially drew opprobrium from Buddhists, preservationists, and even from its sister cities Firenze, Paris, and Edinburgh. Unrepentant city planners retorted that traditional wooden buildings were killing off the area's tourism and retail sales. In fact, until 1994, Kyoto had the lowest percentage of large retail stores among Japan's eleven major cities. With its festive atmosphere and packed weekend concerts, Kyoto Station may offend traditionalists but has succeeded commercially well beyond its planners' wildest dreams. TOP ROW, RIGHT: The Tokyo Motor Show, an annual fall rite of passage, may be the only car pageant in the world where the public comes as much to gawk at the chicks as the coupes. DIRECTLY ABOVE, CENTER: Commuters and kids pause at Osaka's Nanba Station and (*below, center*) main Osaka Station shopping mall.

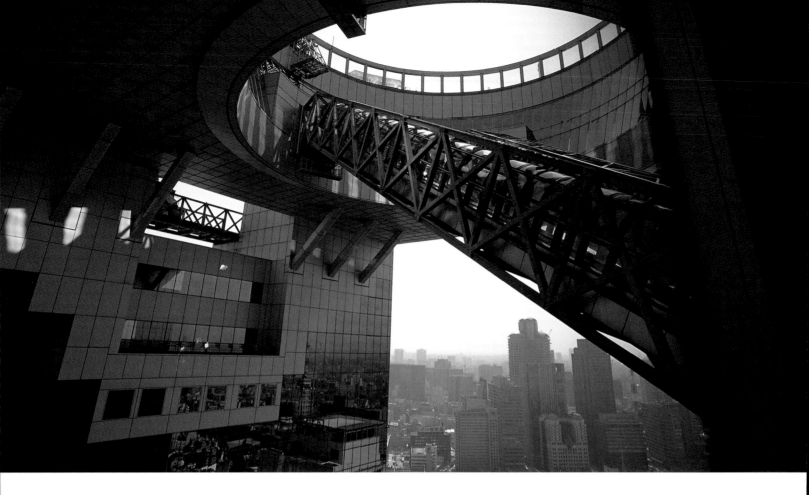

ABOVE, RIGHT, AND LOWER LEFT: **Umeda Sky Building**. Advances in earthquake-resistant technology in recent years have led to an easing of building height restrictions, giving Japanese architects a ticket to go for the sky. A magnet-shaped landmark of the trendy Shin-Umeda district of northern Osaka completed in 1993, the "building" is actually twin skyscrapers connected by an aerial garden. The floors from the third level to sky observatory are linked by a see-through elevator and escalator. Characteristic of the kitchen-sink planning of many Japanese complexes, it contains not only offices, restaurants, and fitness center, but trees, flowers, and a "sky chapel" for staging Christian-style weddings.

BELOW, CENTER: **Shuttle train to Kansai International Airport**. Western Japan's stylishly appointed airport, based on a design by Italian architect Renzo Piano, rivals Osaka's Dotonbori as a favorite setting for movies and TV dramas, and has rightfully drawn plaudits for its soaring roof and sun-filled atrium. But built at a premium on sinking landfill three miles offshore, the picturesque airport struggles to stay above water financially.

BELOW, RIGHT: **Sculpture in West Shinjuku**. Once a seedy district on the wrong side of the tracks, West Shinjuku has blossomed in recent decades into a thicket of high-rise office buildings and hotels, complementing the concentration of bars, movie theaters, and other nightlife to the east.

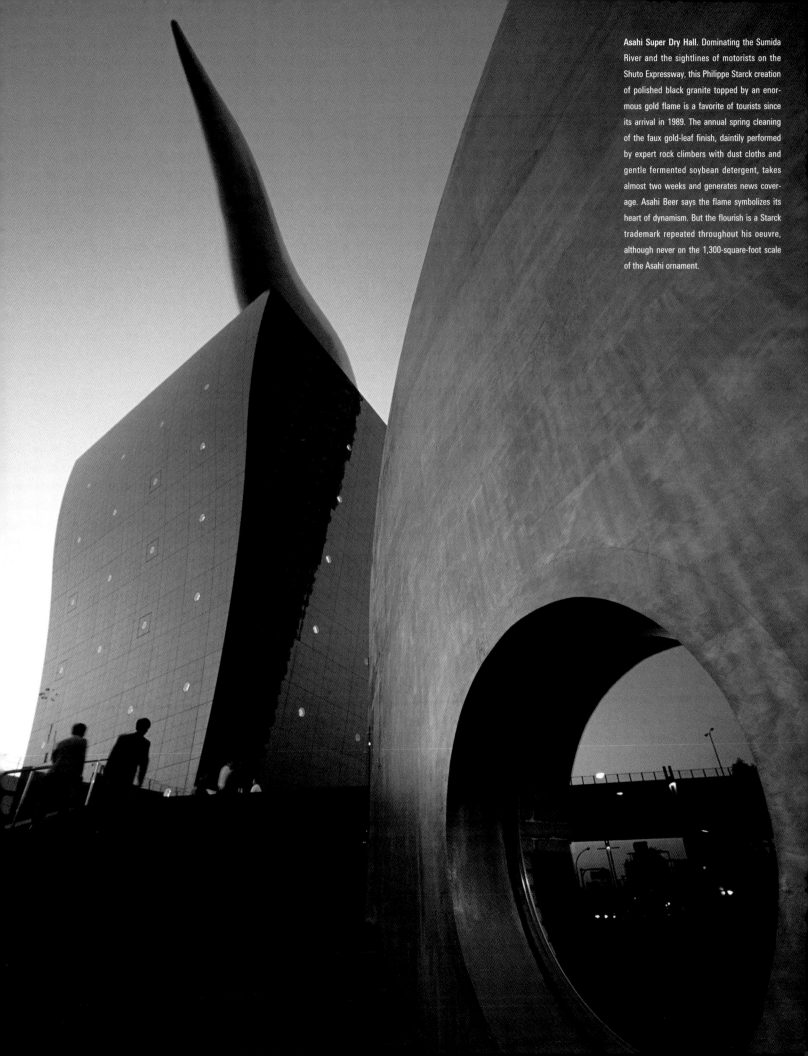

Asahi Super Dry Hall. Dominating the Sumida River and the sightlines of motorists on the Shuto Expressway, this Philippe Starck creation of polished black granite topped by an enormous gold flame is a favorite of tourists since its arrival in 1989. The annual spring cleaning of the faux gold-leaf finish, daintily performed by expert rock climbers with dust cloths and gentle fermented soybean detergent, takes almost two weeks and generates news coverage. Asahi Beer says the flame symbolizes its heart of dynamism. But the flourish is a Starck trademark repeated throughout his oeuvre, although never on the 1,300-square-foot scale of the Asahi ornament.

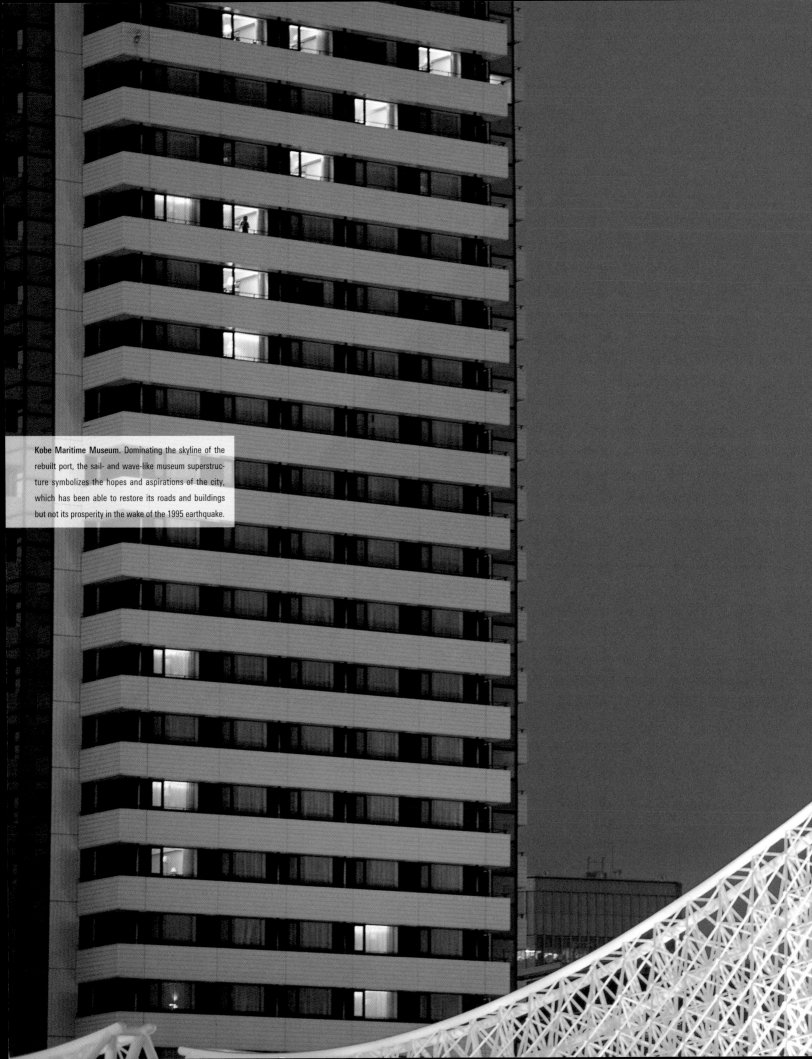

Kobe Maritime Museum. Dominating the skyline of the rebuilt port, the sail- and wave-like museum superstructure symbolizes the hopes and aspirations of the city, which has been able to restore its roads and buildings but not its prosperity in the wake of the 1995 earthquake.

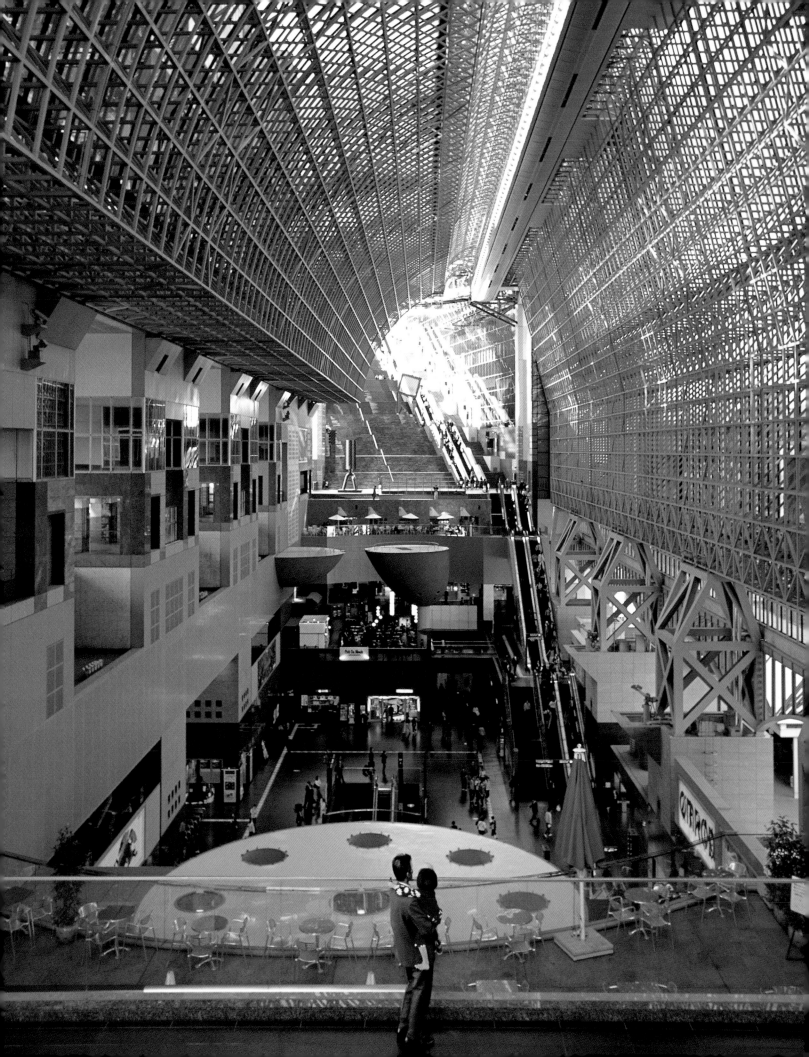

Shinjuku NS Building, West Shinjuku. Named for the first initials of the Nippon Seimei insurance company and Sumitomo Fudosan real estate firm, the 30-story NS Building was part of an unprecedented skyscraper building boom in West Shinjuku that began in 1971. It boasts the "world's largest pendulum clock," a rainbow-colored, see-through elevator, and a roof composed of 6,000 panes of reinforced glass.

specificity with staged tours, the Japanese equivalent of a Wild West revue. "Where's the 'Japan' in Japan?" a frustrated visitor may be heard to mutter, frantically reaching for his Fodor's. Where are those reassuring signposts so carefully nurtured from the thirty-second televised news spots, footnoted from Hollywood movies and mentally clip-filed from tourist brochures? Where, for the love of Pete, are the geisha girls gently swishing along a dimly lit street with quaint wooden temples rising mysteriously in the background to the plucking of shamisen strings? What, no inscrutable "Orientals?" No rock gardens? I want my money back!

Even updated Hollywood portrayals of urban Japan—*Blade Runner* and *Black Rain* are probably the best known—zoom in on the languid neon canyons of Japan's nightlife districts, places Elvis or Liberace could rightfully call home. One might legitimately conclude after viewing these films that, in effect, Japanese cities are essentially Vegas on sushi. In fact, while Japan accounts for a disproportionate share of the world's finest architects, its urban landscapes tend toward the charmless, gray, and brutally functional, reflecting the conservative, techno-wonk tastes of Japan Inc. But that's not in any way meant to imply shabby; in fact, Japanese cities are astonishingly shiny, modern, and new. Through fat times and lean, thanks in part to the fact that nearly every major city except the ancient capital of Kyoto was burned to a crisp in World War II, but also owing to the world's most powerful construction lobby and to a compulsion for incessantly razing and rebuilding—fiscal responsibility be damned—Japan's centuries-old cities show few signs of their age.

Tokyo International Forum. Everything from the MTV Japan awards to corporate stockholders meetings are staged at Rafael Vinoly's Forum, which boasts one of the largest theaters in the world, conference and exhibition space, and restaurants in an imposing flourish of steel frame, glass curtain, and granite.

LEFT: **Kyoto Station atrium.** Featuring a 200-foot-high atrium, 171-step grand stairway which doubles as performance venue on weekends, and a 150-foot, raised-glass east-west passage, the station is emblematic of a return by retailers from suburbs to cities and, says economic commentator Akira Nishimura, enables consumers "to satisfy their big-city aspirations."

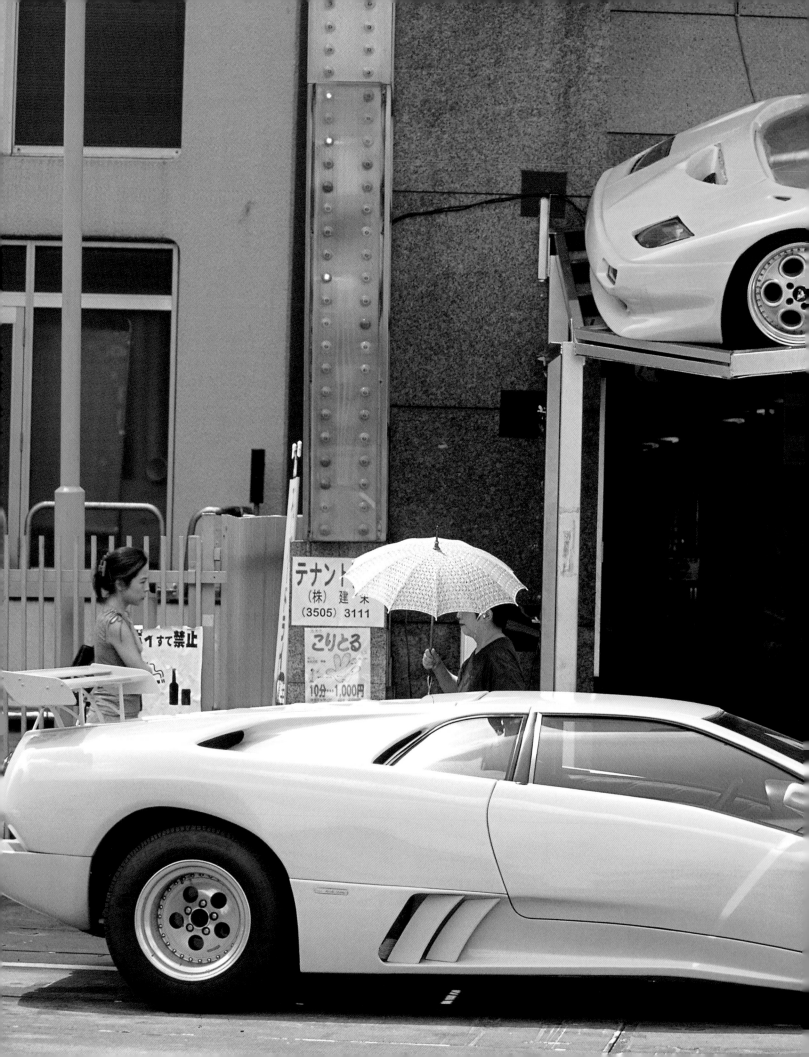

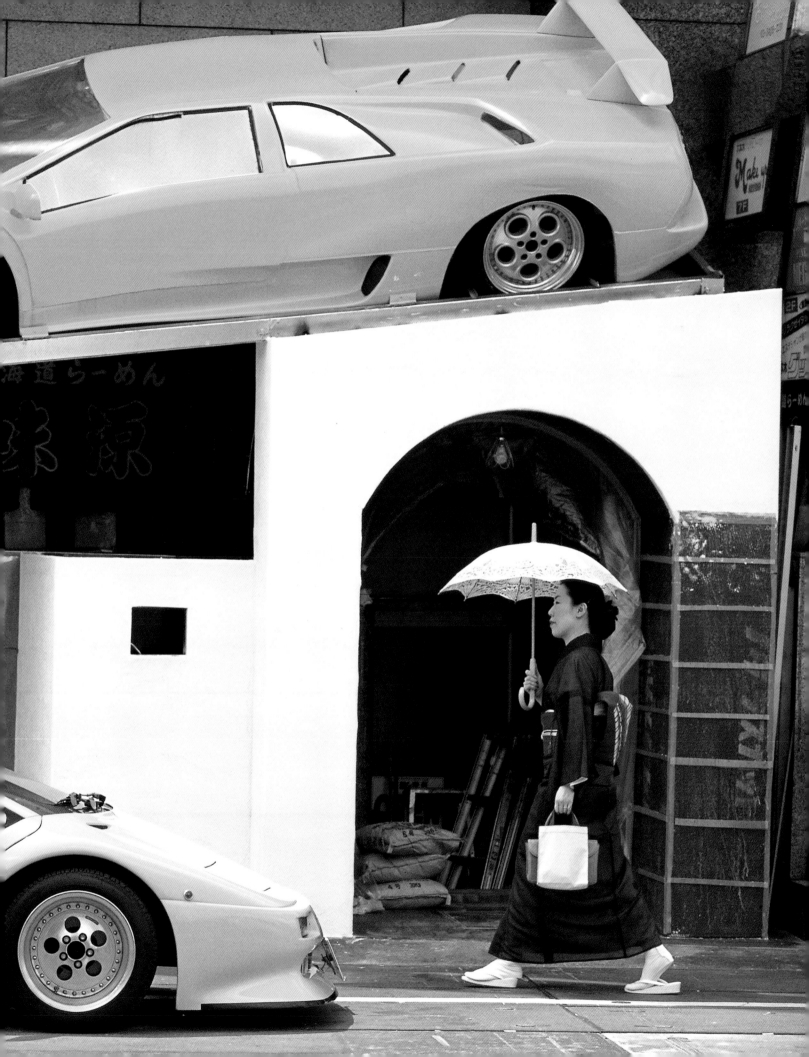

THE THIRD POINT IS THAT JAPANESE CITIES

ARE, AS THE JAPANESE

THEMSELVES ADMIT,

Zenrinmon Gate, Yokohama Chinatown. The most elaborate and most-photographed of Chinatown's ten vivid arches, arranged strategically along the perimeter of the community according to the ancient principles of *feng shui,* the ancient study of the positioning of man-made objects in the natural environment to ensure health, wealth, and power.

NOT MUCH IN THE CITY

PLANNING DEPART-

MENT. MS. BACALL NO DOUBT SUSTAINED

THE VISUAL EQUIVALENT OF INSULIN

SHOCK, TRYING TO PROCESS THE MAZE OF

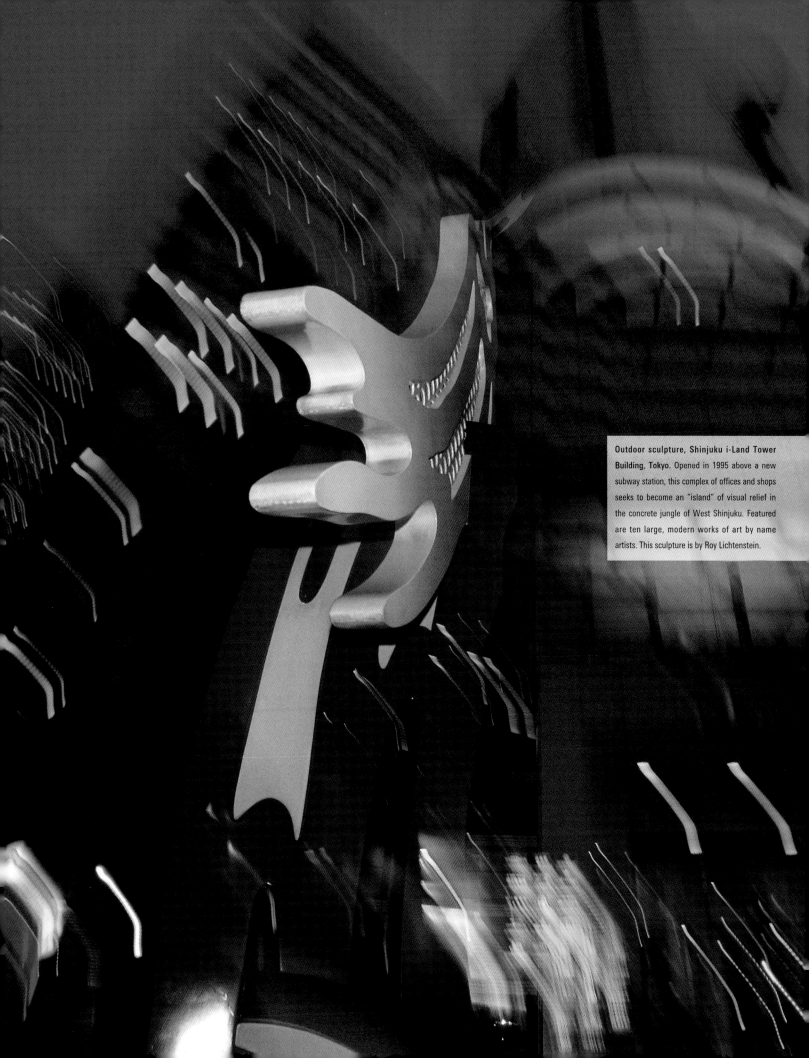

Outdoor sculpture, Shinjuku i-Land Tower Building, Tokyo. Opened in 1995 above a new subway station, this complex of offices and shops seeks to become an "island" of visual relief in the concrete jungle of West Shinjuku. Featured are ten large, modern works of art by name artists. This sculpture is by Roy Lichtenstein.

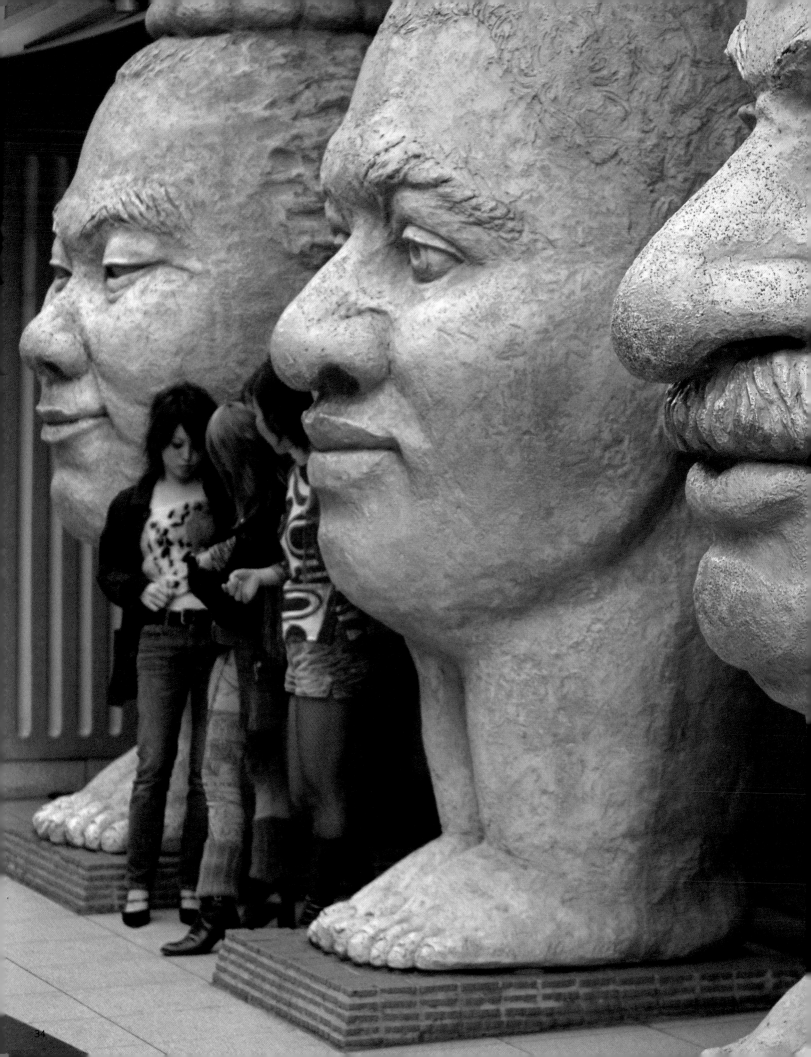

winding narrow lanes and anarchy of billboards written in a demented combination of Japanese and the country's *lingua franca*, bad English. To make matters worse, most streets don't even have names. (Many did, back during the American Occupation, but the dust had scarcely settled after General MacArthur's departure, before this brief fling with imposed Western order was given the bum's rush.)

The renowned architect Kisho Kurokawa once remarked that while cities such as New York or London are organized around rational straight lines and logical addresses, navigating Japan's cities is better accomplished via symbols. Ms. Bacall no doubt would have had an easier time of it, had she taken a crash course in reading pirate treasure maps, which is the way people in Japanese cities give directions: "While facing the big tree, turn right and follow the yellow brick line twenty paces to the eel shop; pass the billboard for toupees and then locate the statue that looks like a bunny rabbit in drag but really is a monument to the patron god of tofu. The road divides into six directions; take the branch at ten o'clock and then look for the 7-Eleven—make sure it's the one near the post office, not the mahjong parlor. . . ." Like mountain climbers grabbing tree branches for support on their descent, Japanese urban dwellers are

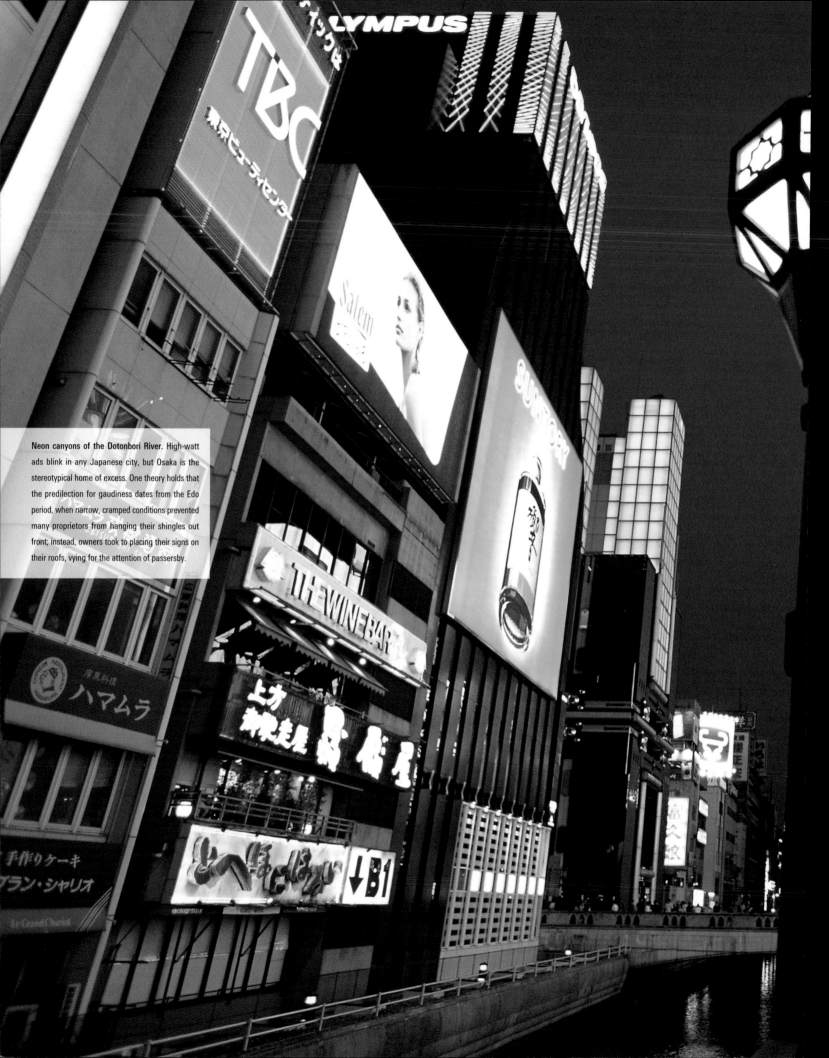

Neon canyons of the Dotonbori River. High-watt ads blink in any Japanese city, but Osaka is the stereotypical home of excess. One theory holds that the predilection for gaudiness dates from the Edo period, when narrow, cramped conditions prevented many proprietors from hanging their shingles out front; instead, owners took to placing their signs on their roofs, vying for the attention of passersby.

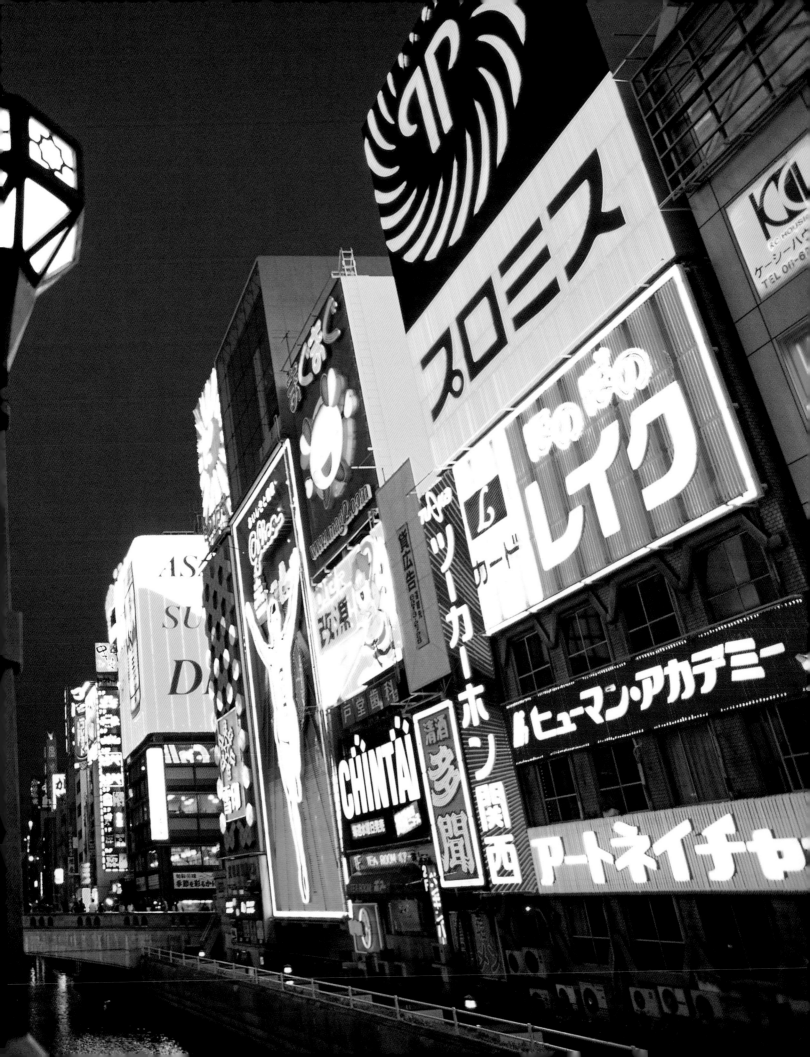

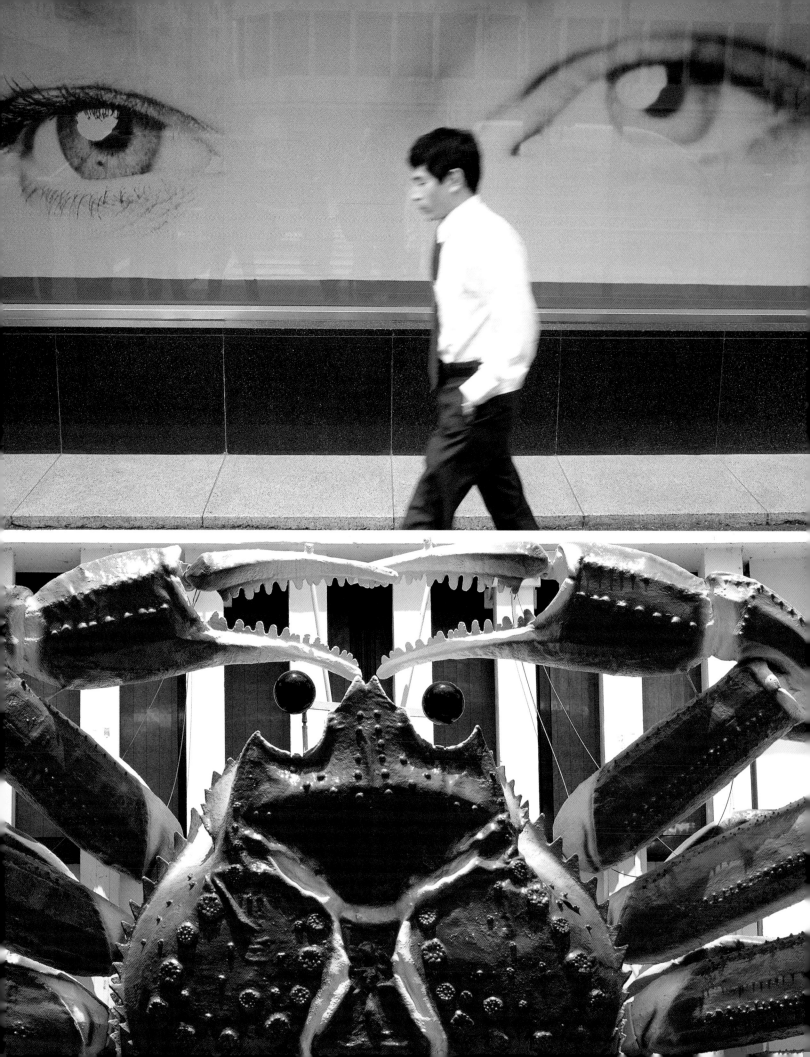

Good things come in big packages. OPPOSITE: A salariman strolls unaware that Big Sister is watching in Shinbashi business district; and a giant crustacean, the bony mascot of an upscale crab-house chain, beckons customers in Kyoto. TOP: A trendy Aoyama boutique is wrapped for Christmas, a holiday celebrated with curiously great relish in this non-Christian country. DIRECTLY ABOVE: A dragon guards the entrance to a restaurant in Yokohama Chinatown (*right*). Though Yokohama has the largest of Japan's three Chinatowns (the others are in Nagasaki and Kobe), most of the Chinese running the town's overwhelmingly Cantonese-style restaurants commute from elsewhere. Those in search of a riskier treat dine at blowfish restaurants like this one (*left*) with a puffer out front in Kyoto's Gion district. Yet for cruising with style, there is still no place like glittering Ginza (*center*).

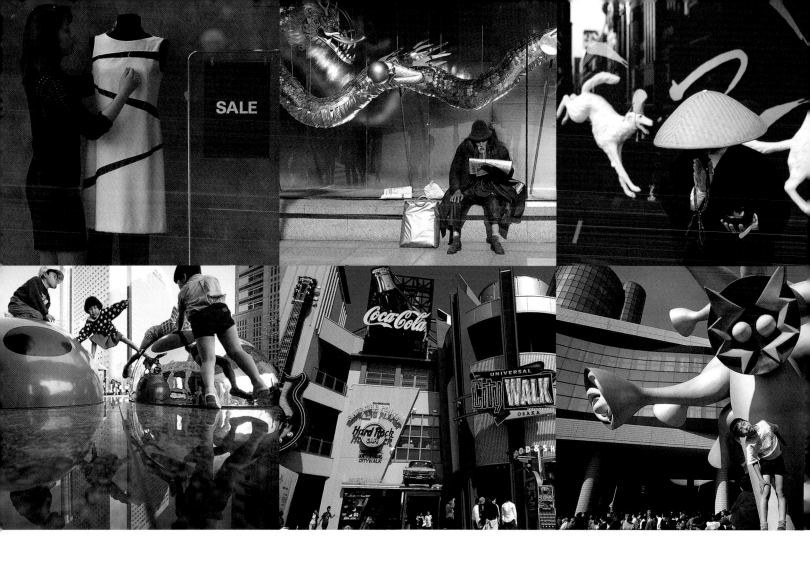

Blending into the scenery. TOP ROW: This trio of photographs offers contrasting views of three Tokyo retailers: window dresser at Mitsukoshi in Ebisu; homeless man at Waco in the heart of Ginza; and mendicant monk in Ginza. One of the paradoxes of early twenty-first-century Japan is that rising unemployment has failed to dampen the appeal of luxury goods. Once the exclusive territory of Japanese department stores and boutiques, Ginza has been transformed into an embassy row of famous western labels. SECOND ROW, FROM RIGHT: For many Tokyoites with children, the National Children's Castle in Aoyama is a second home. Built during Japan's salad days in 1985 at a cost of over 30 billion yen, it is a dizzying department store of play, including an Olympic pool, two performing arts theaters, audiovisual library, music studio, crafts department, and yet still more nooks and crannies for physical activities—in short, a much-needed oasis of diversions in a city where play-space, like space for everything else, comes at a premium. CENTER: From the carefully aged speed-limit signs on Rodeo Drive, to a replica of San Francisco's Fisherman's Wharf, to the period-piece storefronts on New York's Lower East Side, Universal Studios Japan is a lavish, 1.4-billion-dollar re-creation of America's most famous landmarks. No expense seemed to have been spared in bringing the pavements of America to this former industrial wasteland on Osaka Bay. By banking on its celluloid appeal and the Japanese love for Americana, and by carefully calibrating everything from splashing effects to spaghetti and souvenirs to suit Japanese tastes, the theme park rivals its immensely popular cross-country competitor, Tokyo Disneyland. LEFT: Tokyo Metropolitan Government Offices, Citizens' Plaza. Critic Max Bolstad mourns that although this is one of the best-designed aspects of the complex, and a rare urban oasis, it is usually overlooked by visitors making a beeline for the mediocre sky observatory.

RIGHT: **Lounge, Asahi Super Dry Hall.** Japan is the world's fifth-biggest consumer of beer, and boisterous, Bavarian-style beer halls, where office workers slug heavily foamed-up mugs of brew, are a dime a dozen. But stepping into Philippe Starck's acclaimed beer hall in the heart of Tokyo's *shitamachi*, or old downtown, is hardly the trip to Ye Olde Munich Beer Hall. The black granite edifice houses a surreal fantasy world, with windowless rooms, wavy walls, and velvet, velvet everywhere—on doors, drapes, walls, and chairs. This atmosphere heavy on sound-absorbing fabric enhances the sense of wandering through a silent, alien universe, certainly not typical of the places where salarimen go in search of a nice buzz with their mates.

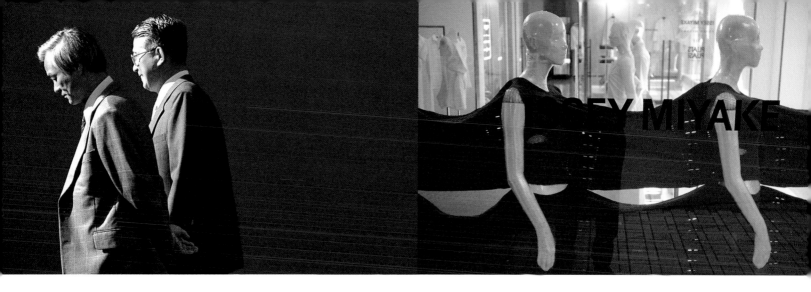

accomplished at spotting and grasping the visual landmarks to their destinations. Granted, for most of us this is an acquired skill, like learning to suppress the gag reflex when eating fermented soybeans or being able to bow naturally, without appearing to have been electrocuted, and some of us fare better than others. I have only once heard a newly arrived foreigner tut-tut over "all this nonsense about culture shock" and boast of having effortlessly located his employer and rented apartment, literally straight off the plane from Berlin. As it happens, he was a professional cartographer.

Living in such cramped conditions seems inhuman and perhaps even inhumane at times, and Japanese don't need French heads of state to remind them of it. But what the French don't get is that population mega-density isn't all downside. When you live in a Japanese city, with population several times denser than would be considered tolerable elsewhere, it means that the essentials of daily existence are never far away; it's like having a drive-thru window for just about everything at your front door. Suburban Americans measure quality of life by the number of amenities within driving radius; life is good if the mall is less than thirty minutes away. But the daily universe of a typical Japanese urbanite is compressed exponentially. Honeycombed into Japanese neighborhoods are shops of every kind: restaurants, doctors, post offices, rec centers, schools, banks. Children don't have to be chauffered to soccer games or the orthodontist because everything is either down the street or, perhaps, a mere few minutes further by train. Teens are emancipated from the tedious ritual of having to bargain with their parents for the car keys; they can get just about anywhere on the subway or the train. Okay, parking is a nightmare, but then, driving is so expensive and difficult and unnecessary as to constitute a self-indulgent and somewhat masochistic luxury—strangely enough for the home of Toyota and Honda.

FAR LEFT: **Breaking away**. The salaried worker, with his lifetime job, guaranteed wage hikes, and stay-at-home wife—the hero who built Japan from ashes to economic superpower—now appears to be walking into extinction. LEFT: Aoyama boutique of Issey Miyake, one of the first Japanese designers to gain international renown when Japanese fashion went abroad in the 1980s.

For all their skill at building rotary engines or getting the trains to run on time, Japanese have not made good use of their preciously scarce land. While New York, like Tokyo a city of eight million, has long prided itself on defying gravity, Japanese cities remain remarkably sprawling and low-rise, even though earthquake-resistant skyscrapers have been technically achievable for several decades. Build higher, economists say, and people get more living space and shorter commutes. (Tokyo, with less than ten percent as many skyscrapers as New York City, ranks fifteenth in total number of high-rises, behind Sao Paulo, Honolulu, and even Mumbai. Only seven of the world's top one hundred skyscrapers are in Japan—found in Tokyo, Yokohama, Osaka, and Nagoya—according to Skyscrapers.com. Highest building in Japan: Yokohama's seventy-floor Landmark Tower, the world's twenty-seventh tallest, at 971 feet.) Gradually, as the recession slashes costs for construction and real estate, high-rise dream homes are starting to become a reality for long-suffering Japanese.

That's what they're wearing. UPPER AND LOWER RIGHT: Snapshots of Aoyama, a Tokyo district of tiny boutiques, French restaurants, and fashion. Aoyama is home to the exclusive Aoyama Gakuin University, the United Nations University, and the leafy Aoyama Cemetery—a favorite picnicking spot at cherry-blossom–viewing time. LEFT: A shop window on Kitano Street seems to speak for all inhabitants of Kobe, site of the Great Hanshin-Awaji Earthquake. The trembler shattered one of Japan's most endearing and historic port cities on January 17, 1995, killing 4,500 and destroying 100,000 buildings. CENTER: A woman in kimono at Nakano Sun Plaza in Tokyo, where weddings are performed, often with the bride switching from kimono to white wedding gown during the event.

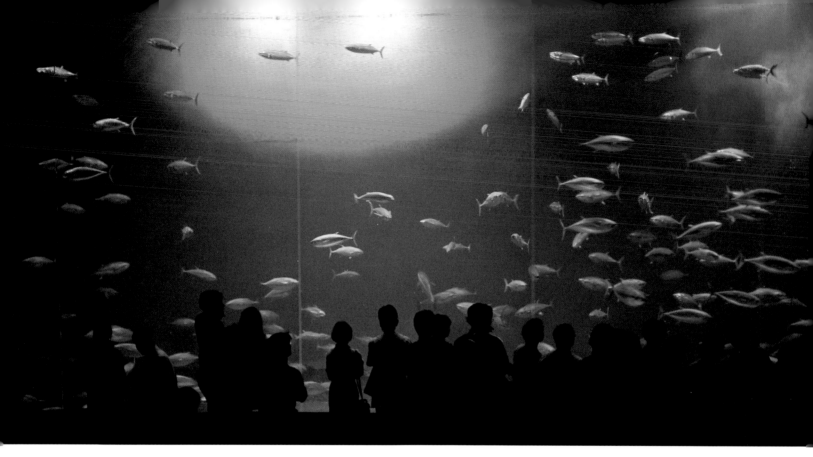

Yum! Bonito and bluefin flounder at Tokyo Sea Life Park, recalling a bygone era when Tokyo Bay brimmed with fish and served as the capital's prime source of seafood.

In the meantime, whenever those concrete cocoons most city residents call home stop being cozy and start becoming oppressive, it's time to hop into the Land Cruiser or even the Marunouchi subway, transportation in this country doing double duty as surrogate living rooms. (In what other country could the Walkman have been invented, and GPS-guided car navigation systems or Internet-enabled cellphones have become so popular? Where else could auto designers have concocted minivans equipped with backseat tatami "lounges," as in a country where people spend the better part of their productive lives in transit?)

Downtown parks have never generated the spontaneous and lively *joie de vivre*—or rather, are too tightly regulated to permit in-line skaters or sidewalk recitals by, say, itinerant musicians from Peru, although budding violinists, sax players, and even drummers looking for a place to practice their scales

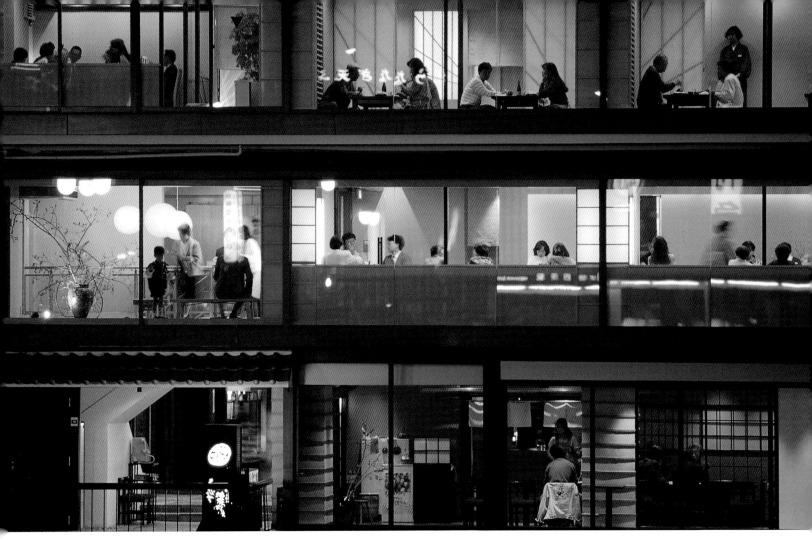

Diners, Kamo River, Kyoto. Whether seated on chairs or tatami, restaurant patrons offer voyeurs a feast for the eyes.

are tolerated. To be fair, workaholic, study-aholic Japanese didn't really need leisure areas until quite recently, with the slow and grudging adoption of two-day weekends at workplaces and schools. As it has for centuries, Tokyo and the Kansai metropolises continue to send out fingers of landfill into the ocean, and it is in these newly founded waterfront leisure areas where the uptight rules are loosened a bit.

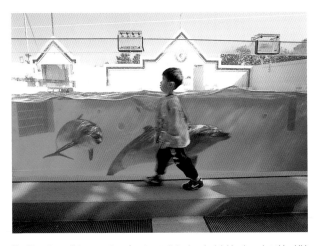

Not flipped out. Shinagawa Aquarium boasts Tokyo's only dolphin show, but this child appears impervious to the charm of Flipper.

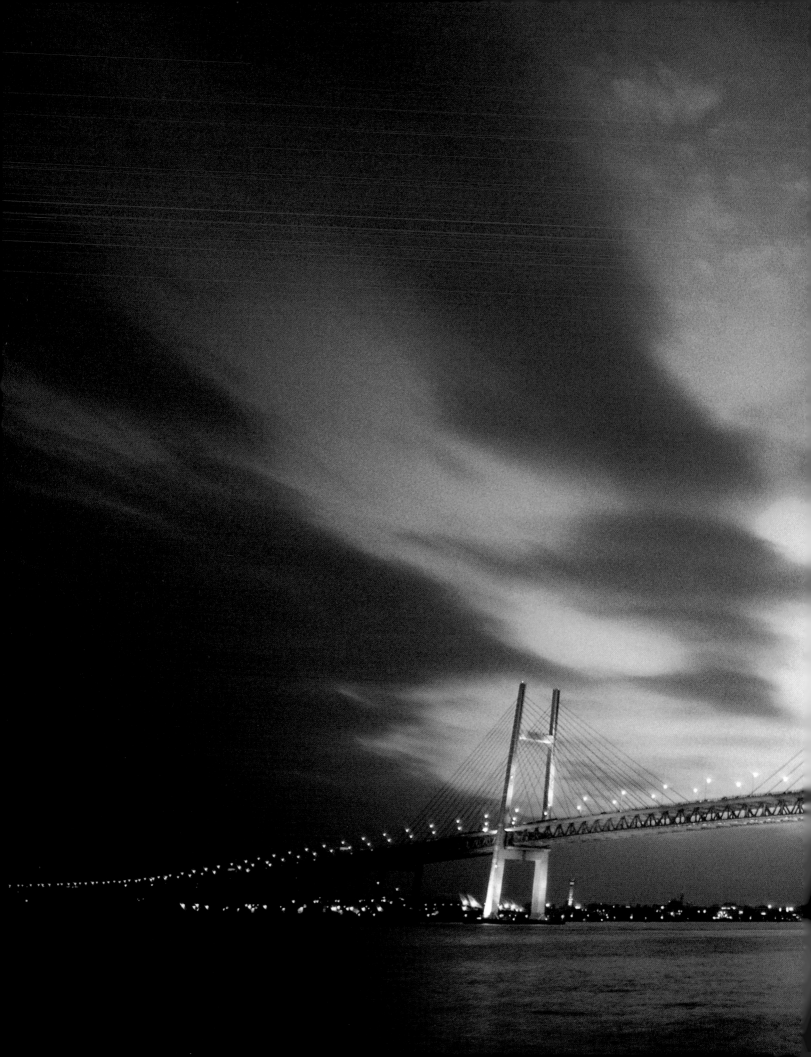

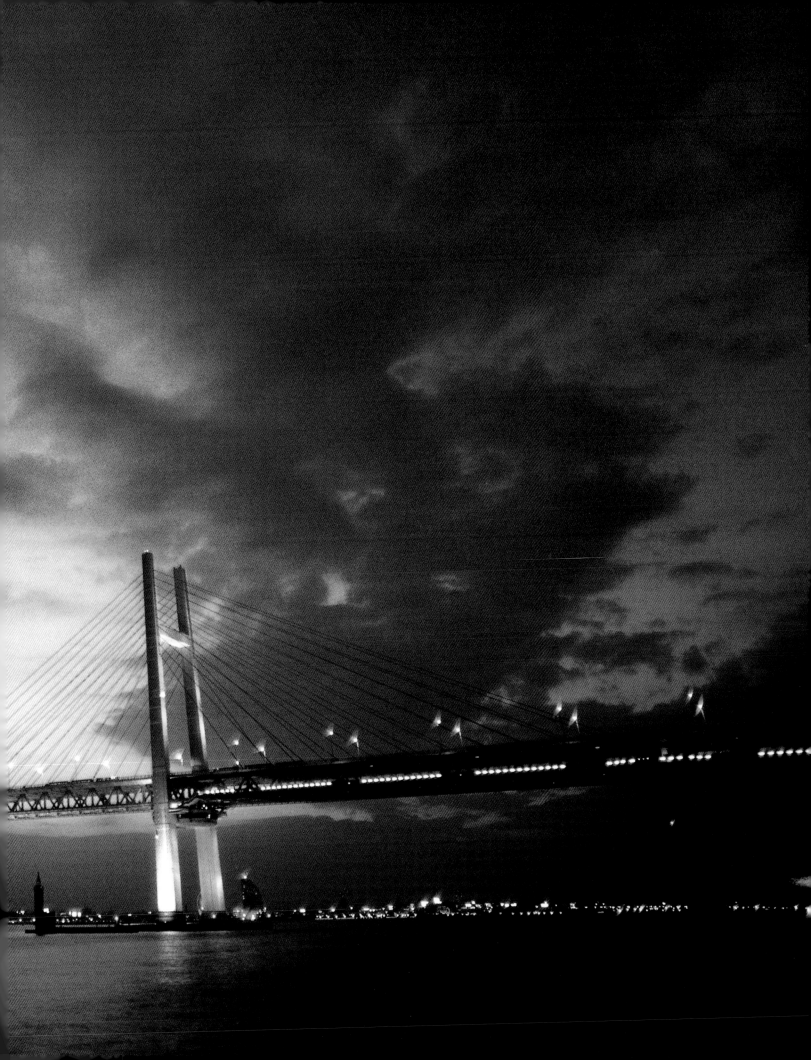

CALIFORNIANS BRAG ABOUT THEIR FUNKY

ROAD ARCHITECTURE,

SAN FRANCISCANS

Ship at anchor with Yokohama Bay Bridge in background.

PRIDE THEMSELVES ON

THEIR ARCHITECTURAL

WHIMSY. BUT GUESS WHAT—TOKYO AND

OSAKA, FOR ALL THEIR GRAY AND DRAB

ARCHITECTURE, ARE NO SLOUCHES

Waterslide of beachside pool, Enoshima. For generations, the seaside area of Enoshima has cooled parched denizens from around Tokyo. At peak periods the crowding is so intense, water and sand seem to disappear under the tide of humanity.

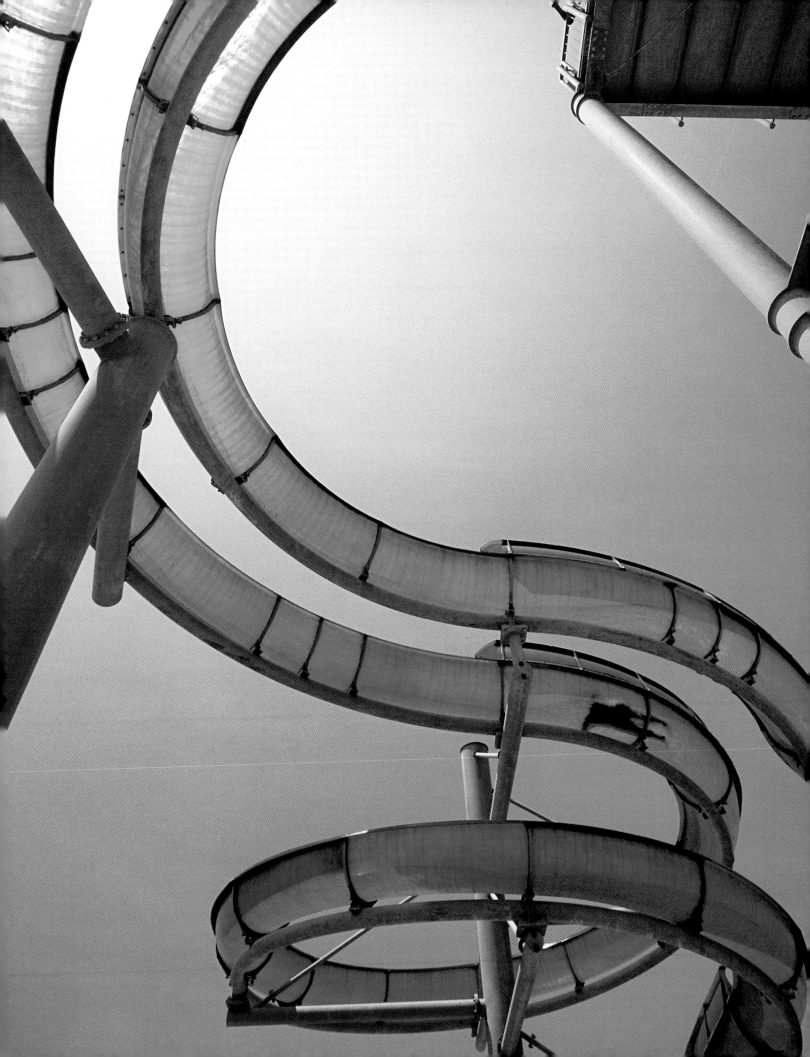

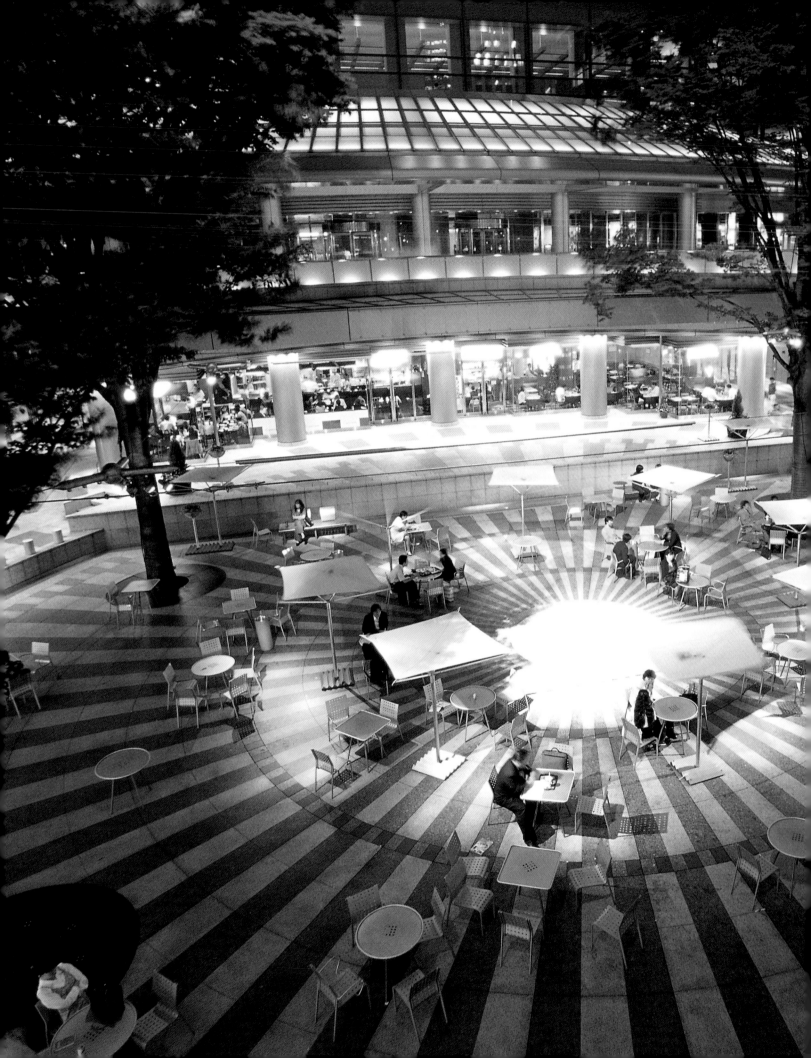

when it comes to the weird and wacky. Osakans worship gaudiness and getting in your face, the truism goes, but decorative excess is really a national trait, the result (or, depending on your point of view, the repercussion) of a culture where comic book reading ends not at puberty but, for many people, around the time they need bifocals. Winsomeness is a dominant strain in pop culture, a trait enhanced no doubt by the archipelago's splendid isolation from other countries and from any direct contact with the terrible problems afflicting the rest of the planet. Other cities are loaded with sculpture erected to immortalize fallen war heroes and sagacious leaders. Tokyo's—no, make that *Japan's*—most famous piece of bronze is dedicated to Hachiko, a curly-tailed canine who earned renown not for dragging injured people from a disaster site or carrying rum to avalanche victims, but because he waited for his master every day after work at the train station, continuing the courtesy for ten years after the man had left this world. The patient mutt's forbearance is fittingly paid tribute every single day, as pedestrians loiter at his forepaws in the Shibuya shopping district, scanning the crowd for their lunch dates, English teachers, or business associates, probably the single most popular meeting spot in the country.

Hachiko is only one manifestation of the street menagerie populating the

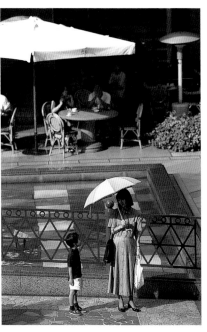

Yebisu Garden Place, Tokyo. Built on the site of a razed beer factory, the office-residential-retail complex brims with odes to European grandeur.

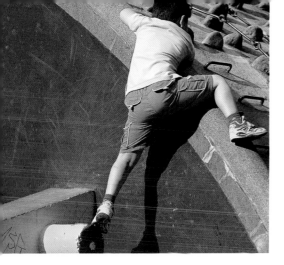

streets of Japan. An upscale crab-house chain sports a monstrous crustacean, its motorized legs gesticu-lating madly like a butterfly pinned to the mounting board too soon, before the chloroform kicked in. Pharmaceutical companies produce smiling, kid-sized anthropomorphized elephants and frogs to display in front of drugstores that shopowners keep carefully dusted and tots can't resist petting on the way in. Then there's the Kentucky Fried colonel, and Peko-chan, the cutie pie with the bobbing dashboard-orna-ment head who stands vigil at Fujiya confectionaries, and even gets a wardrobe change every few months. Finally, wags elsewhere may smirk about skyscrapers as virility symbols, but only Tokyo can boast high-rise corporate headquarters on prime downtown real estate, built to resemble a giant condom.

A personal note. Not long ago, my mother, who left Tokyo to emigrate to the United States after World War II, paused on a corner not far from where Lauren Bacall had once held court, and marveled at the sheer opulence of the cityscape. "We never dreamed," she said, recalling the early 1950s, "it would ever be like this!"

Today, arguably less imagination is needed to envision Japanese cities of the future. Their skylines will inevitably edge higher, gingerly covering those frighteningly unstable tectonic plates with thickets of towers perhaps neither exciting nor beautiful but technically accomplished, gently swaying on their quake-absorbing foundations like windswept groves of steel-and-concrete bamboo.

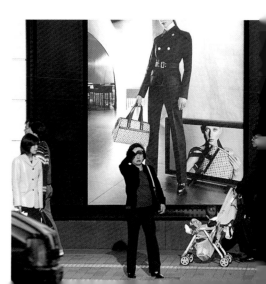

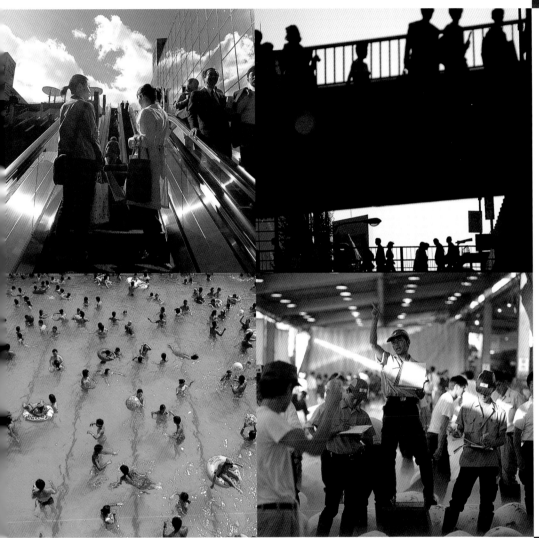

Urban interludes. OPPOSITE, UPPER IMAGES: Wall crawler at Toyo Park in Tokyo's Toyocho district, and woman equipped with the de rigueur accessories of the twenty-and-under crowd: a cell phone and platform heels. A generation ago, Japanese women were self-conscious about their *daikon ashi,* gams that were as crooked, pasty, and zoftig as the root vegetable. But with modern eating and exercise habits, Japanese youth now weigh as much as adults did right after World War II, sleek and strong enough to take medals at international sports events and help dissolve, at last, a centuries-old national inferiority complex. OPPOSITE, LOWER IMAGES: Pedestrians on Sannomiya Street in Kobe; and taxicab fleet at morning rush hour in Shibuya, Tokyo. ABOVE: Saxophonist at a Shinjuku club. LEFT, CLOCKWISE FROM TOP LEFT: Escalator to the heavens at Kyoto Station, and pedestrians in profile on overhead walkways of Shibuya entertainment district. Dawn breaks at Tsukiji fish market in central Tokyo, where tons of seafood from around the world is efficiently auctioned off every morning before most people have had their first coffee, and where bleary but fascinated tourists slosh around in the muck, taking in the spectacle of frozen bluefin tuna carcasses; the clanging of bells announcing the next *seri,* or auction; and the somewhat bewildering anarchy of fish sellers, buyers, and hell-bent deliverymen. Last, rush hour at Toshimaen Amusement Park, Tokyo. During the 1980s bubble period, Japanese developers went quite insane over theme parks, erecting them all over the country despite dubious feasibility. Many of these white elephants proceeded to go belly-up, while those global juggernauts, Disney and Universal Studios, became even more firmly entrenched. By today's standards for global theme parks Toshimaen, built way back in 1926, is strictly minor league. But it does have something Disney and Universal don't have—seven swimming pools. Under Tokyo's torrid temperatures, however, there's never enough blue water to go around. BELOW: Robert Indiana's piece of sixties' nostalgia, *LOVE.*

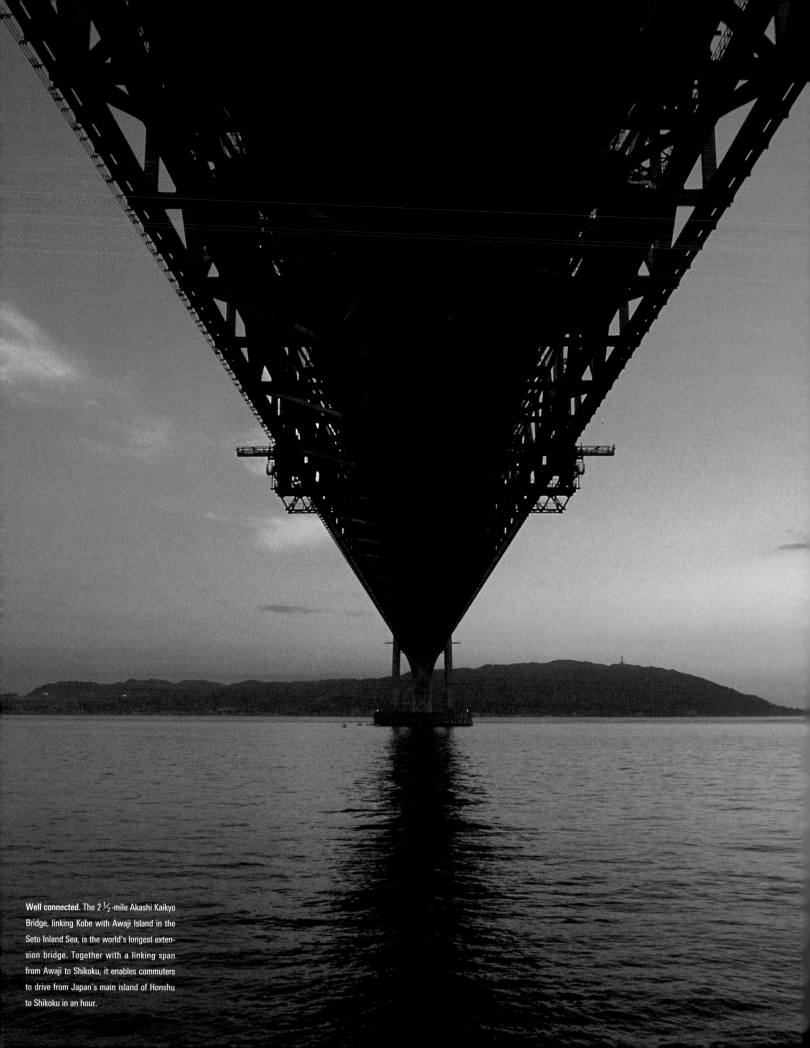

Well connected. The 2 $\frac{1}{2}$-mile Akashi Kaikyo Bridge, linking Kobe with Awaji Island in the Seto Inland Sea, is the world's longest extension bridge. Together with a linking span from Awaji to Shikoku, it enables commuters to drive from Japan's main island of Honshu to Shikoku in an hour.

COUNTRY
JOHNNY HYMAS

A field of lavender along a summer country lane.
The Furano area of Hokkaido is famous throughout
the land for lavender. Kami Furano, Hokkaido.

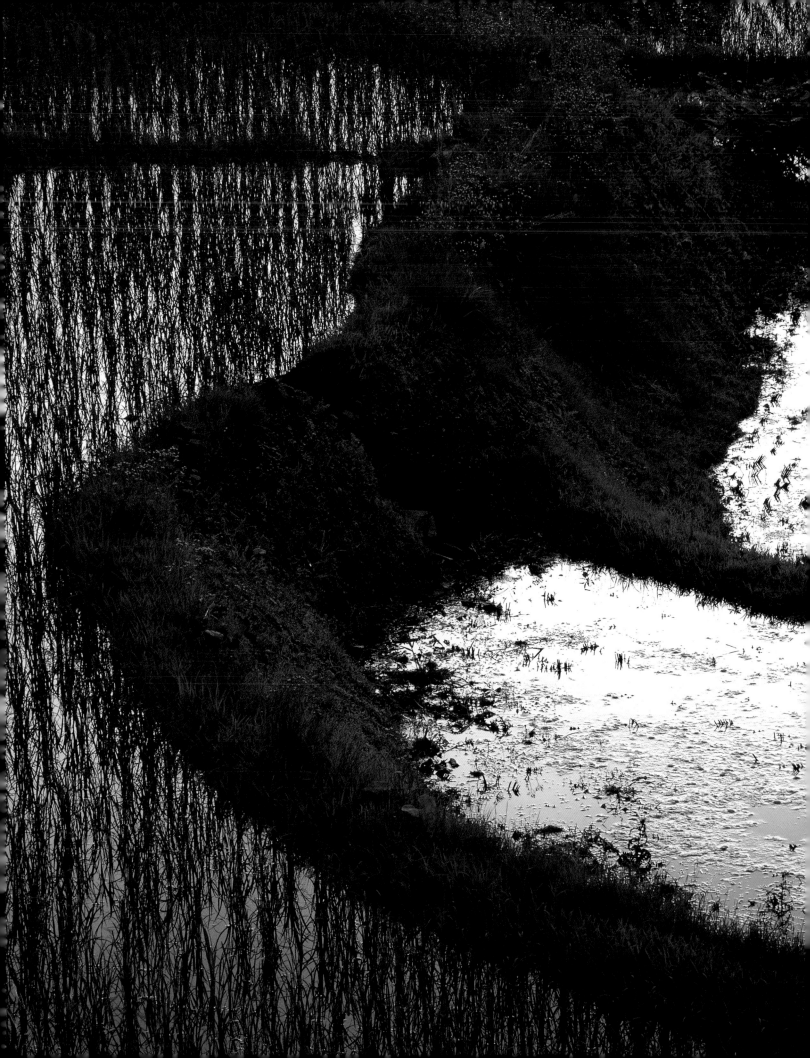

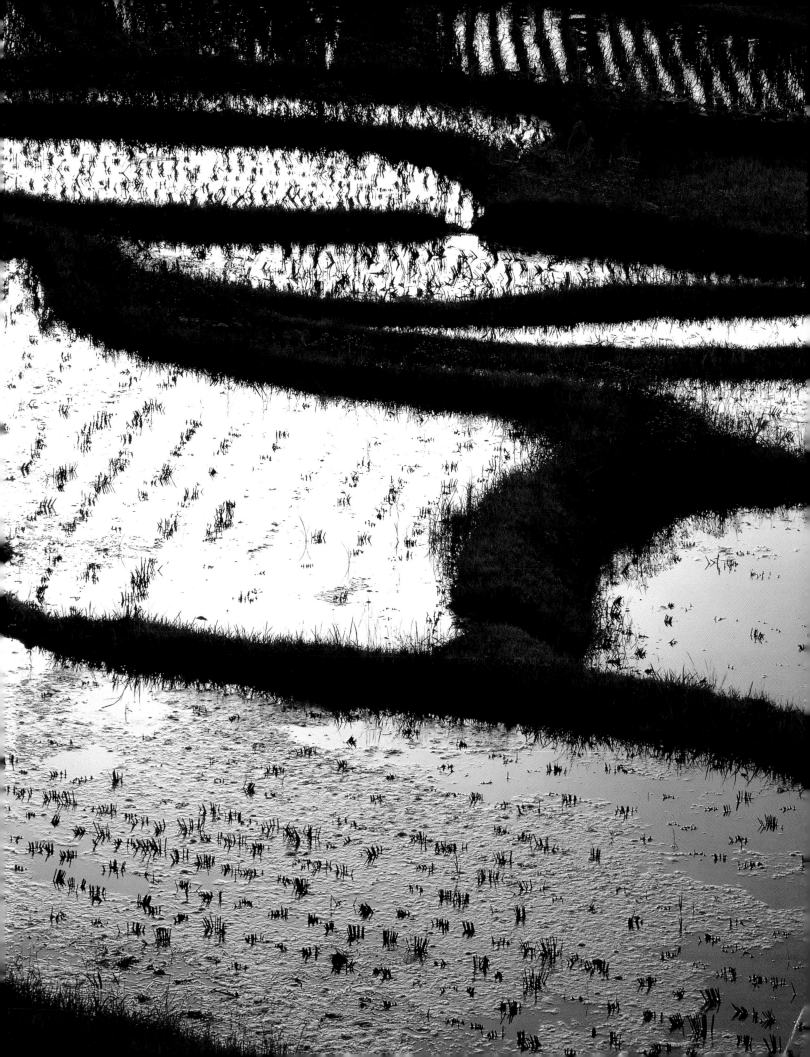

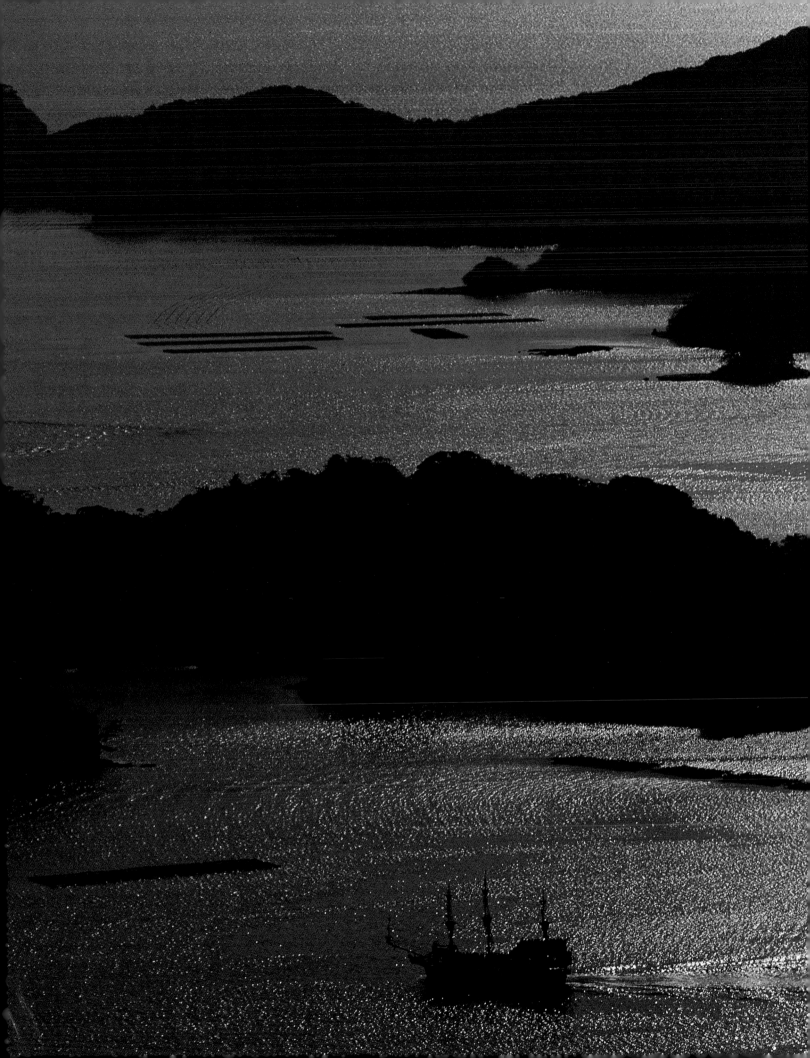

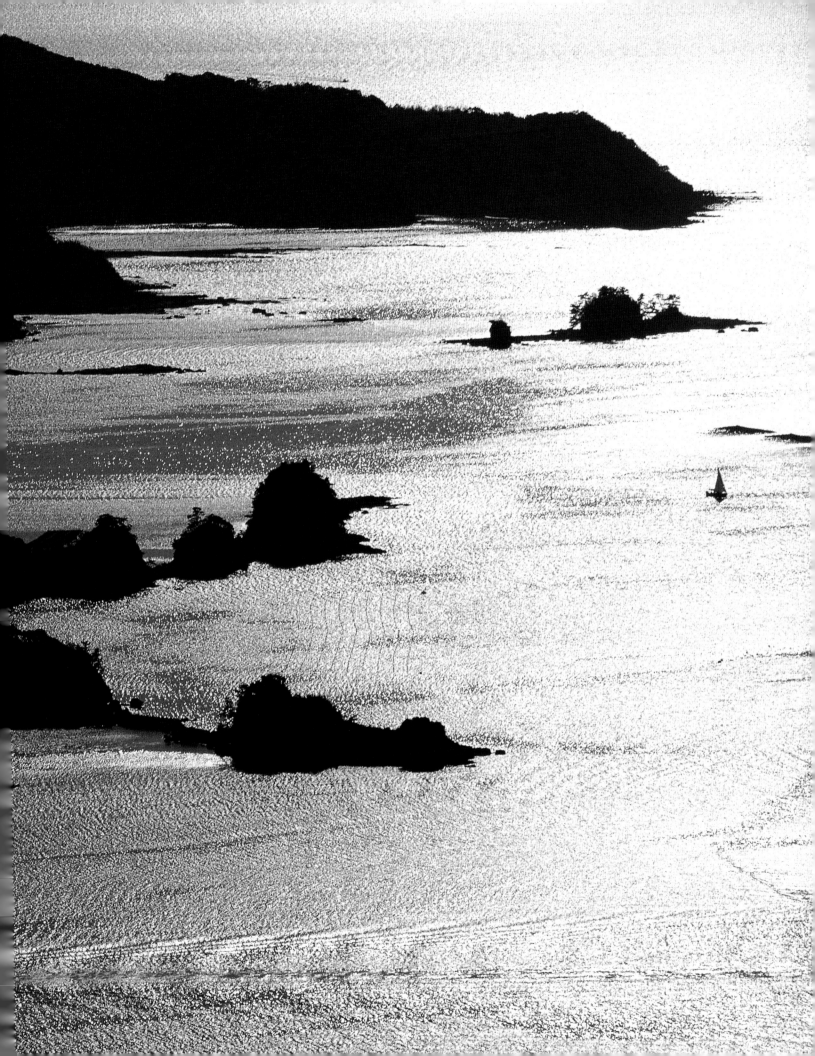

WHEN I FIRST VISITED JAPAN MORE THAN

THIRTY YEARS AGO, IT WAS THE HEIGHT

OF THE CHERRY

Stone Buddhist statues stand guard over rice paddies. Statues like this are always a great delight for countryside walkers. Nakasato Village, Niigata Prefecture.

BLOSSOM SEASON.

EVERYWHERE

I TURNED THERE WERE CHERRY TREES IN

FULL BLOOM AND THE COUNTRYSIDE

SEEMED TO BE CAUGHT UP IN A GRAND

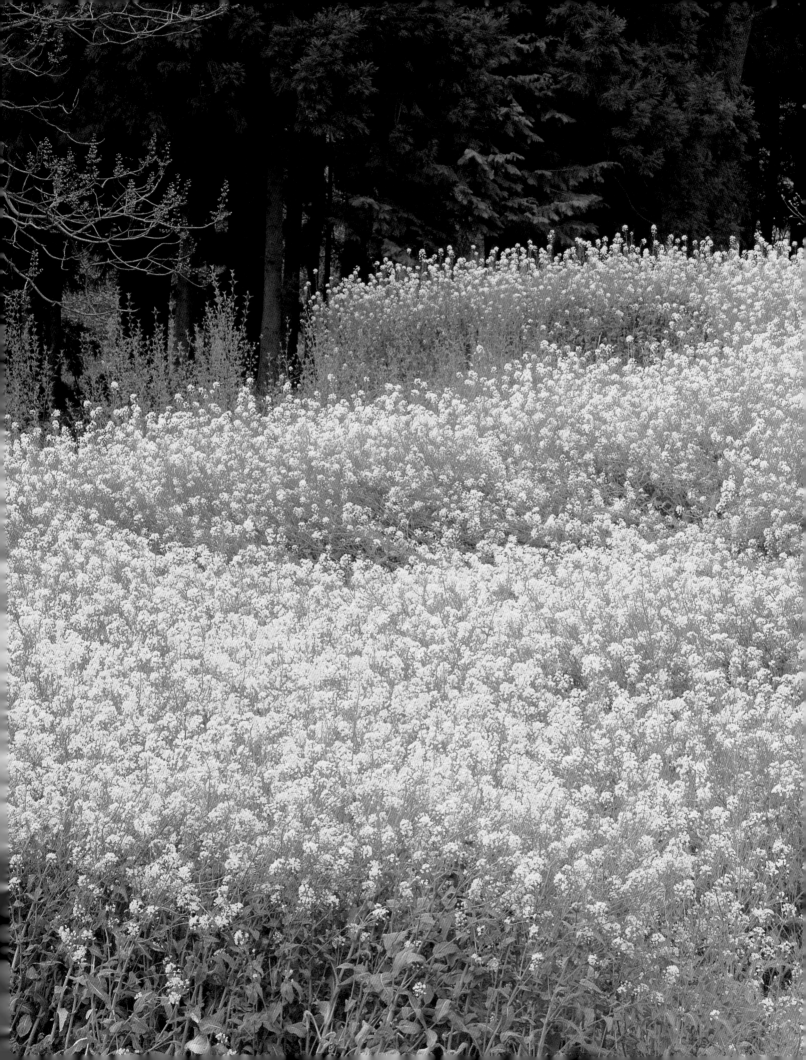

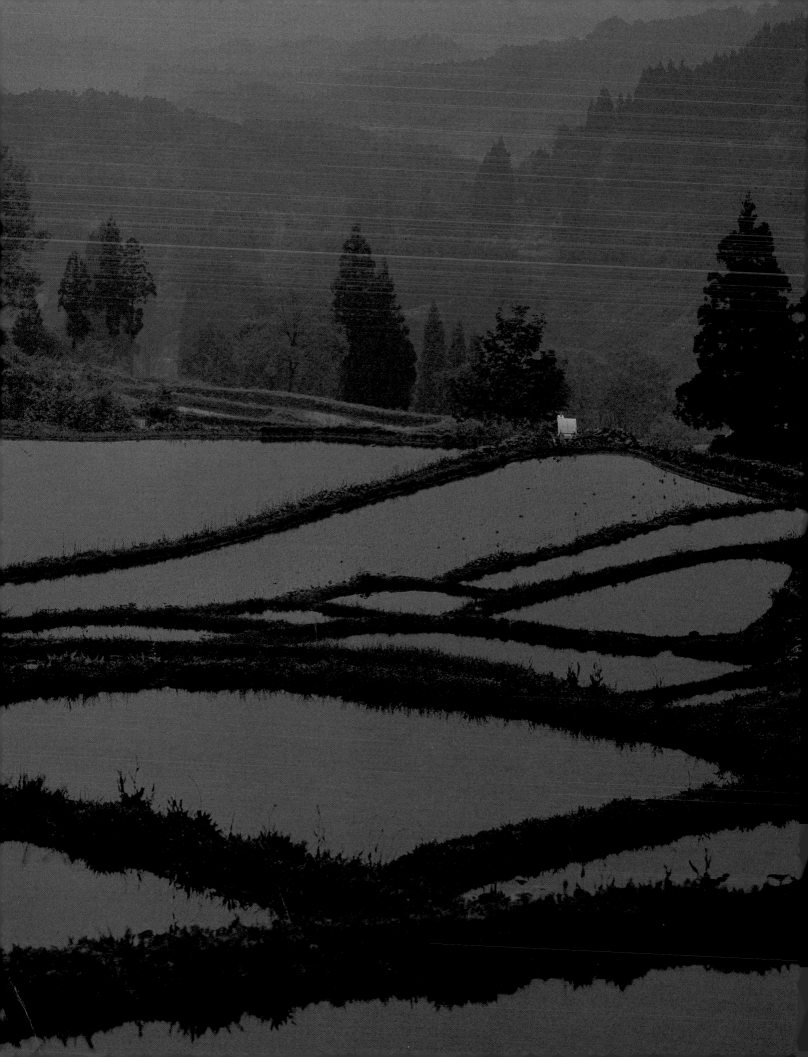

celebration of spring. The landscapes were the most colorful I had ever seen, and the sky exuded a special quality of mutable light that, from dawn to dusk, changed with beguiling uncertainty. Captivated by this kaleidoscope of color and fluctuant light, I thought to myself, "This is a landscape photographer's paradise."

Prior to coming to Japan, I had visited thirty-eight other countries, but nothing had prepared me for the eye-catching, heart-stopping impact of Japan's countryside. The impact of that first experience was so irresistible that I lingered for a year in an attempt to capture the splendor of the landscape on film.

That initial twelve-month journey led me on an adventure of discovery I remember to this day. I was astonished by the infinite variety of natural wonders that constitute the Japanese country landscape, and fell in love with Japan itself, deciding to make it my home. Thirty-three years have elapsed since then, and in that time I have traveled over a million miles throughout the archipelago.

In tramping the length and breadth of this island country, through all seasons and in all kinds of weather, I have grown to love the landscapes and lifestyles even more. Japan has a timeless beauty. There is an intangible atmosphere, an ambiance that captivates the senses—the echo of temple bells, the aroma of incense; the chirping of cicadas, the croaking of frogs in rice fields, and the rustling of bamboo thickets. There are towering mountain peaks, active volcanos, and primeval forests; rivers, waterfalls, alpine marshes, lakes, breathtaking seascapes; and last but not

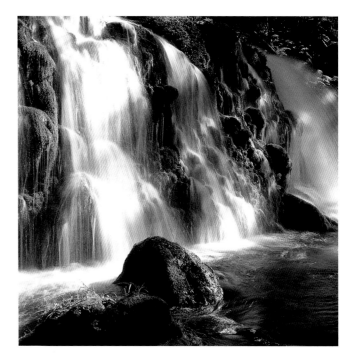

Mototaki Waterfall on steep-sided Chokai Mountain, along the border of Yamagata and Akita prefectures. The rush and fall of fast-moving water form an integral part of the Japanese mountain soundscape.

OVERLEAF: The pendant branches of a *shidare-zakura* weeping cherry are packed with delicate flowers. This rare variety blooms about the same time as its more-famous relative, the *somei-yoshino* cherry. Ouda, Nara Prefecture.

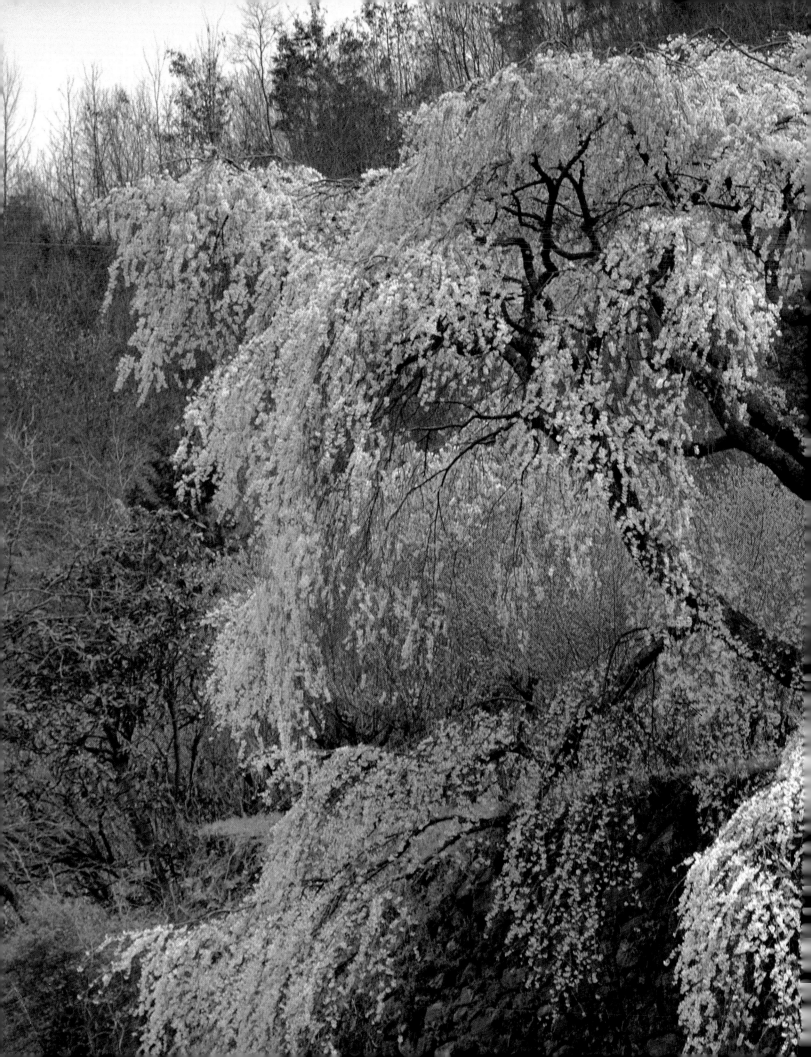

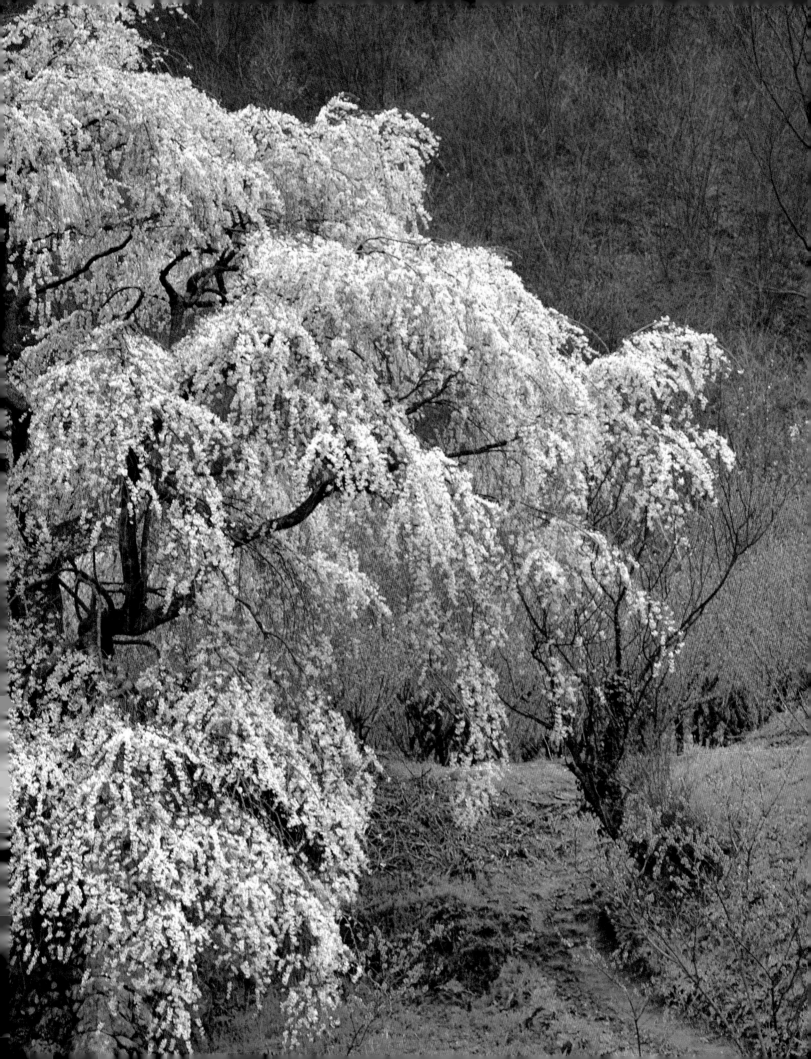

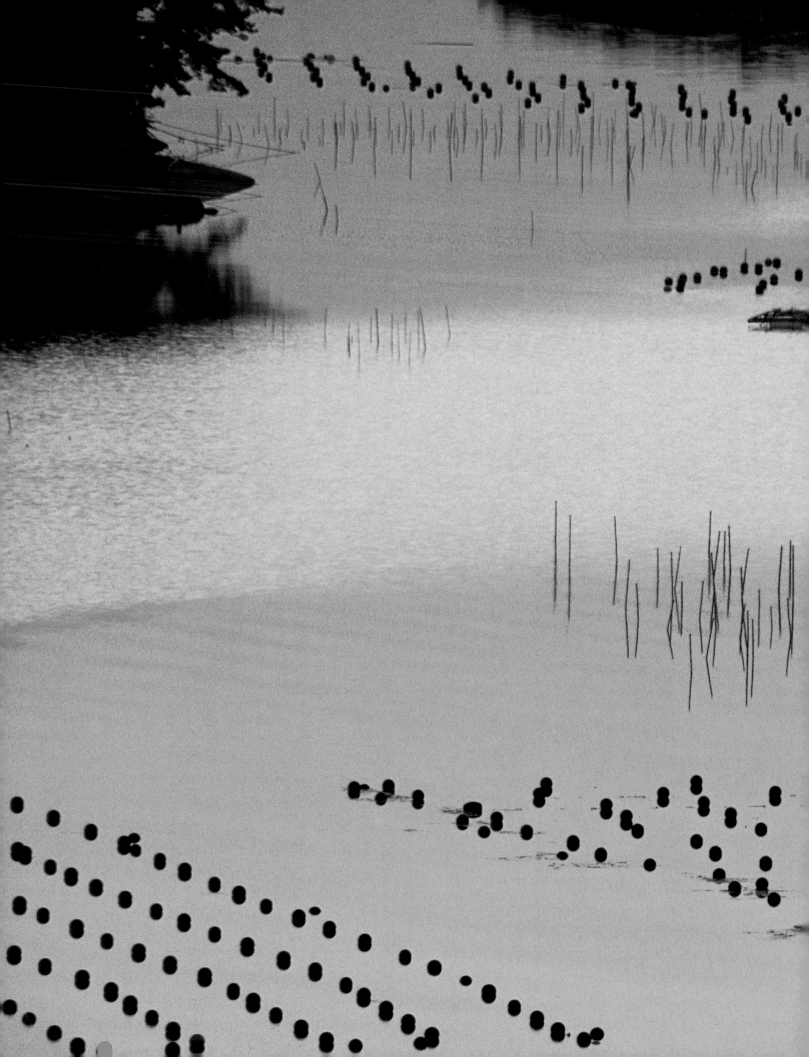

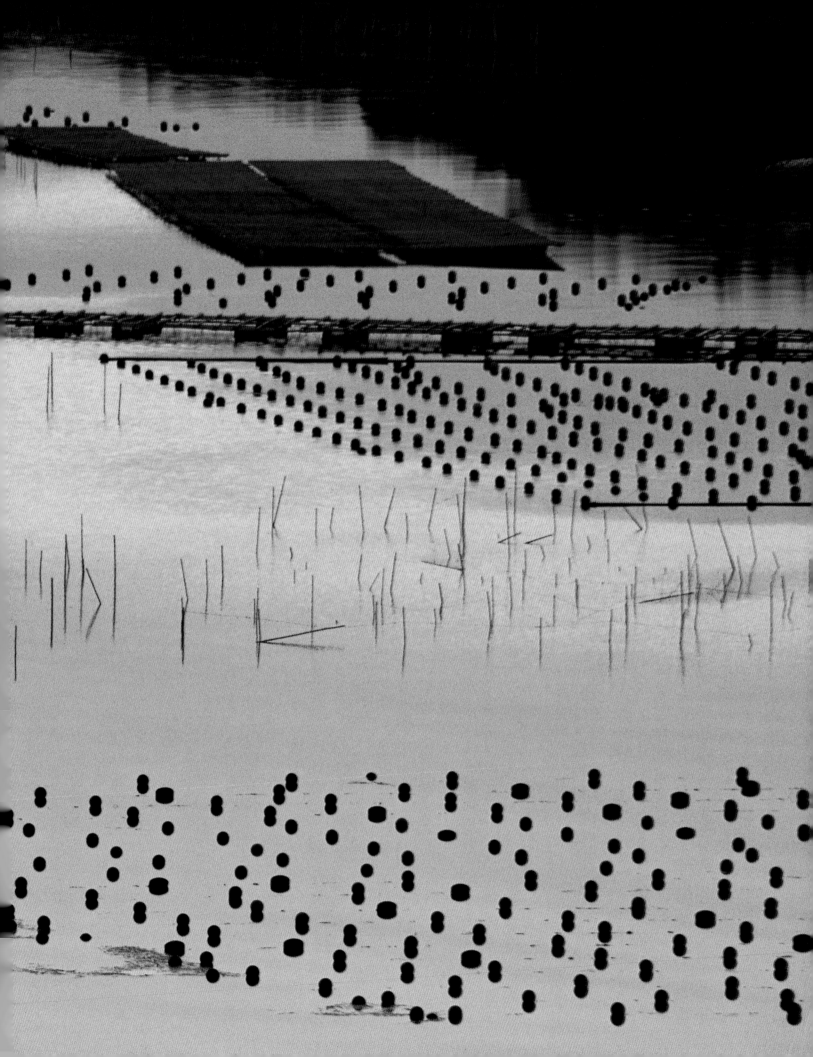

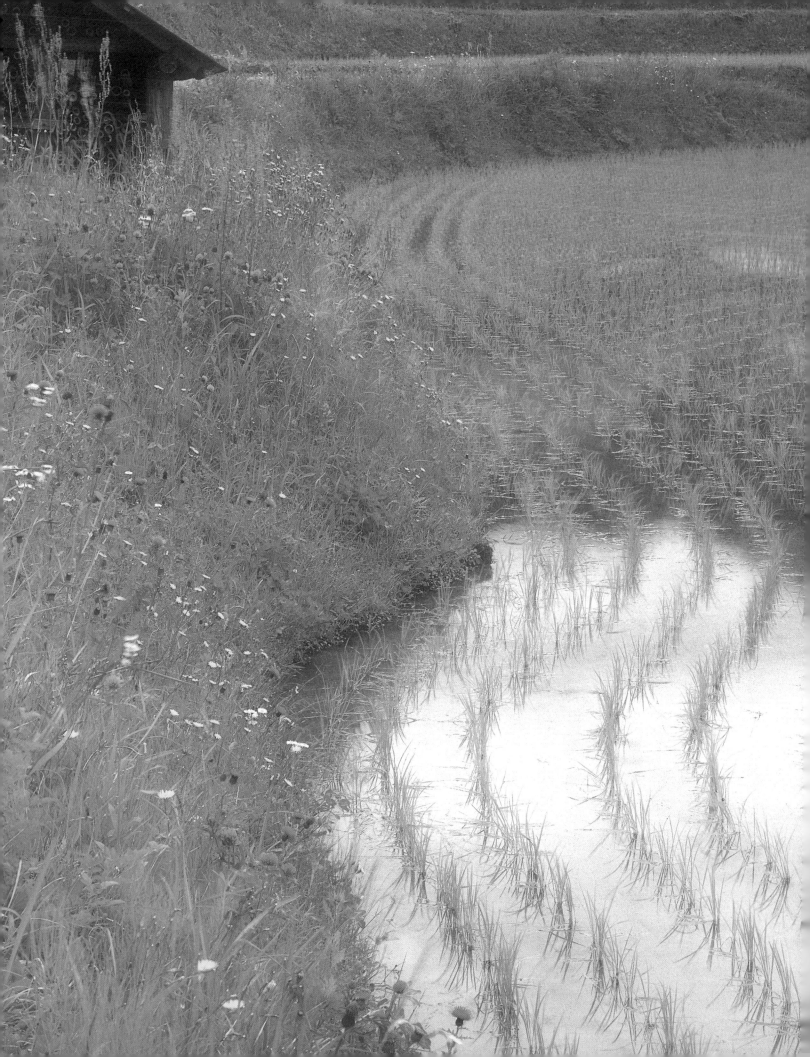

least ancient terraced rice paddies, which in some cases go back more than two thousand years.

A few years ago when I was photographing stepped rice paddies in Nara Prefecture, I came across an old man, all by himself, planting rice. Wondering about the history of the area, I approached him and asked if he knew the age of the paddy he was planting. At first he didn't hear me, so I raised my voice and repeated my question. "Sorry," he replied, "I'm a hundred years old and a bit deaf, could you speak up!" My third attempt, in an even louder voice, drew a wide grin and an amused reply: "The rice paddies, like myself, have been here from the beginning of time."

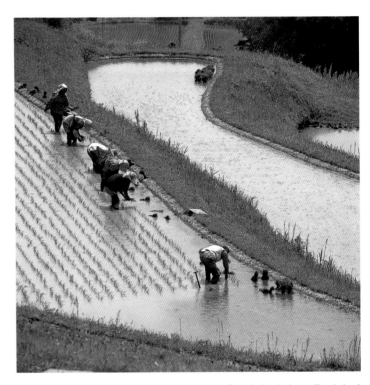

Transplanting the rice seedlings by hand was once a common sight throughout the countryside. The whole community worked together, moving from paddy to paddy until an entire hillside or valley was completed. Kamogawa, Chiba Prefecture.

The Japanese islands cover a latitudinal span of only fifteen degrees, but stretch nearly 2,000 miles from the Yaeyama Islands in the south to Cape Soya at the northern tip of Hokkaido. Natural habitats range from peat marshes and sub-arctic boreal forests in the north, to sub-tropical broad-leaved evergreen forests in the south. In addition, seventy-five percent of the land mass consists of steep, mountainous terrain, with peaks reaching to heights of 6,000 and 10,000 feet. As hikers climb skyward they pass through dense deciduous forests of beech and oak, sub-alpine groves of birch and dwarf pine, then finally to the treeless stretches of the high alpine zone.

LEFT: Rows of newly transplanted rice seedlings follow the sinuous curves of a late-spring paddy, while thistles, fleabanes, and other wildflowers bloom in profusion along the dikes. Kamogawa, Chiba Prefecture.

69

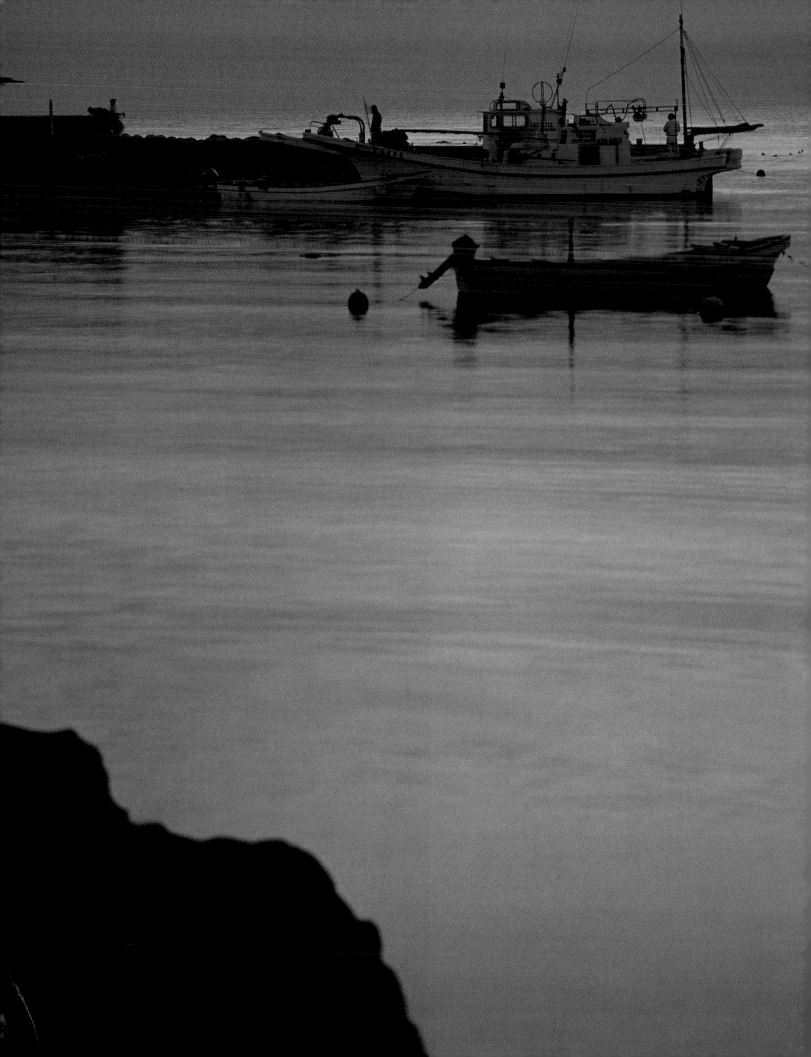

Outboard skiffs and inshore hand-lining vessels moored at Arasaki Fishing Port. Tiny fishing villages, where the boats go out daily to work inshore waters, are found all along the Japanese coast. Miura Peninsula, Kanagawa Prefecture.

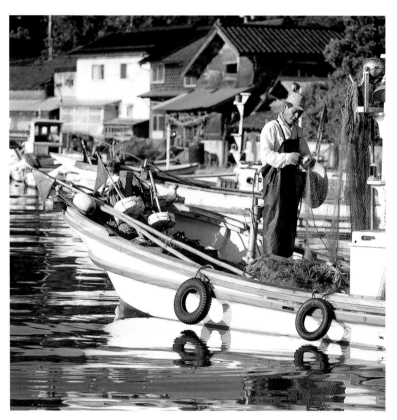

A fisherman repairs his gill nets. Almost all coastal fishing is accomplished as a small family business. Noto Peninsula, Ishikawa Prefecture.

Japan is home to a truly amazing diversity of plants. The main island of Honshu alone has over 1,100 species of woody plants. Sixty-seven percent of the land is forested, and the country is home to 350 varieties of cherry trees and 26 species of maple.

All these mountains mean that Japan is poor in terms of arable land. Still, Japanese agriculture has for over two thousand years supported a large population and vibrant civilization. The secret of this success lies in intensive but ecologically sensitive and sustainable use of the land. The same sustainable lifestyles that have allowed for steady production have also created the beautiful countryside landscapes that have so thoroughly captured my eye and heart.

Intensive but sustainable utilization of local resources can also be seen along Japan's coasts. The shores are washed by the warm Kuroshio Current flowing from the south, and by the cold Oyashio Current from the north. Coastal habitats include ice-choked seas, long, sandy beaches, sheltered inlets filled with tidal wetlands, rugged rocky coasts where the mountains drop precipitously down to the water, and even beautiful coral reefs and sparkling-white coral beaches. This diversity of habitats supports a rich resource base, and almost the entire coast is lined with tiny fishing villages where the men venture out in small open boats. Like the agricultural countryside, the lifestyles of the fisherfolk often complement rather than disrupt the natural landscape.

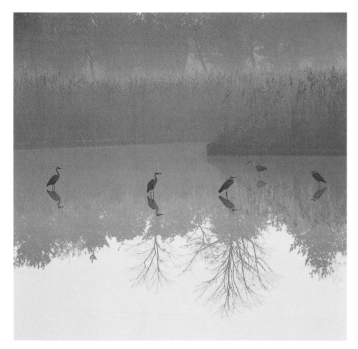

Gray herons fishing the shallows at daybreak. Japan's coastal and waterside habitats are perfect for long-legged, long-necked wading birds like herons and egrets. Nagoya Harbor, Aichi Prefecture.

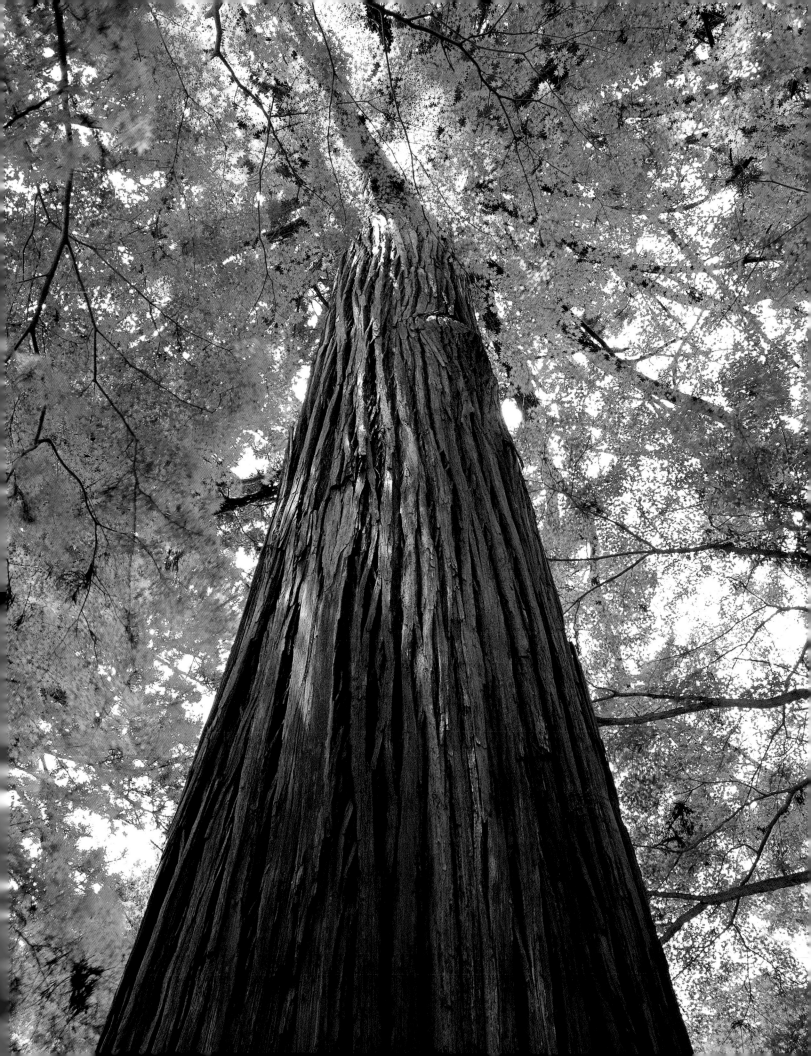

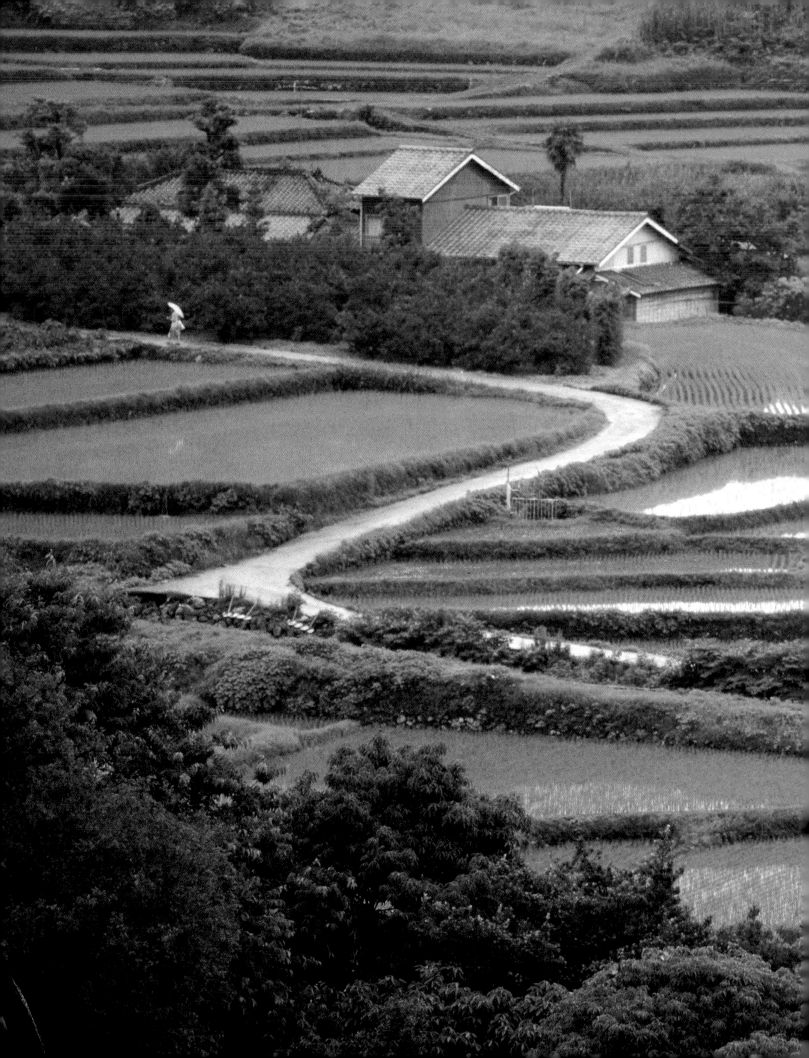

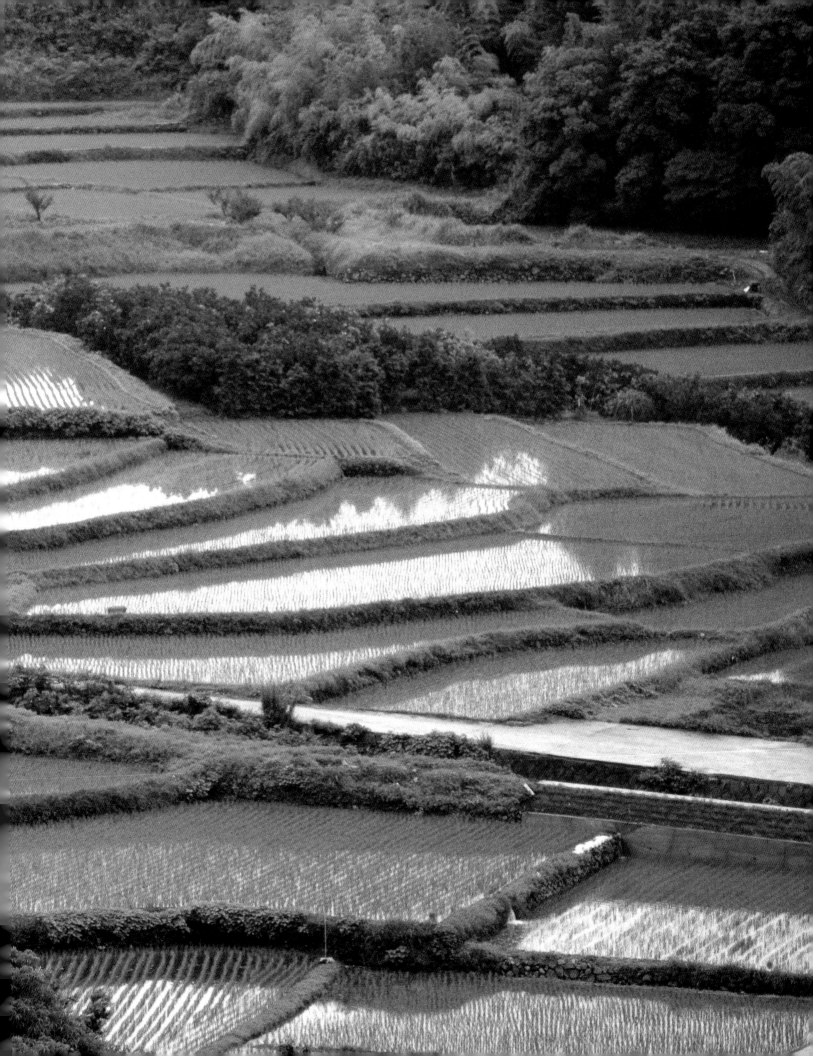

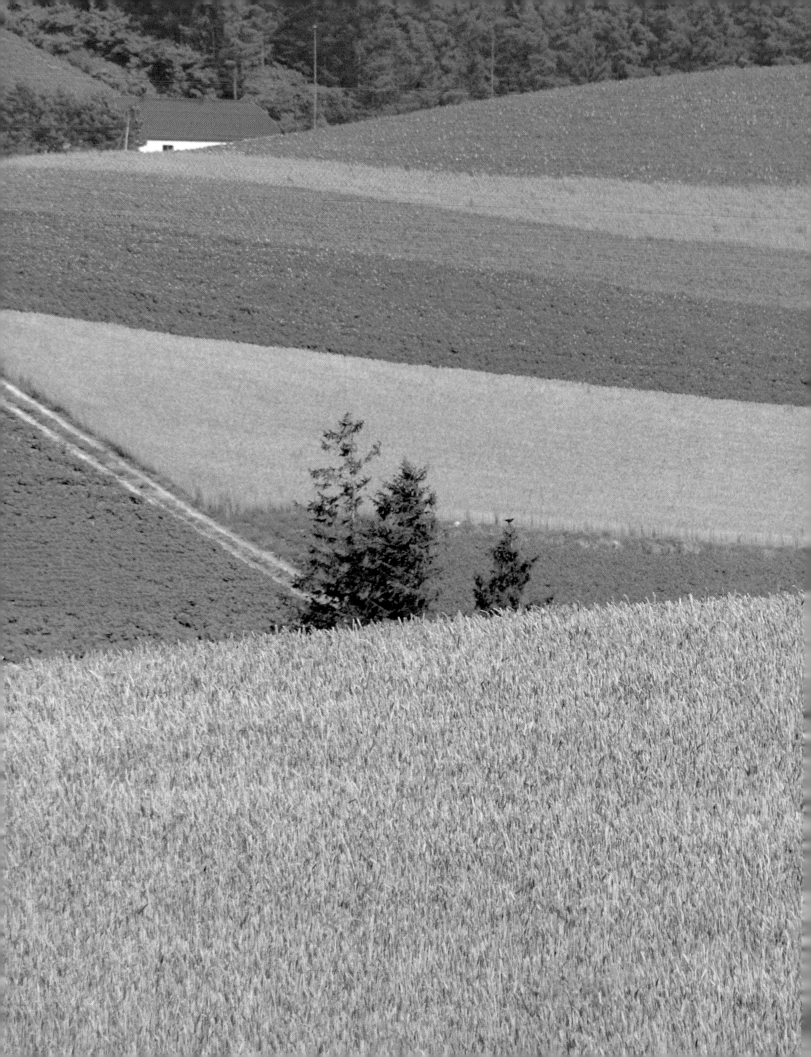

Wheat and barley planted along the drier upland slopes. Traditional countryside land usage places irrigated rice paddies in the valleys and plains, and nonirrigated fields of vegetables and other grains on the well-drained uplands. Biei, Hokkaido.

Poppies, lavender, and other ornamental flowers. Kami Furano, Hokkaido.

OVERLEAF: Great peaks appear as islands in an *unkai*, or "sea of clouds," a poetic alpine landscape greatly appreciated by hikers. Northern Japan Alps.

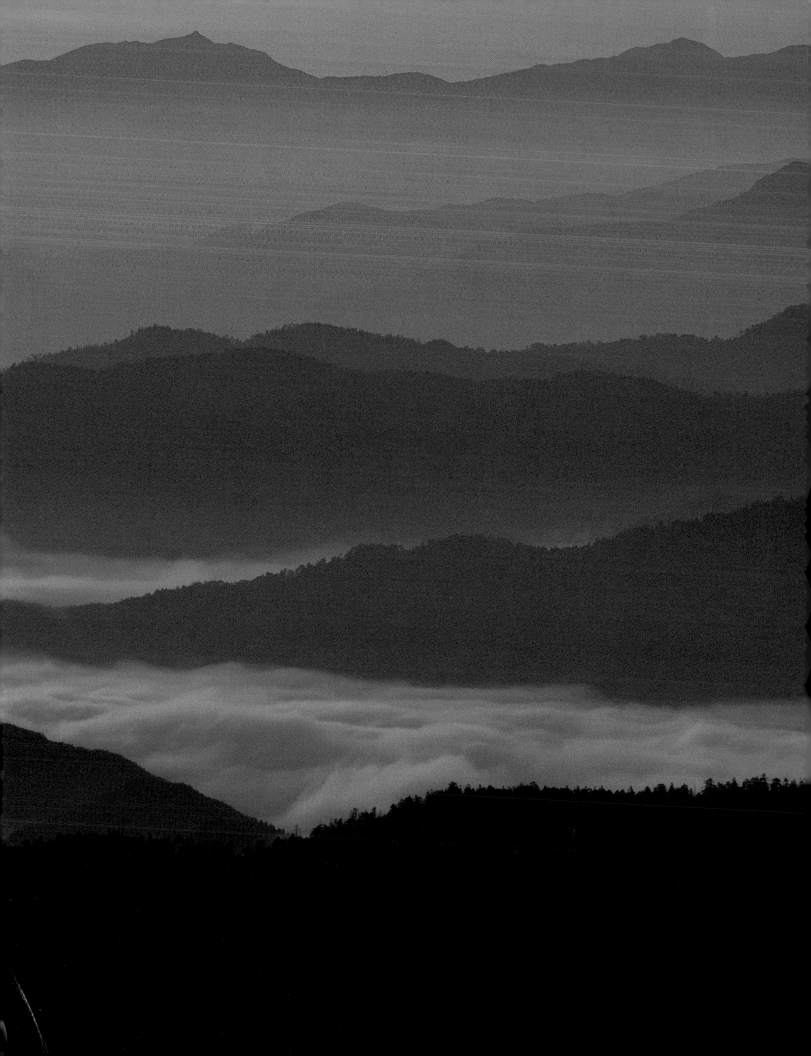

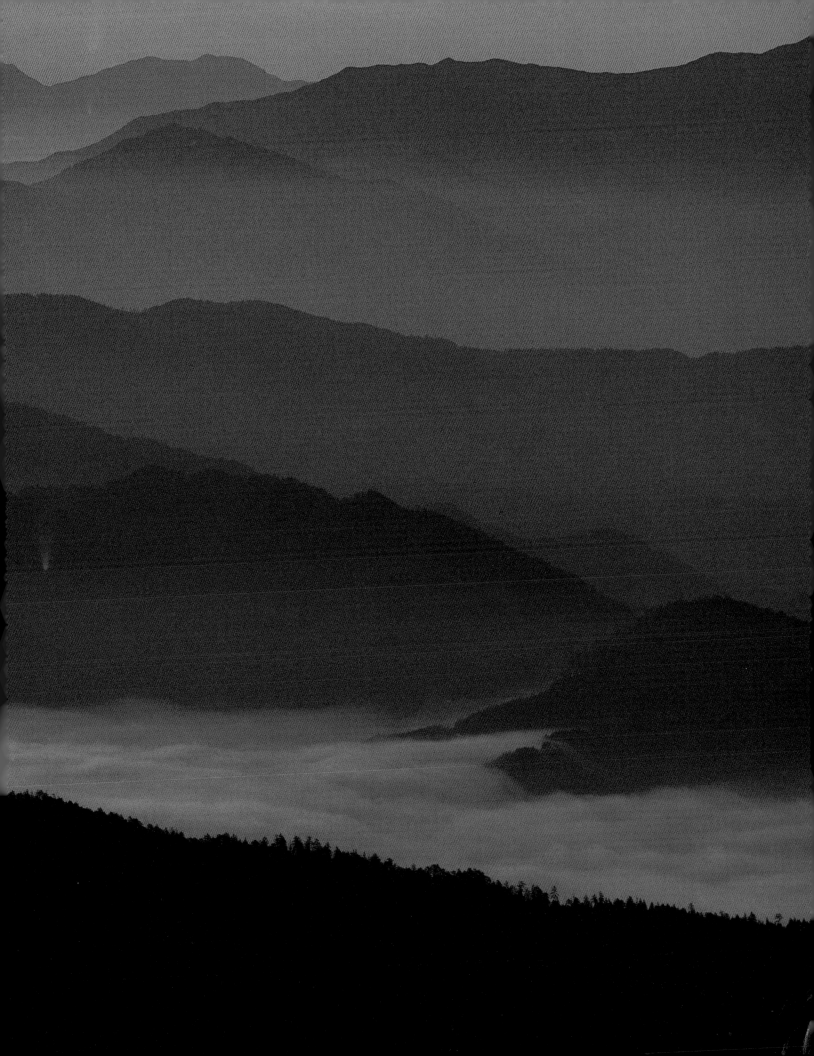

Rice plants heavy with grain await harvest, while clusters of bright-red spider lilies decorate the dikes. These spider-lilies are called *higan-bana* in Japanese, which translates literally as "autumn-equinox flowers." Tosa Village, Shikoku.

Despite the dense population and intense utilization of land and resources, there are still places in Japan where wilderness reigns supreme. I did not discover these wild, inhospitable regions of the archipelago until I moved to Japan and began to explore the deep mountains more thoroughly. Once, when hiking through a mountain forest, I decided to get off the beaten track and take a short cut. I carried a map and compass with me, but they proved to be of little use and I became hopelessly lost. It took two days to find my way back, but luckily I had an emergency supply of nuts and raisins, which helped to sustain me.

Farm women set down their large *shoikago* backpack baskets to take a rest. Country women on the farm work as hard as their husbands, collecting wild greens and taking the vegetables to market. Daigo, Ibaraki Prefecture.

As an artist, I have always loved Japan's rich change of seasons. Although I may visit a favorite spot over and over, each time it shows me a landscape painted with a different palette. In the warmer southern regions, the seasonal changes are quiet and tranquil. Spring and autumn especially,

PAGE 82: A fisherman and boat at sunset. Many coastal fishermen still work their lines and nets in small, open boats like this. Noto Peninsula, Ishikawa Prefecture.

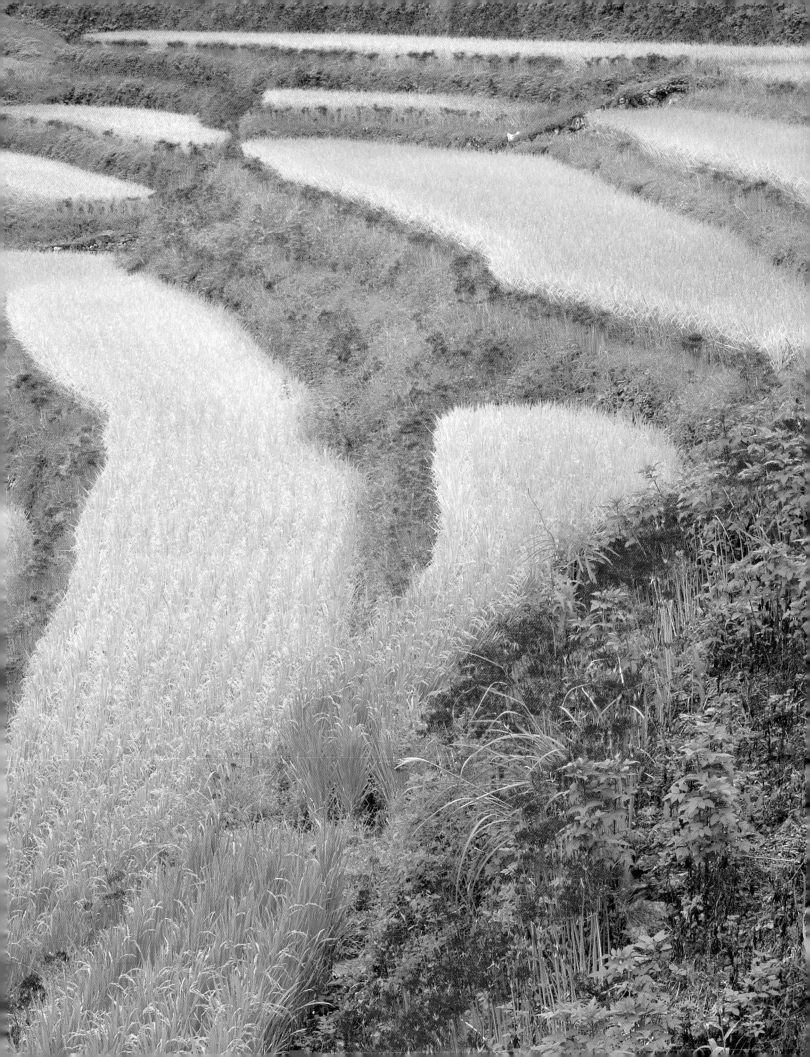

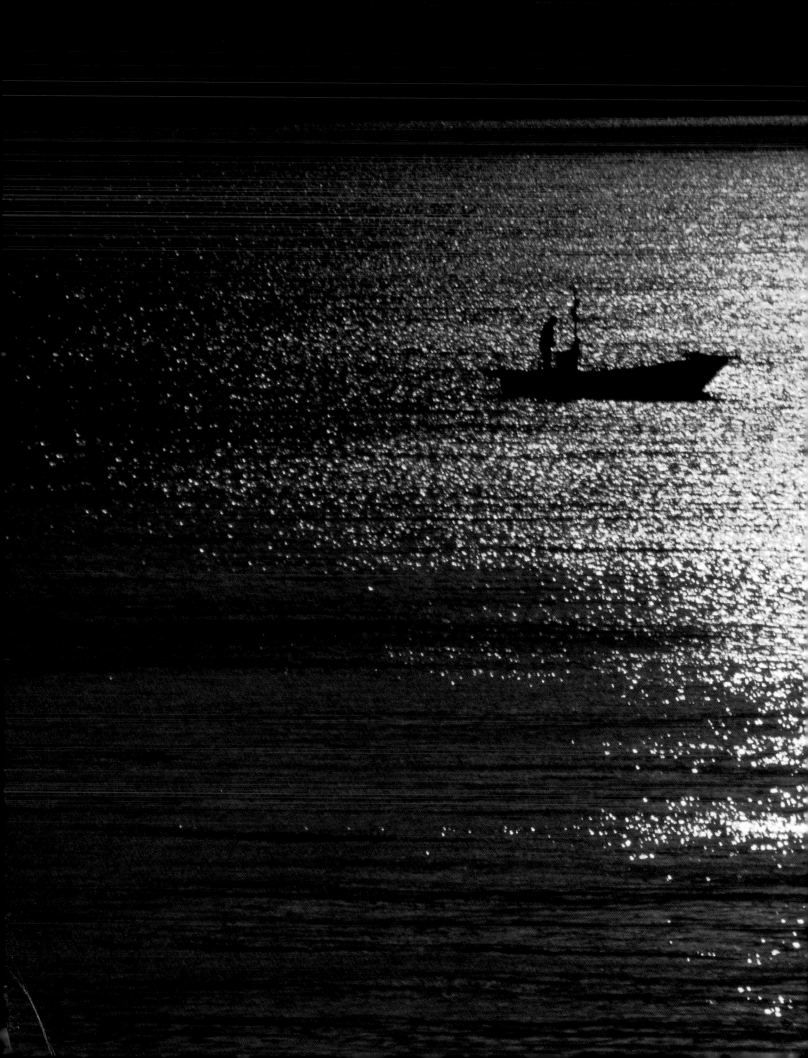

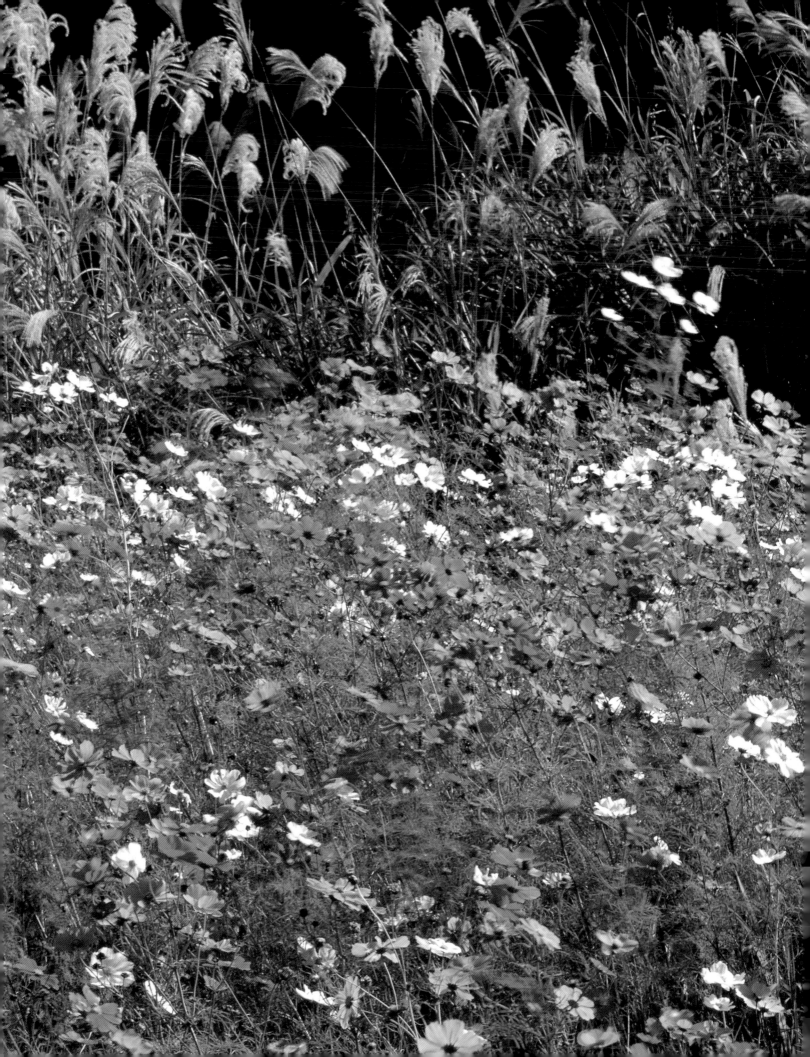

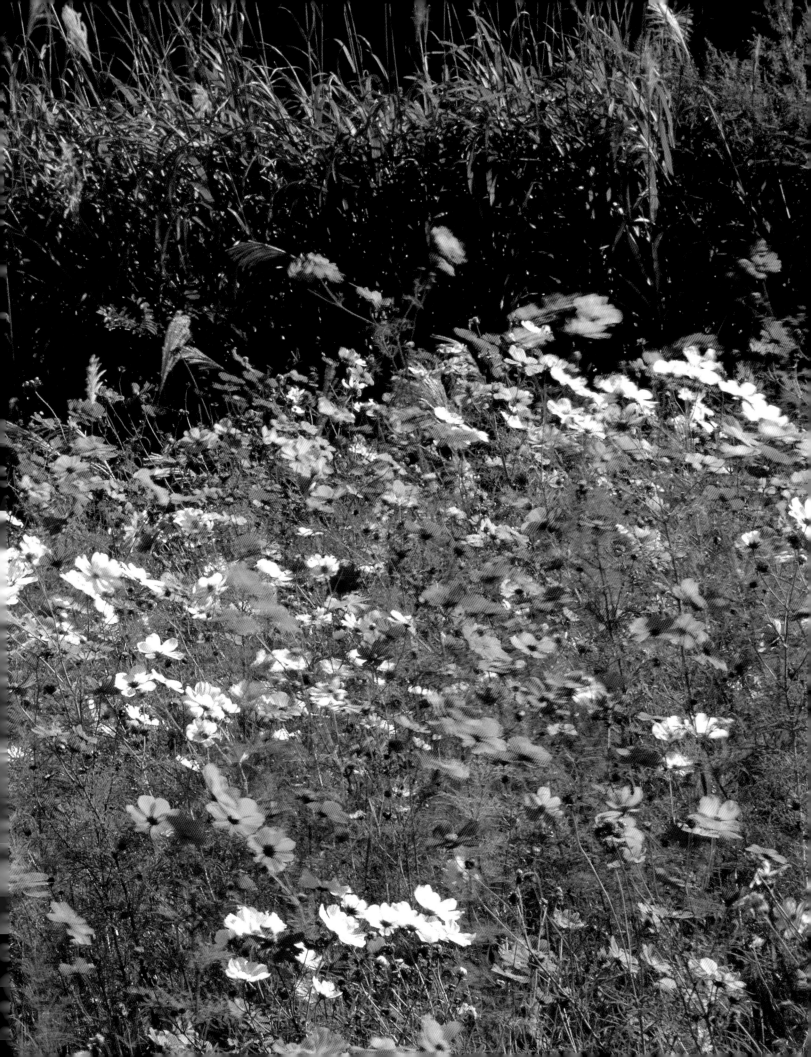

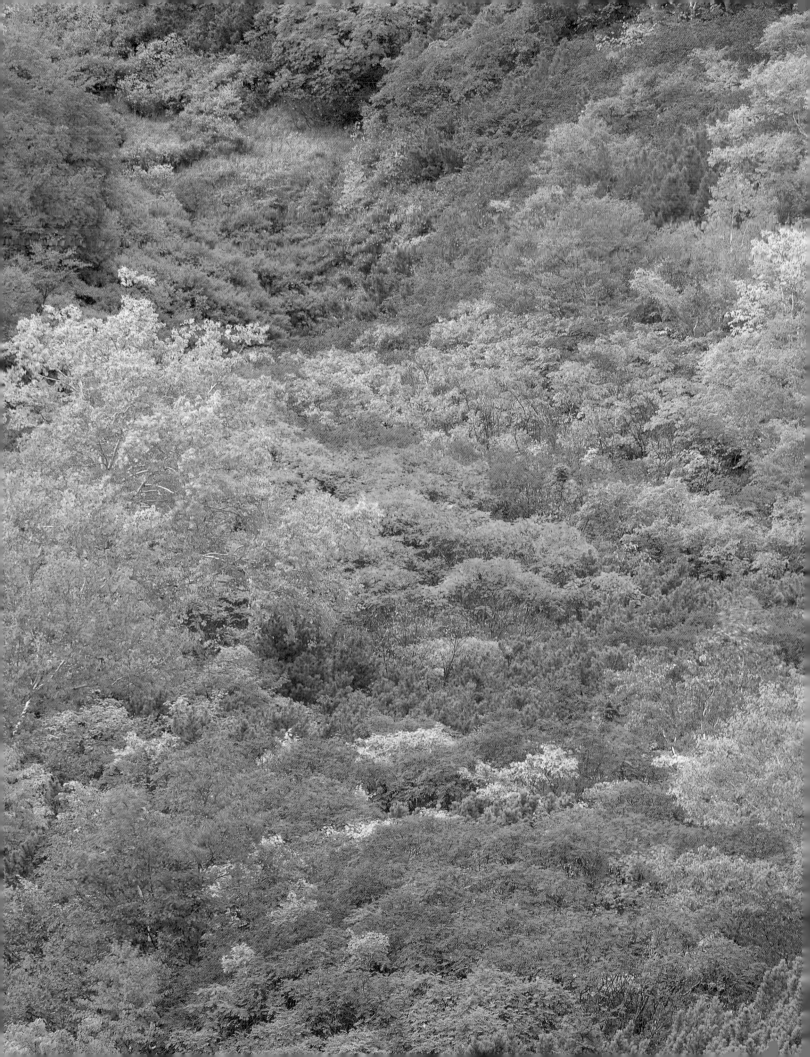

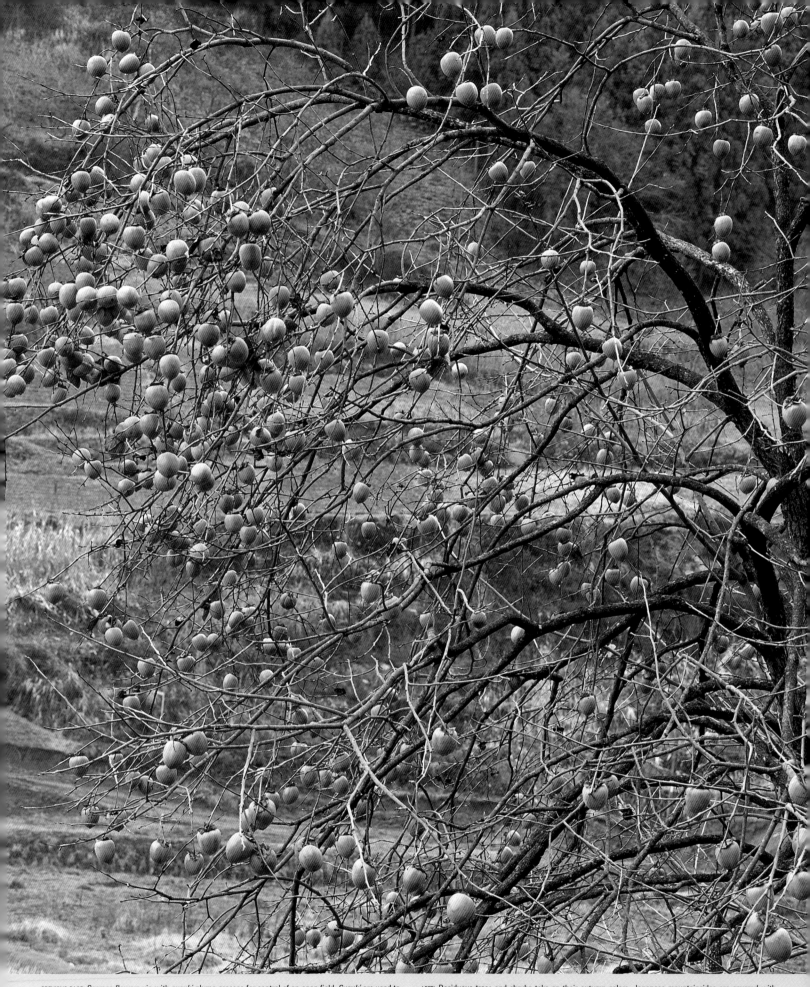

PREVIOUS PAGE: Cosmos flowers vie with *susuki* plume grasses for control of an open field. *Susuki* are used to decorate the small altars set up for the traditional harvest moon-viewing parties. Yusa, Yamagata Prefecture.

LEFT: Deciduous trees and shrubs take on their autumn colors. Japanese mountainsides are covered with groves of beech, oak, and maple that put on a magnificent show in autumn. Daisetsu Mountain, Hokkaido.

ABOVE: Ripe persimmons overhang rice fields in Togakushi, Nagano Prefecture.

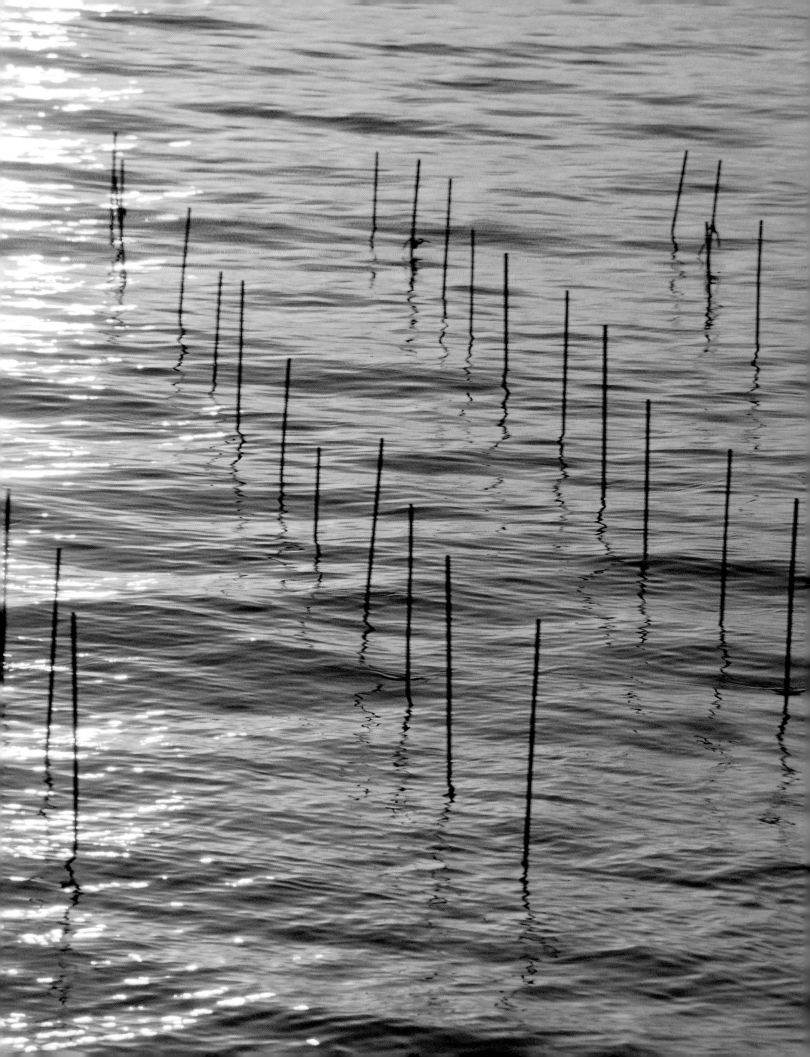

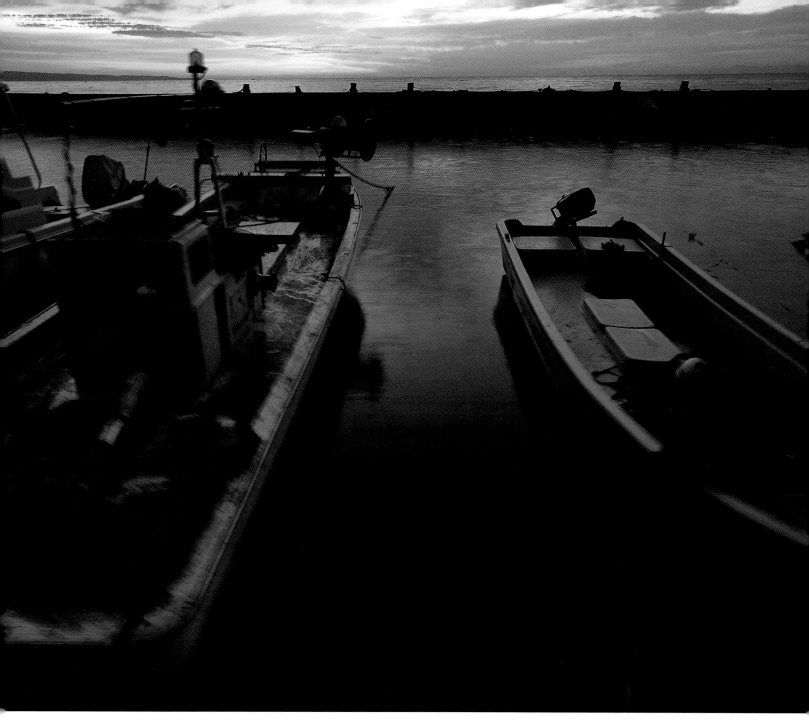

ABOVE: Outboard skiffs and gill-netters at rest. Japan's coasts are washed by both warm and cold currents, producing an incredibly rich marine environment that supports the coastal fishing industry. Benten Island, Noto Peninsula, Ishikawa Prefecture. RIGHT: Working a gill net. Meeting and talking with fishermen and their wives is one of the great pleasures of walking the Japanese coast. Noto Peninsula, Ishikawa Prefecture.

LEFT: Poles for *nori* sea laver culture stand at attention in the shallow shoals at sunset. *Nori* grows best in shallow areas where fresh and sea water mix. Kamakura, Kanagawa Prefecture

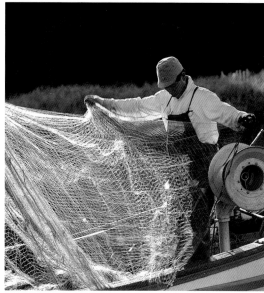

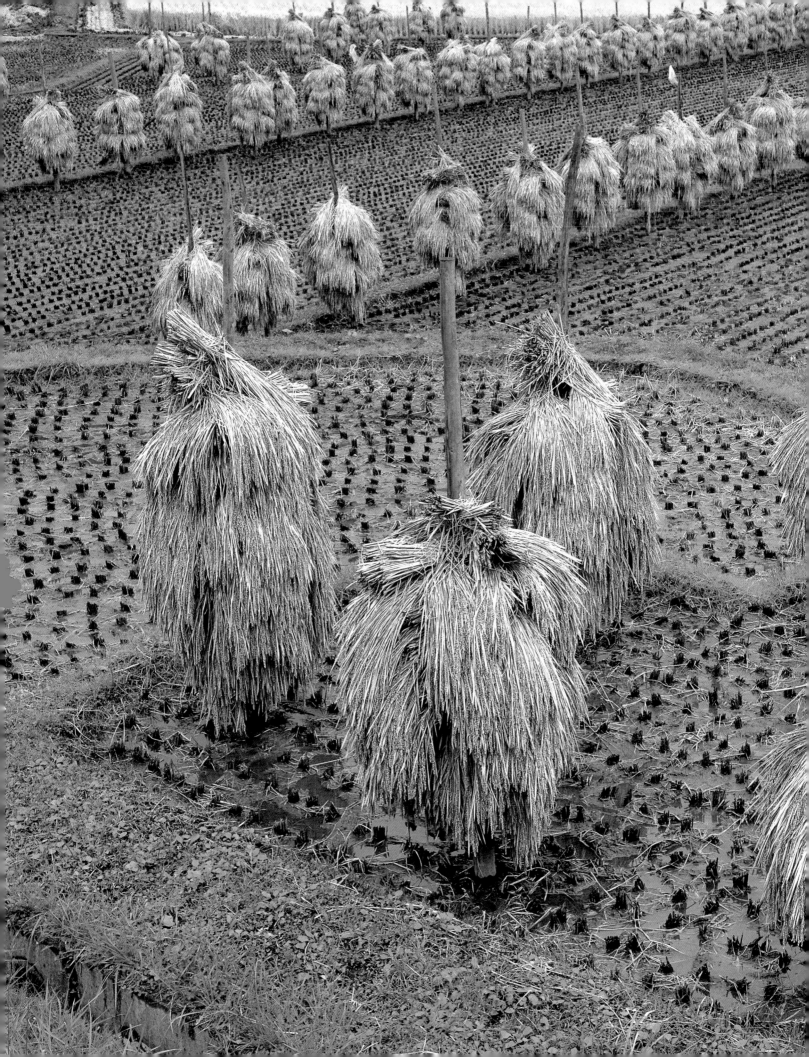

Bundles of newly harvested rice tied to poles, ready to dry naturally in the sun. The customs for binding and drying the rice crop varies from region to region, producing a great diversity of landscapes. Ajigasawa, Aomori Prefecture.

stretch out over a season of several months each, with subtle changes occurring on an almost daily basis. In the colder northern regions, however, the changes are far more dramatic, with the transitions often coming on at breakneck speed. Here the winters are long and severe, and spring and autumn emerge in short bursts of brilliant colors.

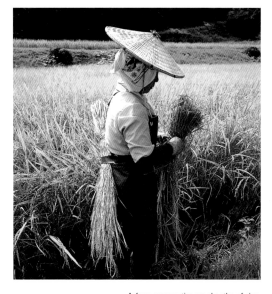

Perhaps nowhere else on earth is there a nation so small as Japan in area, yet so rich in natural and cultural diversity. Even after more than thirty years of tramping all over the land, I feel like I have just barely begun to scratch the surface. Every time I step out, be it for a short drive through the countryside or along the coast, or an arduous trek through the high mountains, the landscape always manages to thrill me with something new.

A farm woman ties up sheaths of rice to be set out on drying poles. She works with a long-practiced rhythm and grace that borders on ceremonial dance. Matsunoyama, Niigata Prefecture.

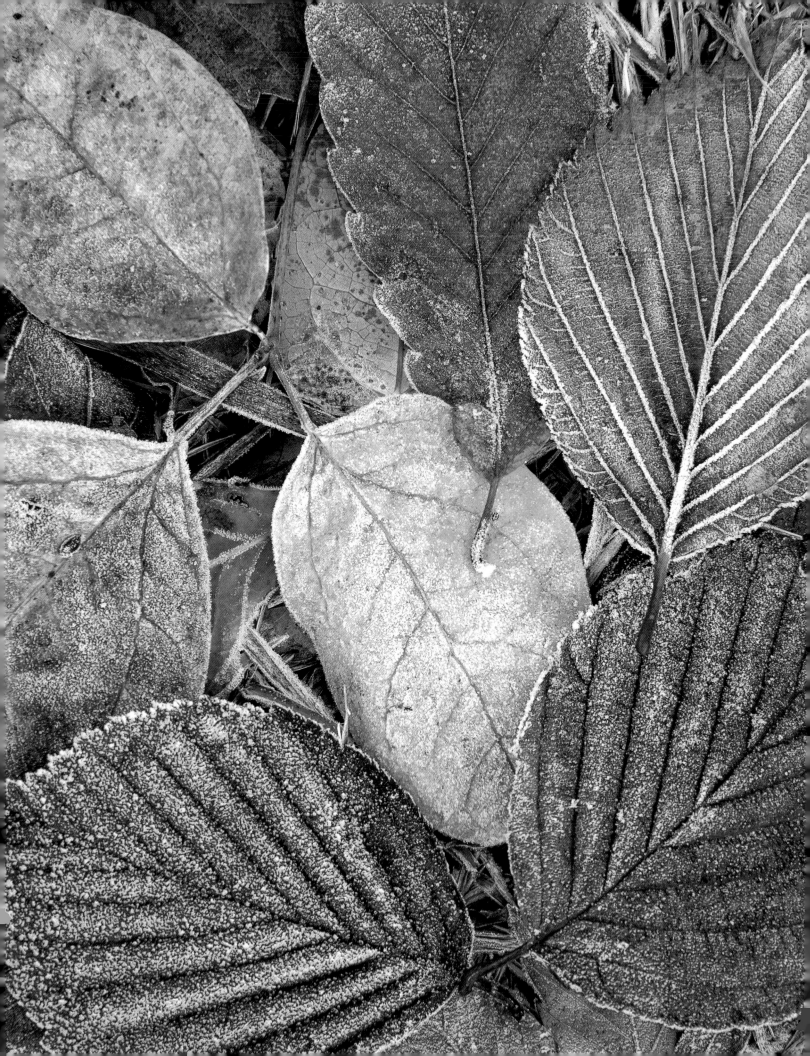

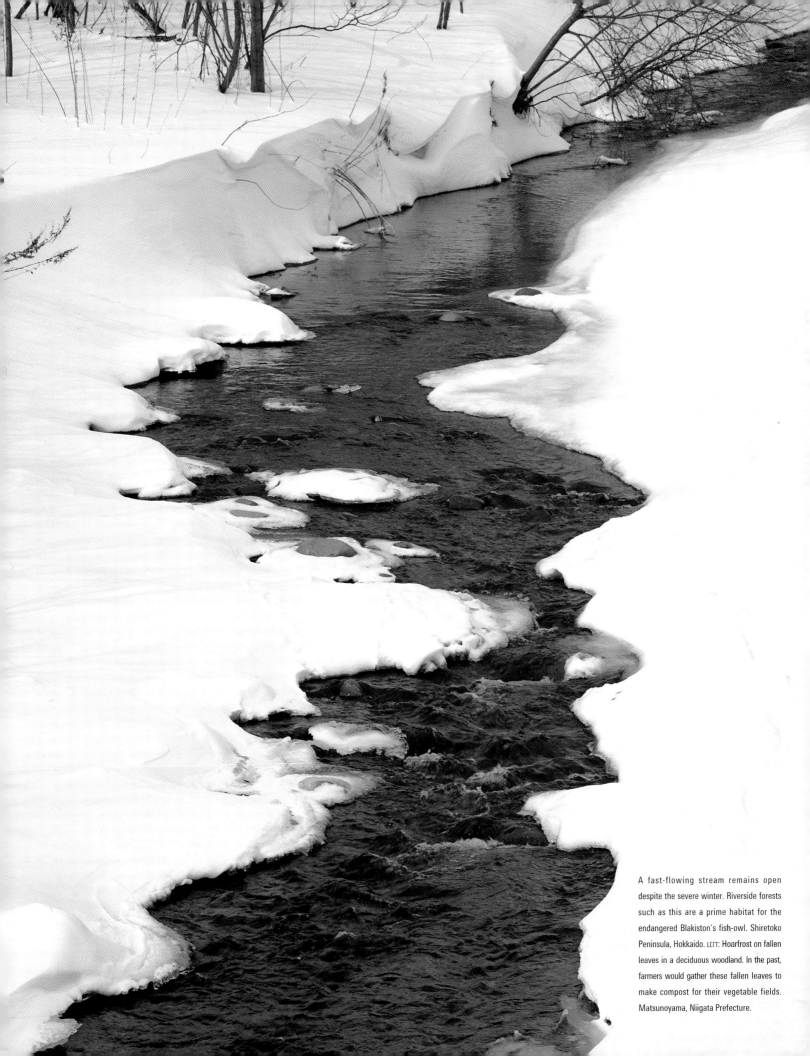

A fast-flowing stream remains open despite the severe winter. Riverside forests such as this are a prime habitat for the endangered Blakiston's fish-owl. Shiretoko Peninsula, Hokkaido. LEFT: Hoarfrost on fallen leaves in a deciduous woodland. In the past, farmers would gather these fallen leaves to make compost for their vegetable fields. Matsunoyama, Niigata Prefecture.

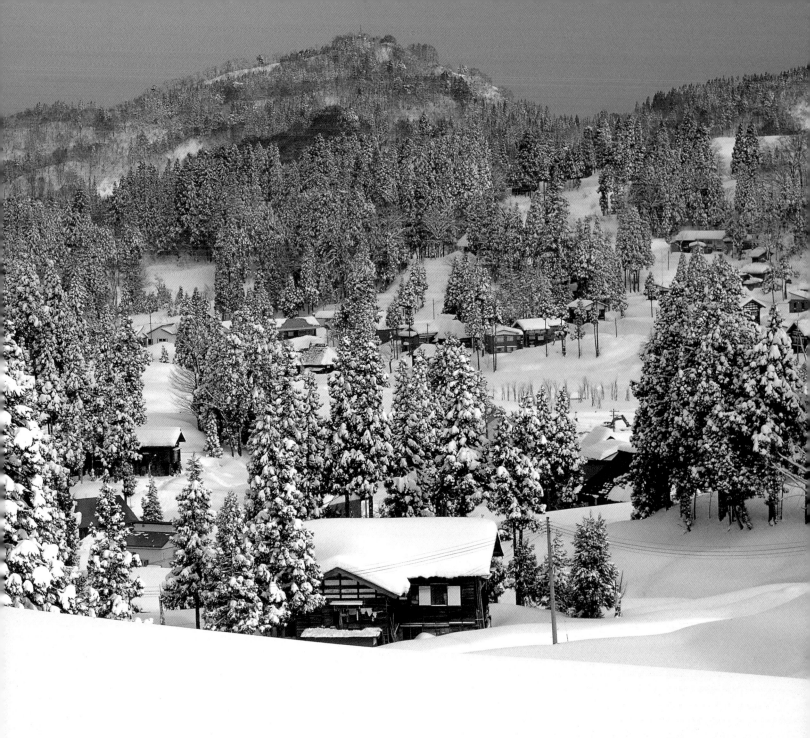

Cryptomeria and cypress conifers protect farmhouses from the deep snows and wild winds of winter. Japanese farmsteads often consist of the main house and several sheds surrounded by a grove of tall trees. Matsunoyama, Niigata Prefecture. RIGHT: A farmhouse stocked for winter: firewood for cooking and to heat the bath, and rice straw for thatching the roof and strewing in the barn. Japanese farming villages were traditionally self-sustaining units, producing all their living needs locally. Hakuba, Nagano Prefecture.

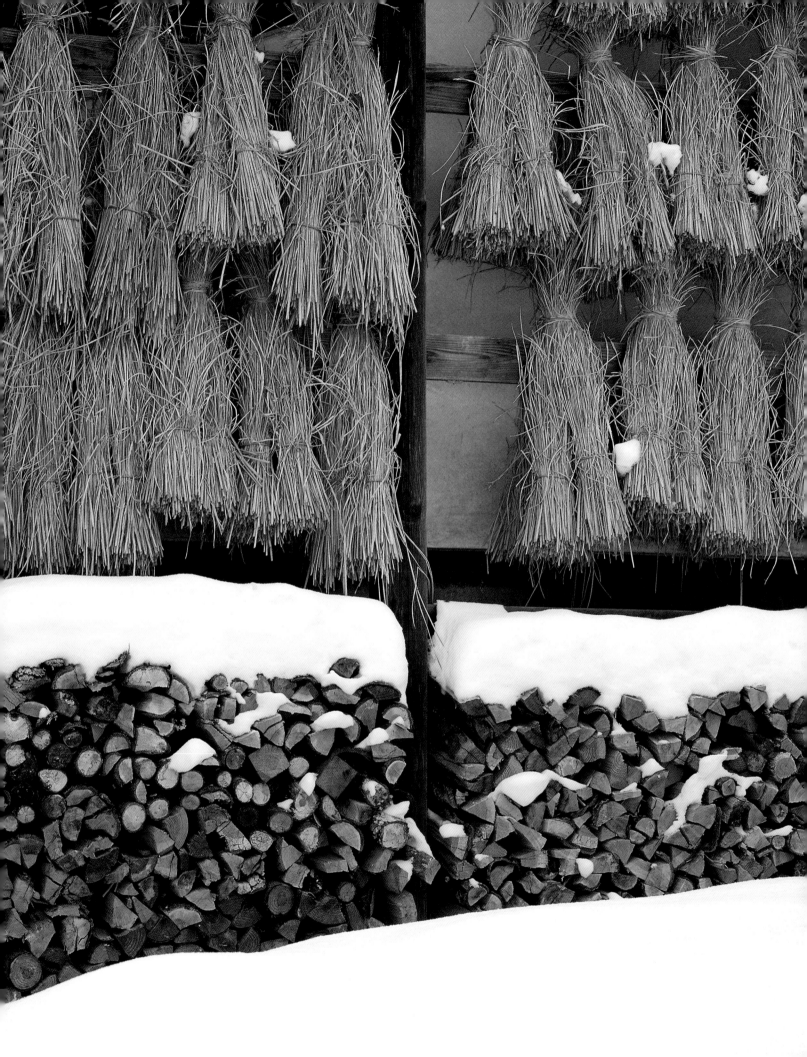

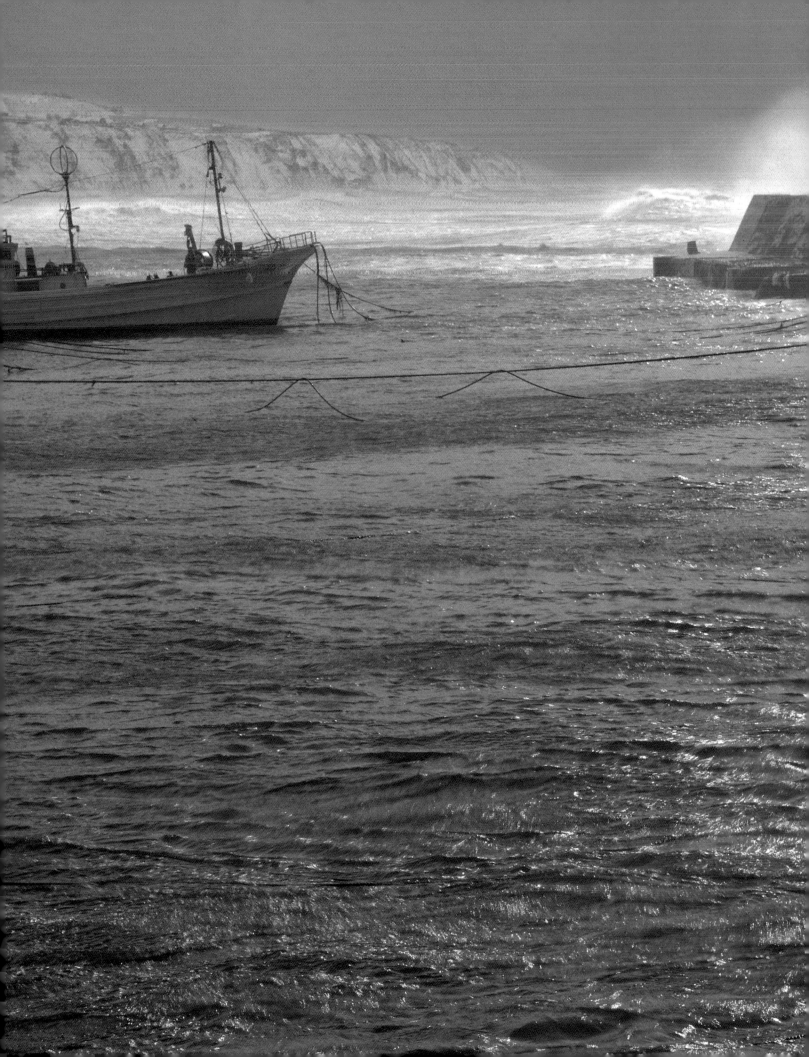

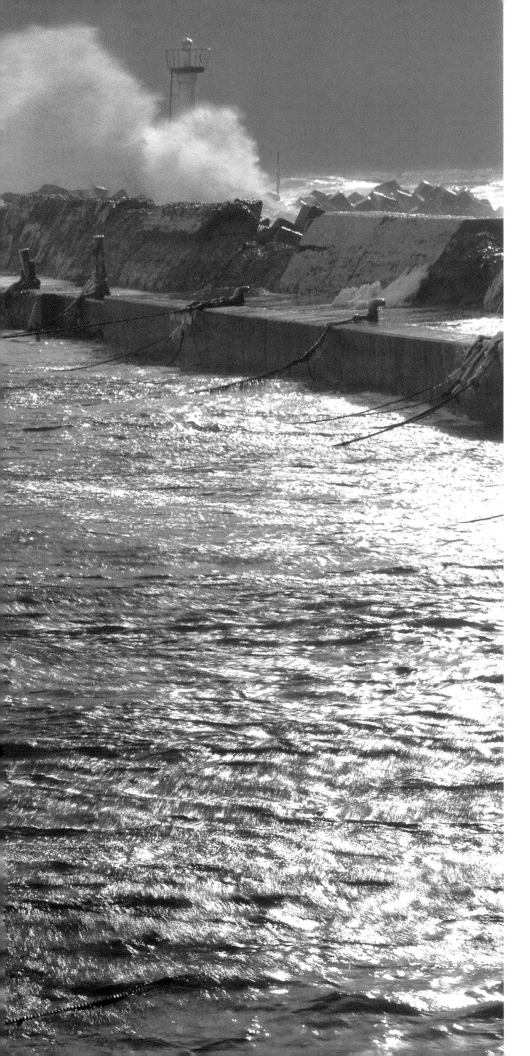

A solid breakwater protects fishing vessels from a wicked winter storm. Few natural landscapes are as awesome as a heavy surf pounding the coast. This is raw, elemental power. Sea of Japan, Hokkaido.

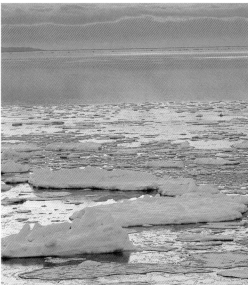

Drift ice in the Sea of Okhotsk. By midwinter the shore is choked with ice. Japanese coastal landscapes range from coral reefs and mangrove forests in the south, to frozen arctic seas in the north. Shiretoko Peninsula, Hokkaido.

OVERLEAF: Brilliant colors spread across the sky as the sun sinks slowly into the East China Sea. Coastal landscapes change from day to day, stormy and violent one day, quiet and placid the next. Kayo, Okinawa Prefecture.

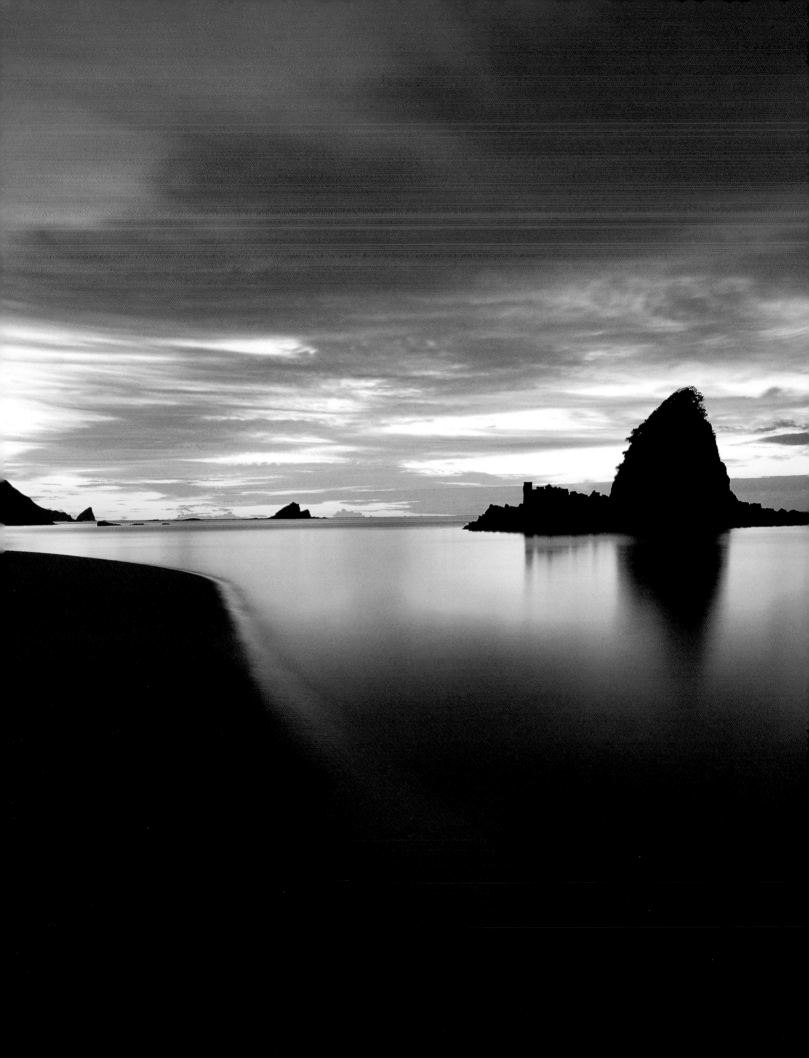

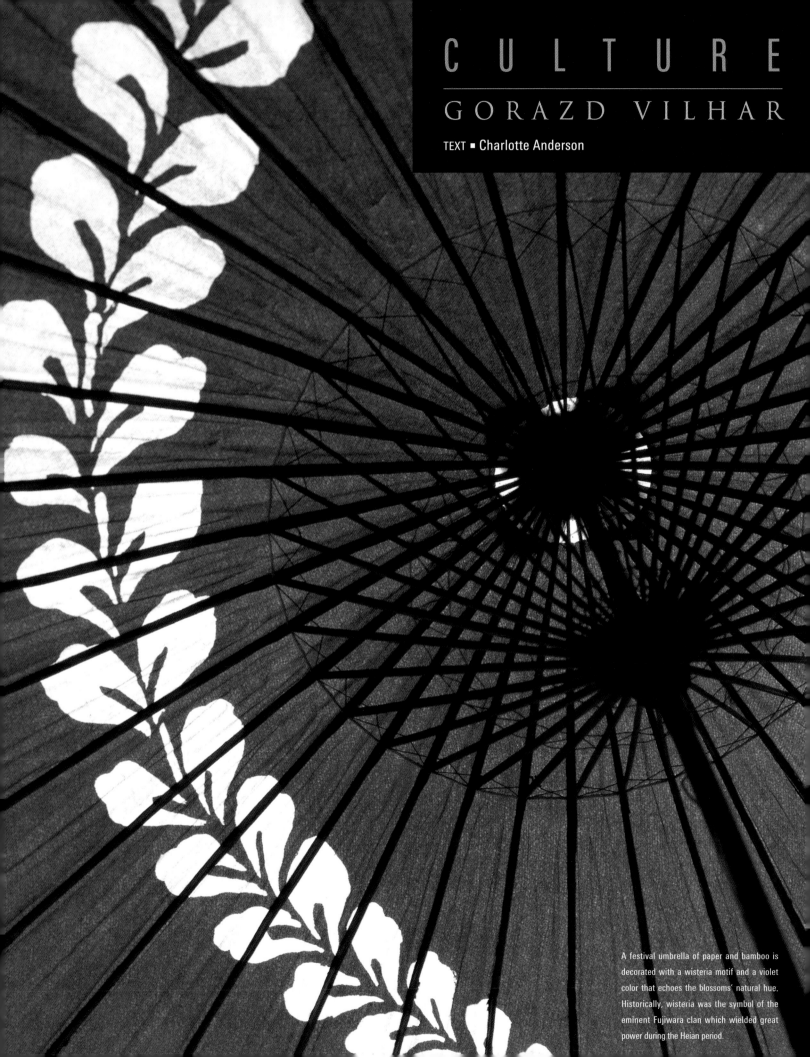

CULTURE

GORAZD VILHAR

TEXT ■ **Charlotte Anderson**

A festival umbrella of paper and bamboo is decorated with a wisteria motif and a violet color that echoes the blossoms' natural hue. Historically, wisteria was the symbol of the eminent Fujiwara clan which wielded great power during the Heian period.

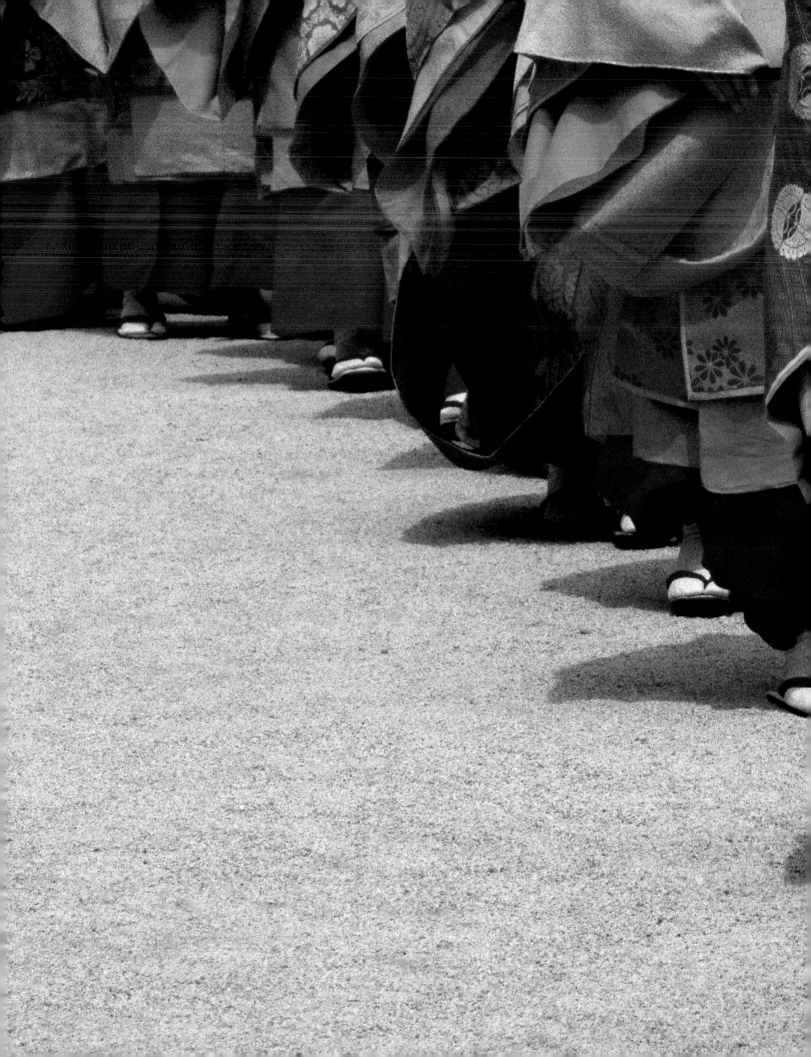

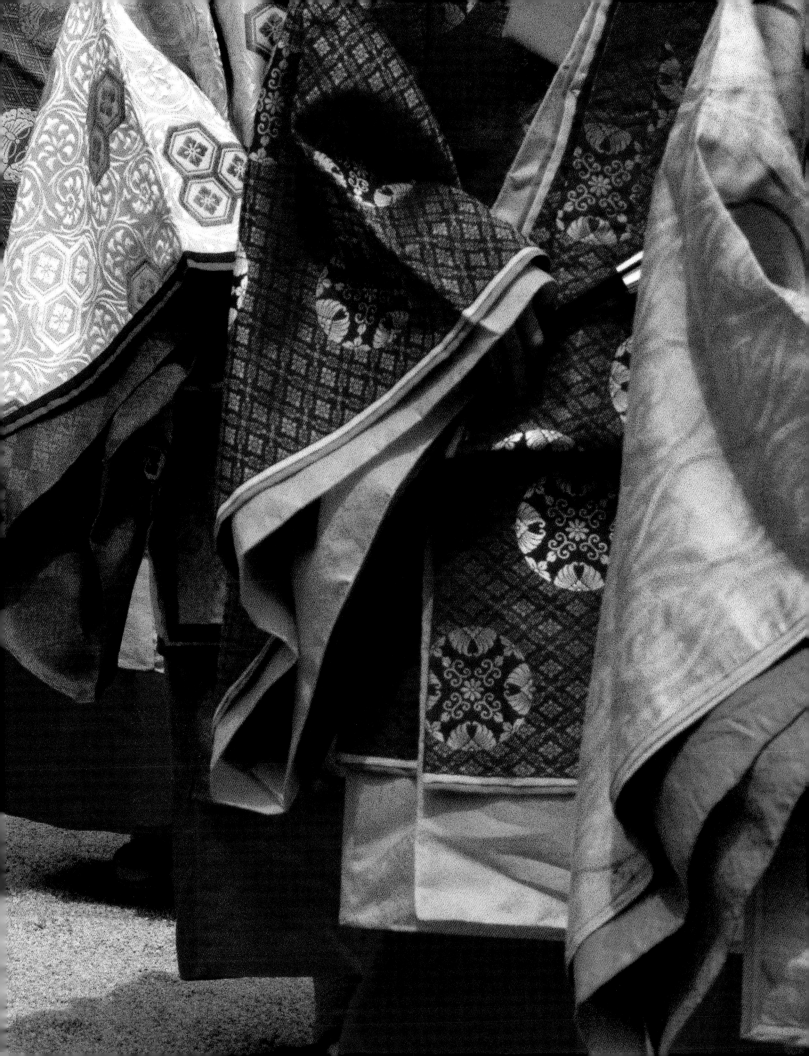

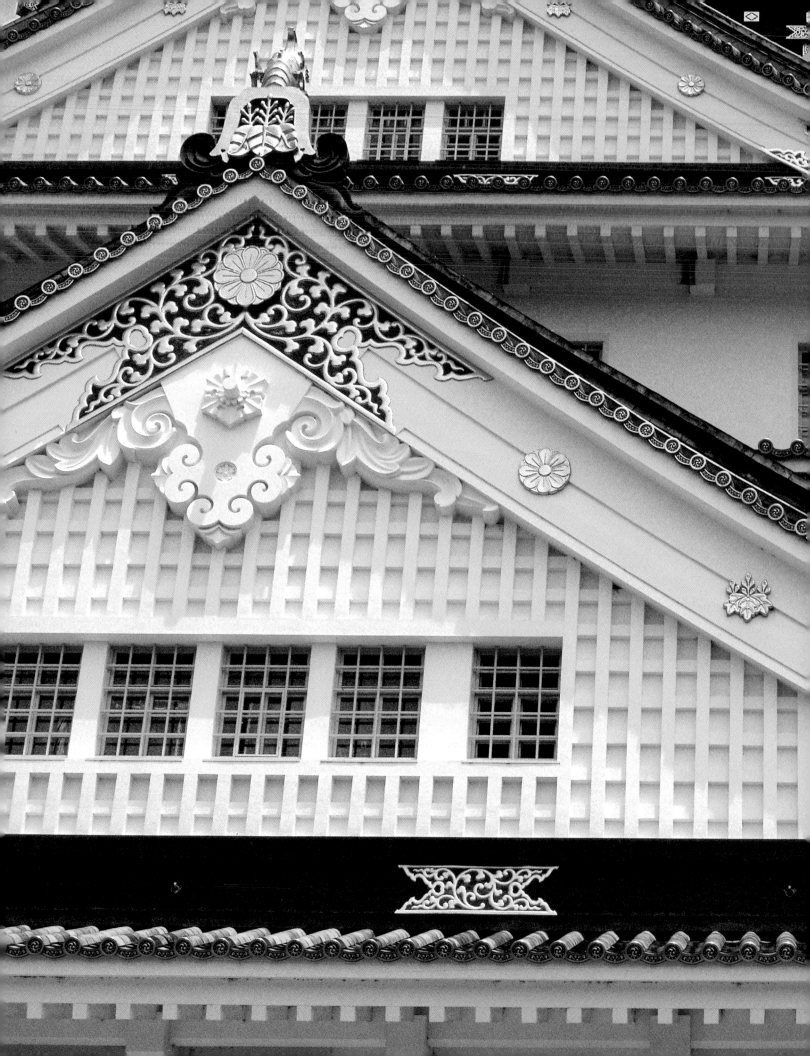

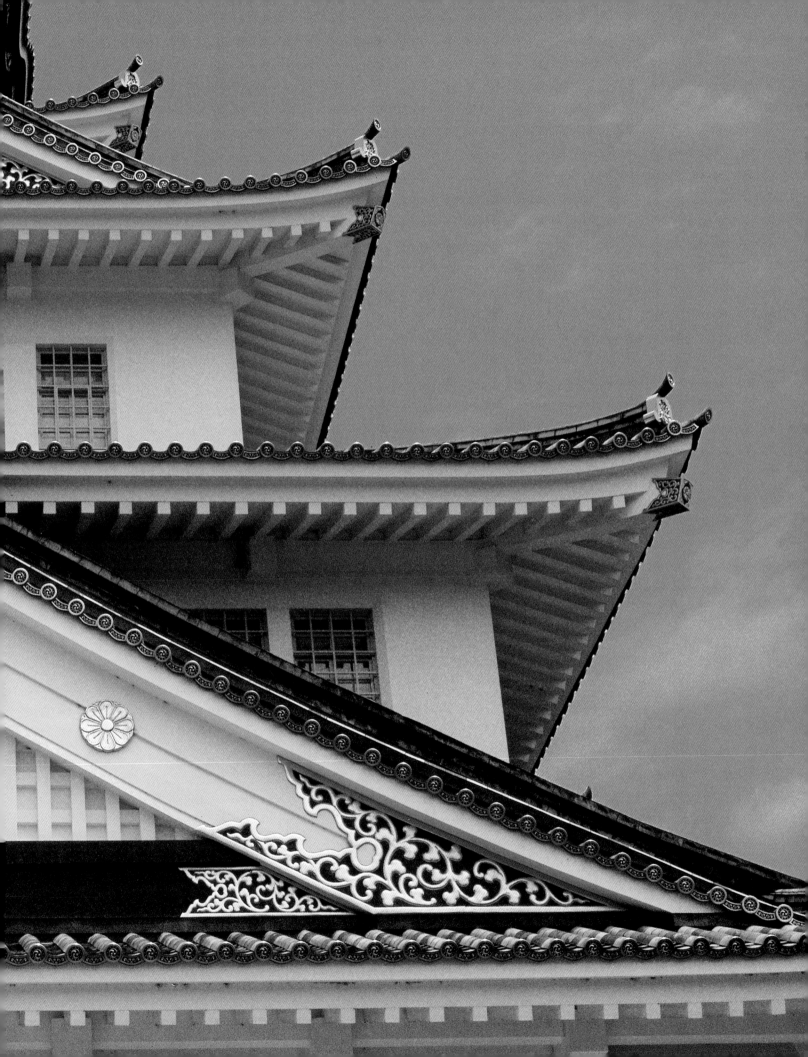

PAGE 100: Kyoto women, dressed in silk brocade robes in the style of the Heian period, walk in the five-mile procession of the Aoi Matsuri. The festival, one of Kyoto's three greatest, has been celebrated since the sixth century.

OVERLEAF: Osaka Castle was built in the late sixteenth century by Hideyoshi Toyotomi, a warlord who helped unify Japan. Although only certain sections have been preserved, originally the entire castle complex occupied an area covering 1.5 by 2 miles.

Three young women show off their dangling-sleeved kimono and ornamental *obi* sashes on Coming-of-Age Day. This annual event, held in nearly every community in Japan, celebrates twenty-year-olds' entry into adulthood.

ONE OF THE MOST INTRIGUING AND

COLORFUL

CULTURES IN

THE WORLD

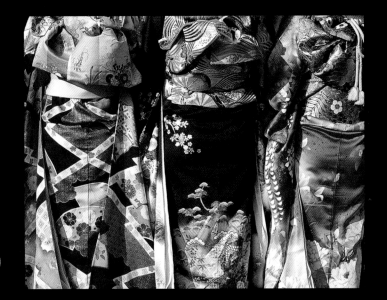

WAS CREATED

AND NURTURED IN JAPAN. ALTHOUGH IT

WAS, FOR A TIME, GREATLY INFLUENCED

BY THE HIGHLY DEVELOPED ANCIENT

RIGHT: A splendid silk-and-gold brocade *obi* wraps the waist of a young woman's kimono. The fact that the woman is young and single is apparent in the showy sash and decoratively tied cords. As costly as a kimono can be, a good *obi*, purchased as a distinct item, is often two or three times the price.

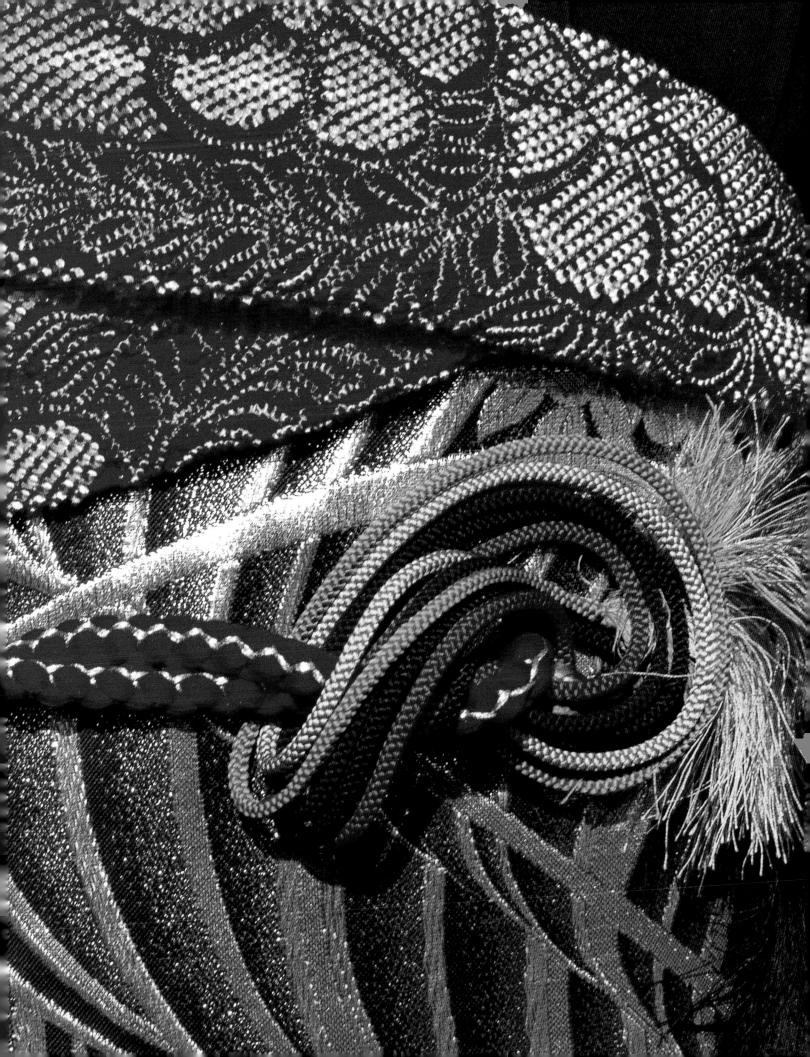

New Year is enthusiastically celebrated throughout the country. Among the numerous customs associated with the holiday festivities is a visit to a shrine to secure blessings and good fortune for the coming year, and the sipping of sacred saké.

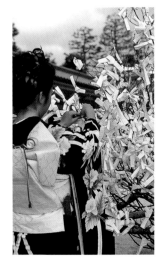

On New Year's Day, a young woman dressed in a festive kimono ties to a tree on the shrine grounds her *o-mikuji*, a luck-of-the-draw fortune for the year ahead.

civilization of China, what ultimately evolved was a unique and truly Japanese aesthetic.

Japan brings the tremendous weight of its past to its contemporary life. Its new modern and polished surface, so apparent in the urban areas, overlays a deep foundation of history and tradition built and honored through centuries. The fascinating cultural expressions of Japanese religion, celebration, attire, gardens, architecture, and arts possess an extraordinary visual appeal and find striking interpretation through the discriminating eyes of an adept.

The traditional Japanese way of life has always been closely intertwined with the practices of Shinto, which appeared millennia ago as a body of acts and rituals to spiritually connect the ancient people to their intimate and natural world, to understand it and define their place in it. In the eighth century this native faith was finally given a name, and then only as a means to differentiate this "way of the gods" from the growing popularity of Buddhism and other beliefs and philosophies which had been adopted from the continent.

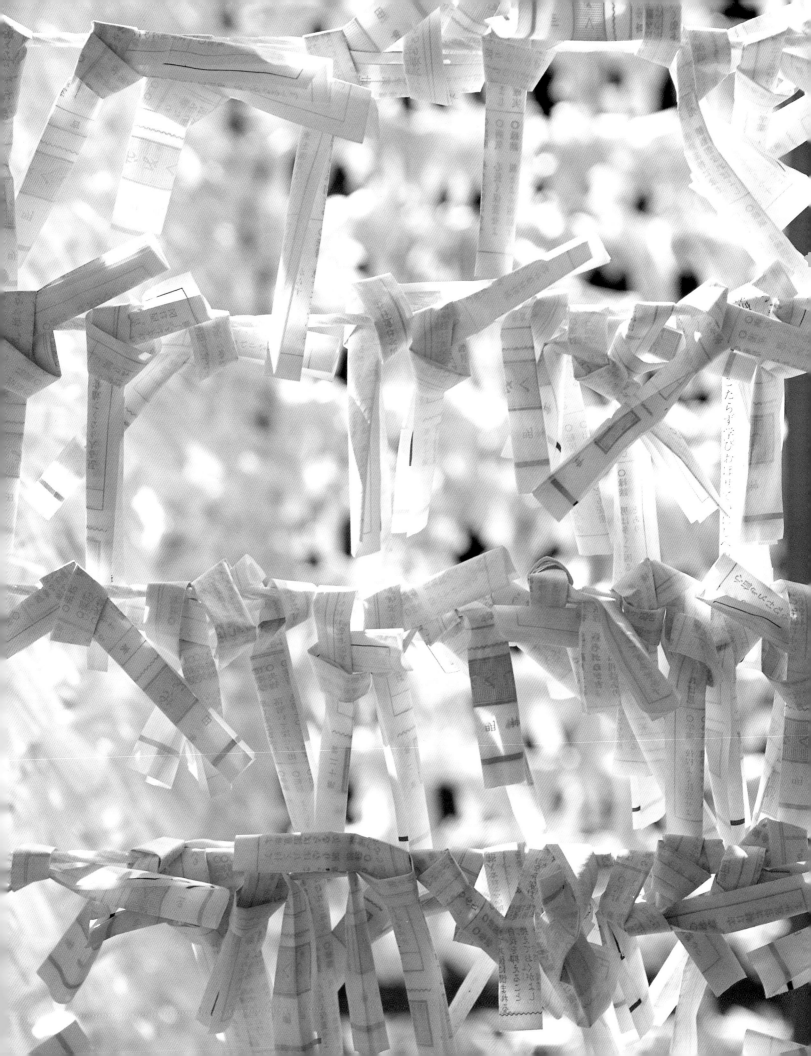

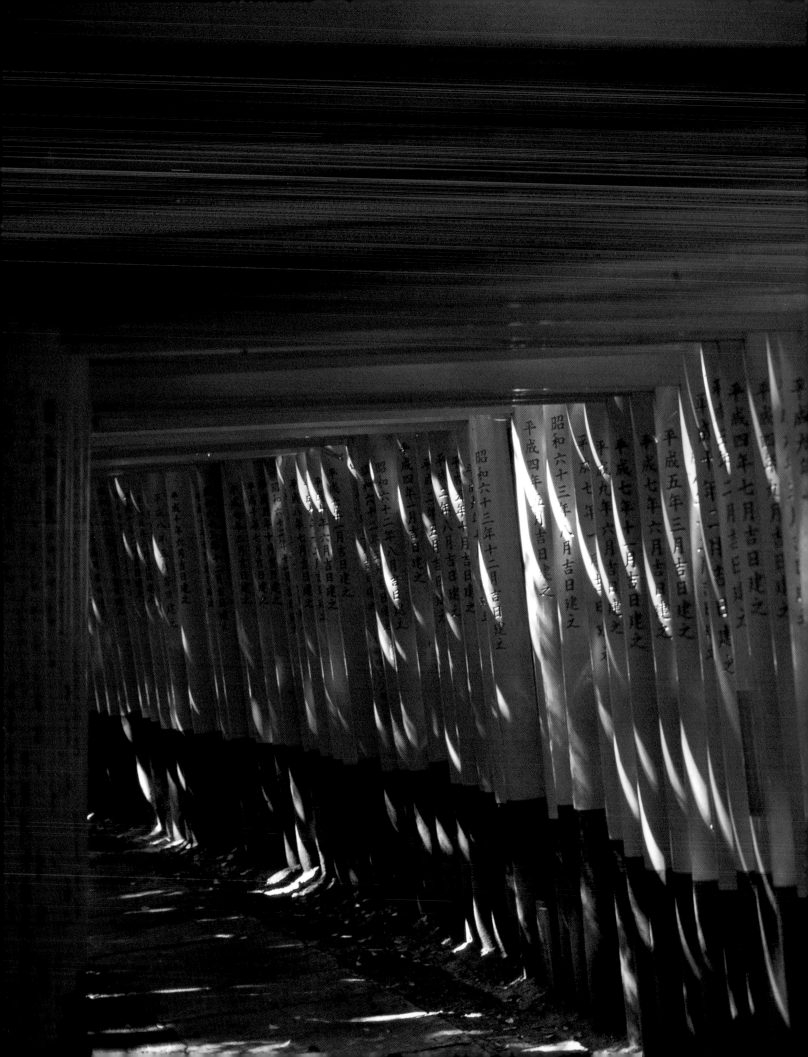

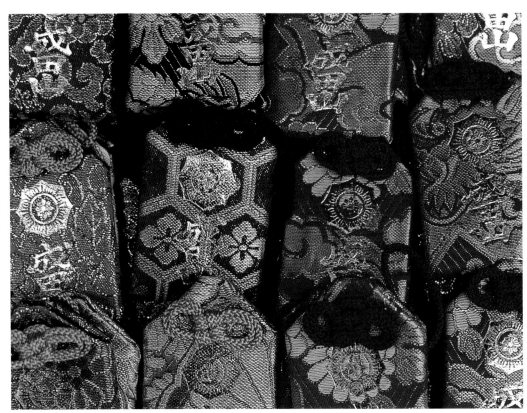

O-mamori, amulets in countless variations, are sold at virtually all temples and shrines. Often they consist of a blessed object contained within each small brocade pouch.

The domain of Shinto is nature, the cycle of seasons, and the force of life itself. Its principal deity is Amaterasu-O-Mikami, goddess of the sun and the mythical progenitor of the Japanese imperial line. Deities, divine forces called *kami*, are countless in number and are believed to be manifest in all things, animate and inanimate, pervading all aspects of life.

Shinto shrines, their sacred space marked by the characteristic orange arched *torii*, are to be found in every community, with some one hundred thousand of them throughout the country. It is there that the Japanese formally welcome the New Year, and where from time to time they participate in other age-old rituals which still continue today to give framework and meaning to their lives. Shinto, in a very quiet way, lies at the very heart of the Japanese identity.

Thousands of *torii* arches placed in offering by worshipers, line the mountainside at Kyoto's Fushimi Inari Taisha. This vast and renowned Shinto shrine is dedicated to Inari, the deity of grains, harvest, and commerce.

RIGHT: New rice and sacred saké are typical offerings at a Shinto harvest festival. In the distant past, saké was brewed for the gods alone and was one of the earliest sacred offerings in the Shinto faith.

A straw rope hung with papers folded in a zigzag pattern marks sacred space at a Shinto shrine. Beneath it the priest's purification rod, paper streamers bound to a wooden stick, stands ready in its mount for later use in a ritual.

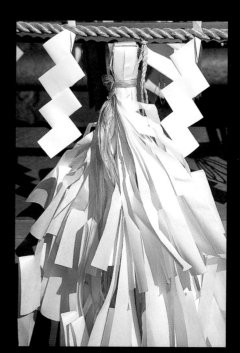

FROM ITS BIRTHPLACE IN INDIA, BUDDHISM

THEN MADE ITS WAY OVER HUNDREDS OF

YEARS TO CHINA, KOREA,

AND EVENTUALLY, IN

THE SIXTH CENTURY, TO

JAPAN. IT WAS ENTHUSI-

ASTICALLY TAKEN UP BY

THE IMPERIAL COURT AS A FAITH WITH

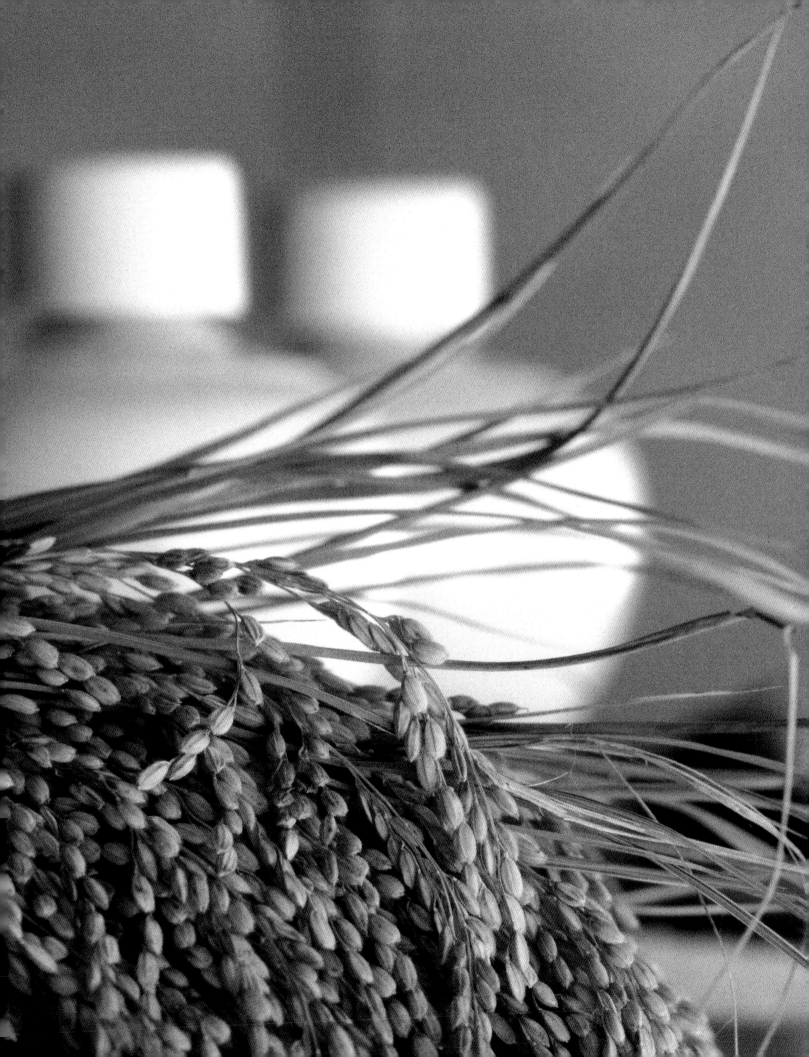

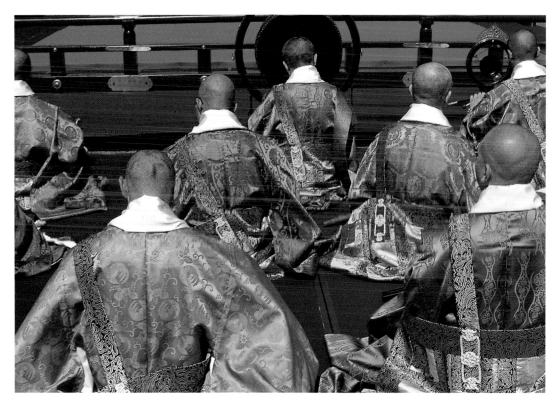

Temple priest-musicians at Zojo-ji in Tokyo prepare to accompany traditional *bugaku* dancers during Gyoki Hoyo, the annual celebration of the temple's founding.

possibly greater divine power than that of the native gods of Shinto. While it took several more centuries for Buddhism to reach the Japanese commoner, when it finally did, it flourished. Since then, for at least a thousand years, it has been a substantial influence in Japan.

Buddhism had a history of accommodating itself to local faiths as it spread across Asia, and adaptation in Japan followed a similar course. After some initial rivalry, Shinto and Buddhism soon settled into

Wearing the ceremonial vestments and lacquered wooden clogs of his office, a Shinto priest strides across the shrine grounds.

a mostly peaceful coexistence, with Shinto gods often recast as local manifestations of Buddhist deities, rather than as competitors. As Shinto focused on life, Buddhism found a complementary niche tending to the spiritual needs surrounding death and the afterlife. However, the religions mingled and at times even merged, so that even today the line between the two is sometimes a little blurred.

Although Japan is a relatively small country, it supports nearly as many Buddhist temples as Shinto shrines. The vast majority of people call upon each religion as needed, without any sense of personal conflict. Together, the two religions seemed to create for society a well-rounded spiritual support which neither one nor the other could provide alone.

RIGHT: As part of their formal vestments Buddhist priests wear over one shoulder a small silk rectangle that symbolizes the humble robe the historical Buddha once wove for himself from scrap threads gathered along the road.

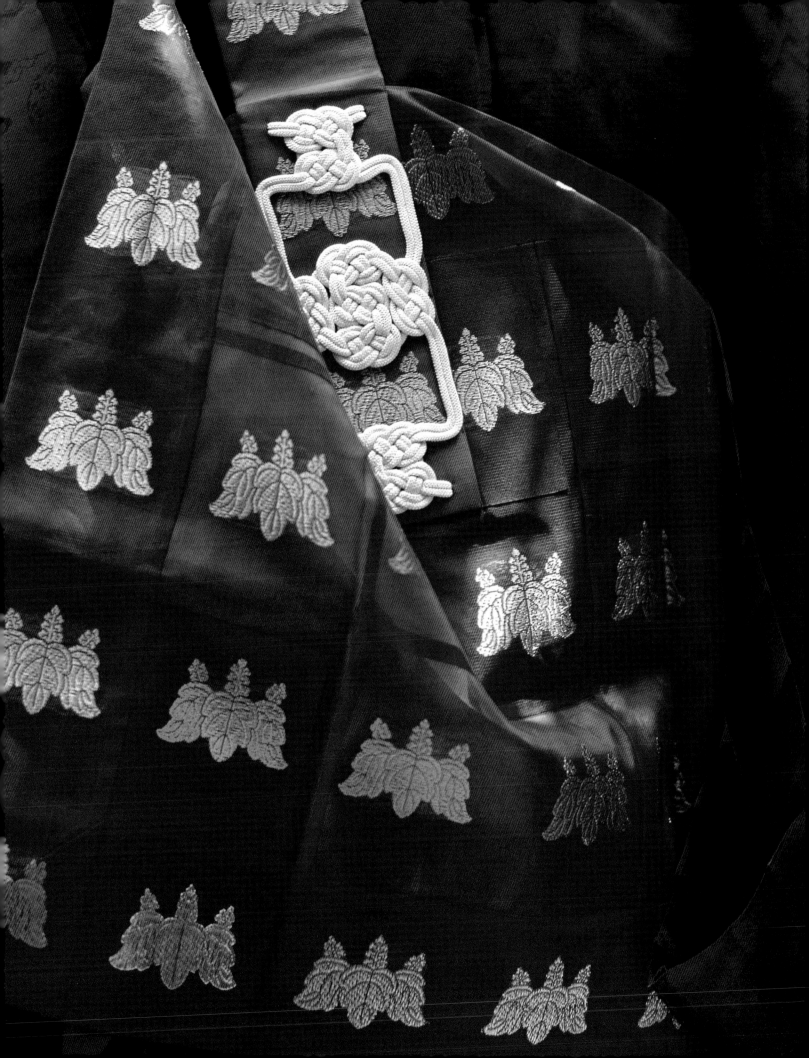

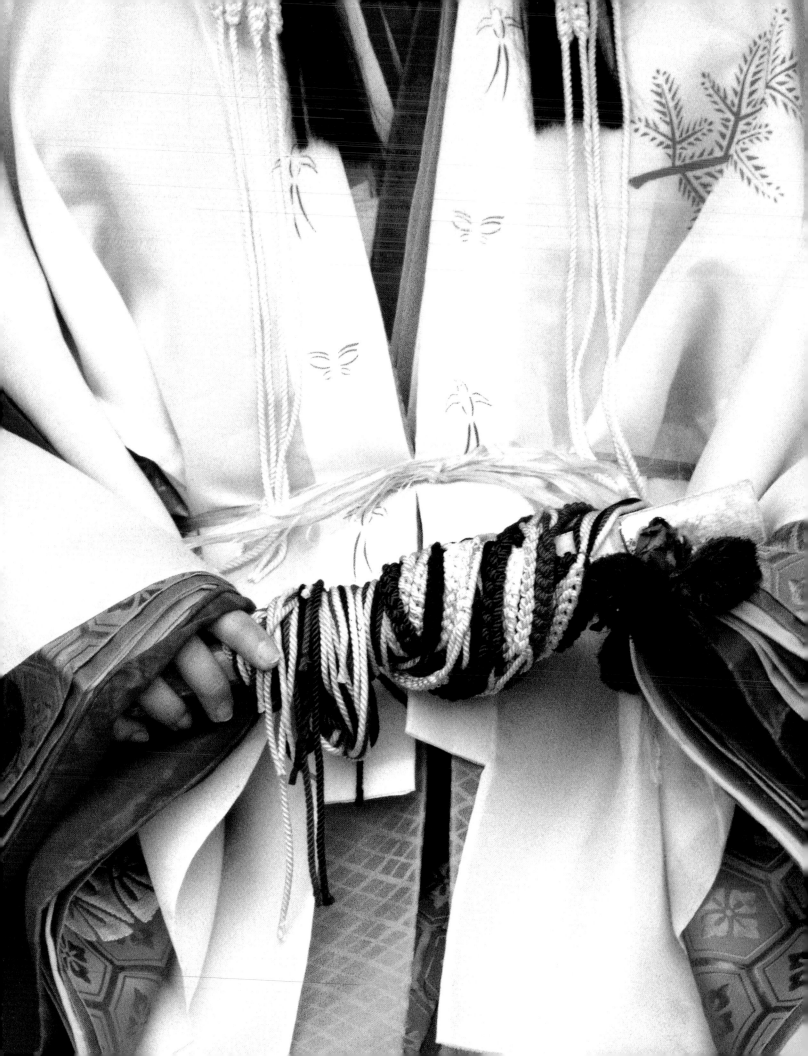

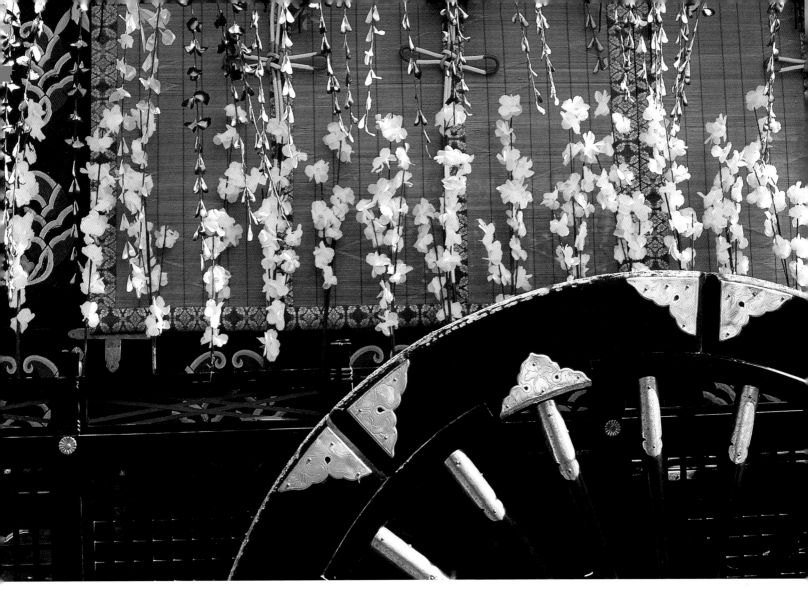

An ancient-style lacquered cart of the type once used to transport emperors is decoratively bordered with wisteria and cherry blossoms for the Aoi Matsuri procession.

Daily worship, if undertaken at all, consists of the simplest act of prayer and a small offering, usually in front of home altars, or almost casually when a temple or shrine is encountered in passing. Ceremonial events, on the other hand, can be highly choreographed enactments—rich in history, ritual, and symbolism, with dozens, hundreds, or even thousands of participants.

Festivals called *matsuri* are a formalized means through which the people can collectively tender the divine world their prayers, offerings, and gratitude. Though originally and still predominantly Shinto observances, they came to include certain calendrical rites of Chinese Buddhist origin. Japan may well enjoy more festivals than any other country in the world, for it is said that some two hundred thousand of them are celebrated in any year throughout the country.

The glorified celebrant of the Aoi Matsuri is Saiodai, an honorary princess wearing the magnificent twelve layers of colorful silk robes said to be identical to those in *The Tale of Genji* picture scrolls of the Heian period.

A great many festivals are related to rice growing, the very foundation of Japanese culture, or to
other phenomena of nature. Others are family oriented, mark life's milestones, or honor the guardian
deities of clans, villages, towns, and districts. Still others reenact legends or celebrate events or person-
ages of the nation's history and culture.

Common to all festivals is the purification of both place and intermediaries before seeking the favor
of the divine world. The deity is then invited to descend to the festival site, where praises are offered in the form of prayer. Generous offerings of the finest of food and drink are placed on festival altars, and sacred music, dance, drama, or other entertainments are performed. The spirit of the deity may be ceremonially transferred to a *mikoshi*, a portable Shinto shrine, and borne about by parishioners on an entertaining and unrestrained ride through the neighborhood, or even sometimes into a river or sea.

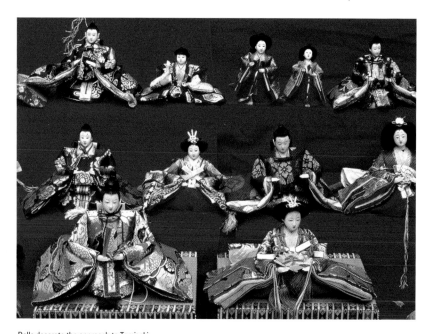

Dolls decorate the approach to Tomisaki
Shrine in Katsuura, Chiba, during Hina
Matsuri, the festive March 3 Girls' Day
celebration. On display are 850 dolls out
of the shrine's collection of 2000. It is
among the largest of such displays in
Japan.

Although extremely varied in form or accouterment, constant throughout nearly all festivals is the
ardent appeal for good luck, health, and prosperity. In the past when life was difficult for most, well-
being seemed wholly at the mercy of the *kami*. Yet even today, the protection and sense of security
the *kami* offer maintain their appeal.

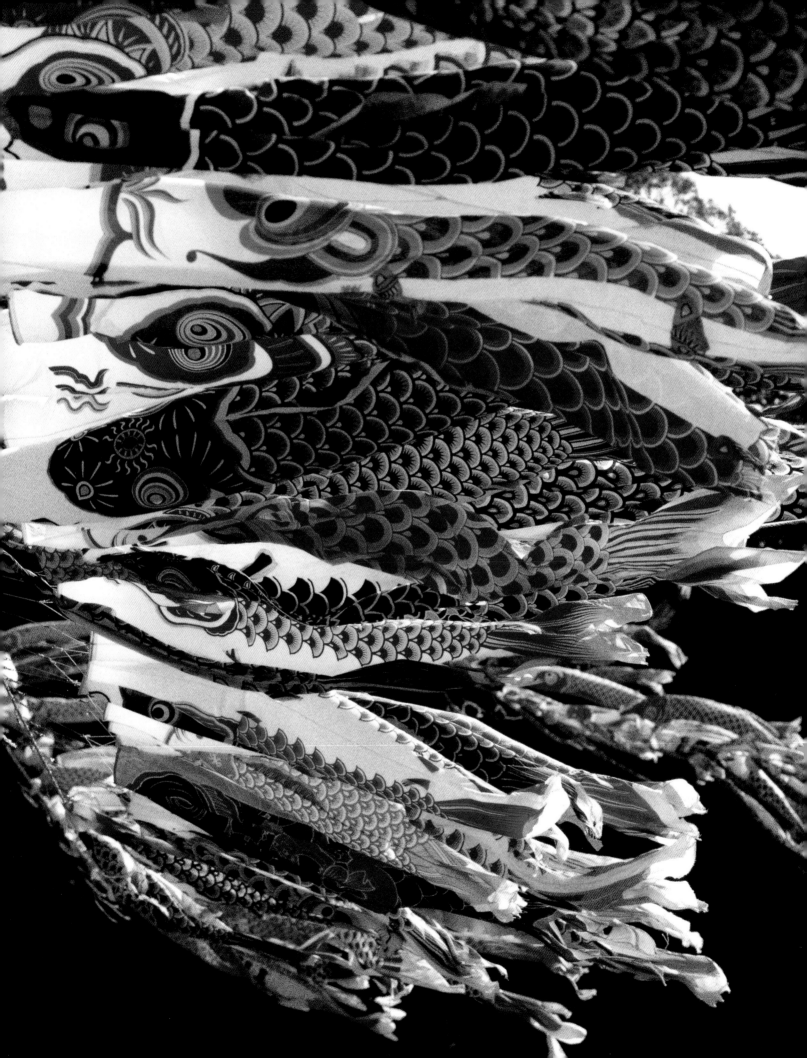

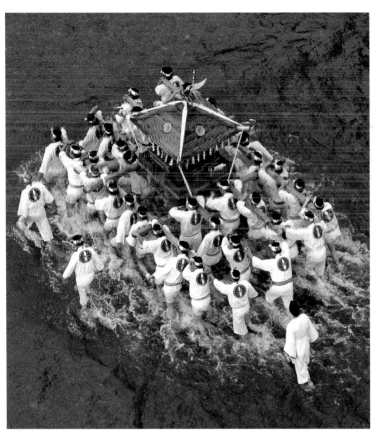

Men representing the seven districts of the Chichibu region bear a portable Shinto shrine housing the spirit of Susano-o-no-Mikoto, the honored deity and brother of the Sun Goddess, into the Arakawa river during Kawase Matsuri.

A pouch used by men in earlier times to carry their flint-stones is secured to a festival participant's pocketless garb to hold his cigarettes and lighter.

An army of bearers pauses to rest from the weight of the four-ton portable shrine during Torigoe Matsuri, one of Tokyo's most famous summer festivals.

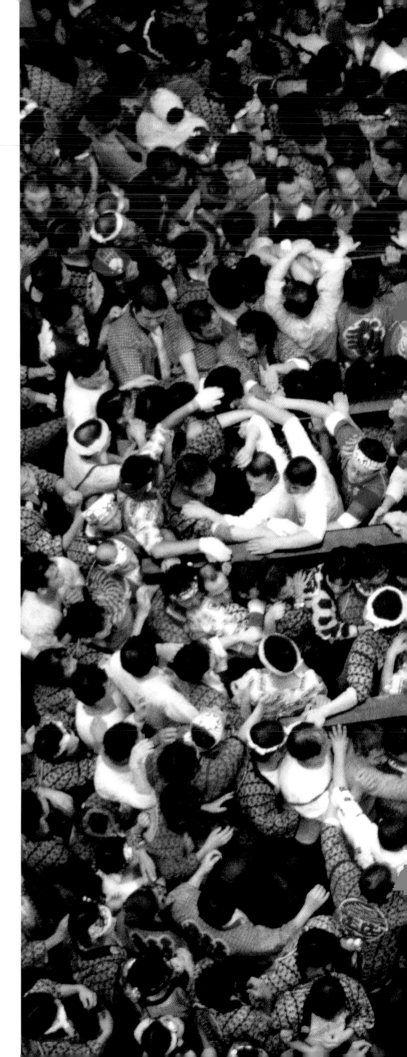

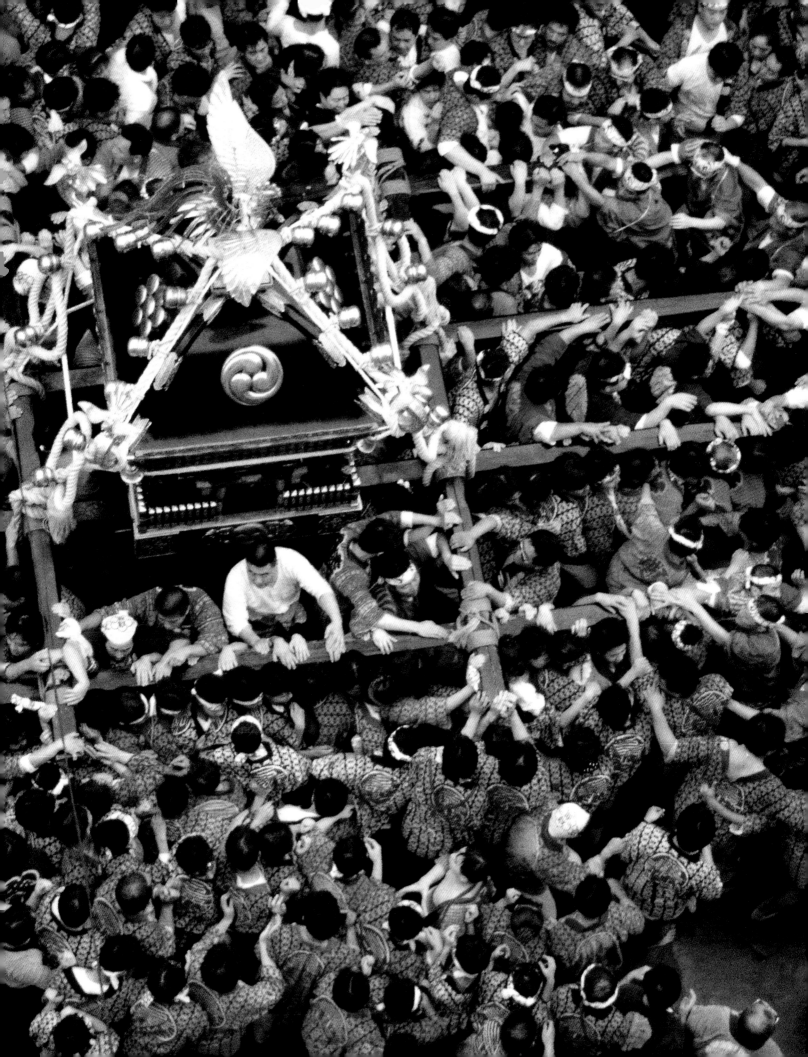

JAPANESE GARDEN ARTS ARE AMONG

THE MOST SOPHISTICATED IN THE WORLD.

THE PRIMITIVE

PREDECESSOR OF

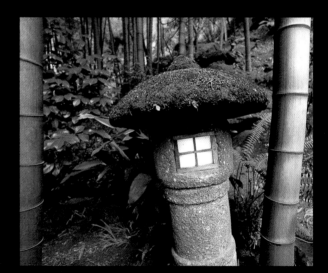

A stone lantern covered with moss stands in the shade of a bamboo grove at Hokoku-ji, in Kamakura. This fourteenth-century Buddhist temple is more popularly known as the Bamboo Temple.

THE GARDEN

CONCEPT WAS

THE SACRED SPACE OF THE EARLY SHRINES —

BARE CLEARINGS IN IMPRESSIVE GROVES

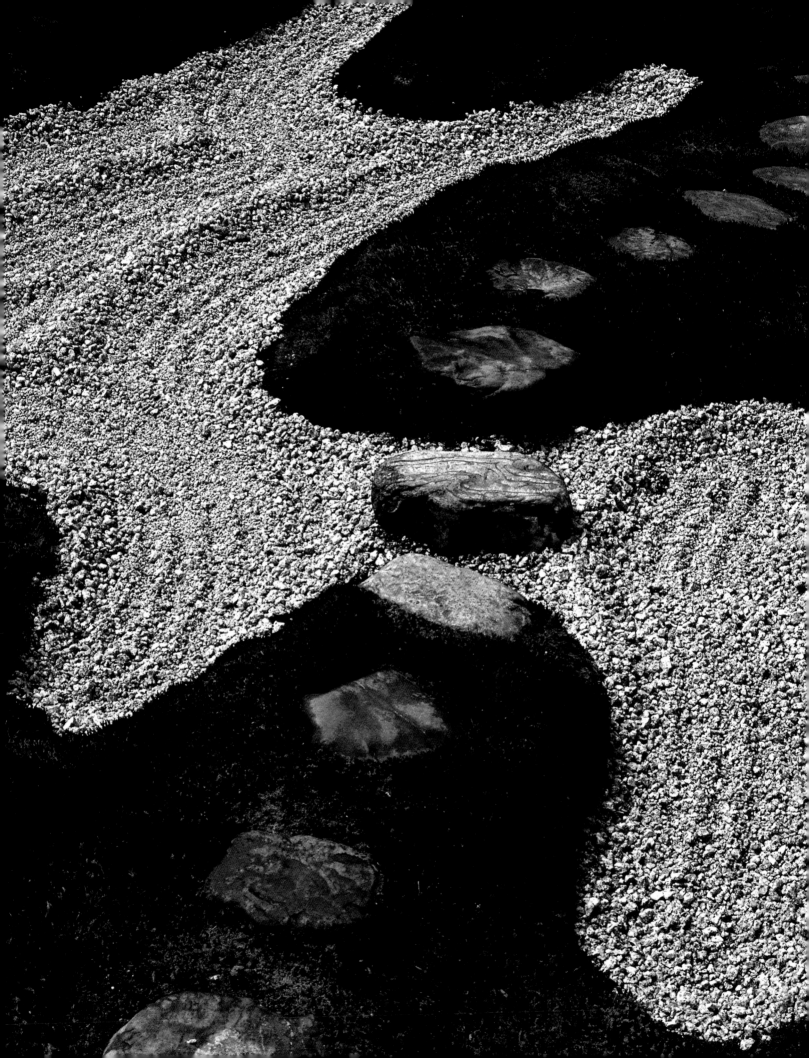

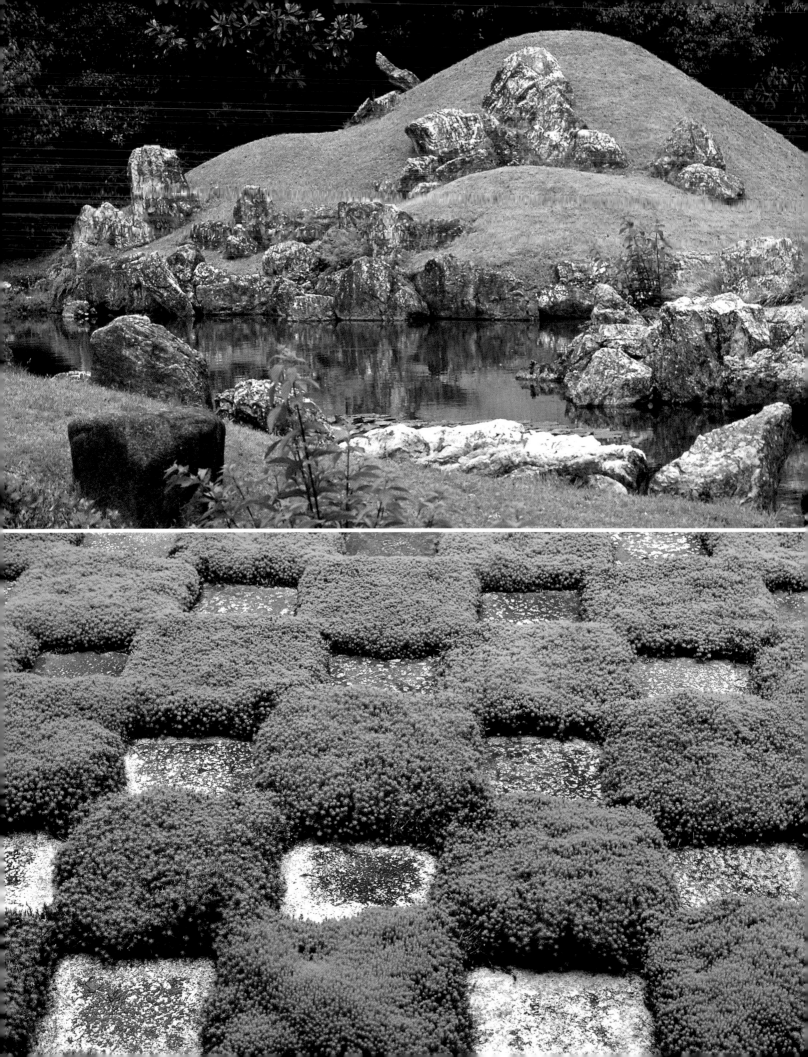

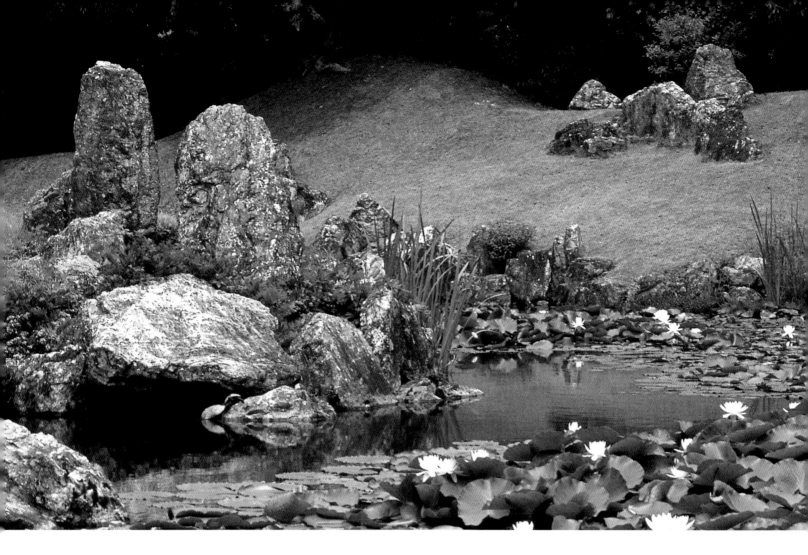

Stone is integral to the design of most Japanese gardens. In its whole and massive form, it finds its way into gardens such as that of Makaya-ji, above, in Hamamatsu in Shizuoka, dating from the thirteenth century. Landscapes are created with stone specimens chosen for their shape as well as for their spiritual presence. Within the landscape, their physical beauty is but the first consideration. The shape of the stone may not only evoke scenic elements such as waterfalls or mountains, but is often rife with auspicious, religious, or literary symbolism. In Buddhist meditation gardens of the *kare sansui* idiom, gravel or sand are raked into mesmerizing patterns representing the changeable waters of life—placid or rippled rivers and seas accented by the occasional whirlpool. At Sento Imperial Palace, smooth beach stones pave the shore of the South Pond, while alternating squares of stone and moss comprise an uncommon and modernistic temple garden at Tofuku-ji.

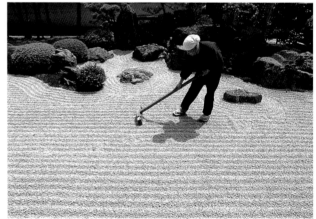

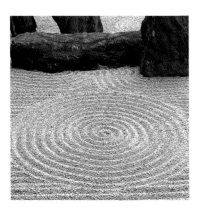

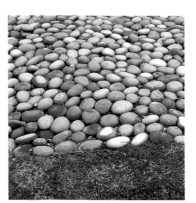

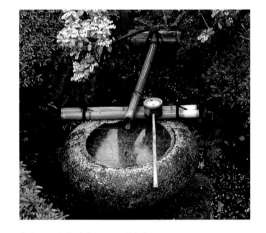

A stone waterbasin is an essential element in any tea garden. It is here that the guests invited to the tea ceremony pause to cleanse their hands and mouth before entering the teahouse.

of ancient trees. Already in the Nara period, evidenced by poetry of the time, gardens imitating natural vistas were created along the lines of T'ang gardens seen by court emissaries to China.

Once the capital was moved to Kyoto, gardens became ever more splendid, with wondrous scenes fashioned of rare rocks and careful plantings. Masterly garden design arose as one of the highly regarded talents among the aristocracy, and men of means surrounded their villas with elaborate gardens, aspects of which inspired pleasant anticipation as they came into their own in season.

When luxury and decadence gave way to martial values in the Kamakura period, the austere and disciplined Zen sect of Buddhism began to exert its influence even in the garden arts, leading to their golden age in the Muromachi period. Disciples returning from study with the Zen masters of China sought to emulate esteemed Sung-period ink landscape paintings of craggy mountains, rocks, trees, and waterfalls. These monochromatic paintings even inspired the creation of superb gardens known as *kare sansui*, "mountains and waters without water." Through sand, pebbles, and rocks, a whole world of spiritual thought was represented, creating an ideal place of meditative contemplation.

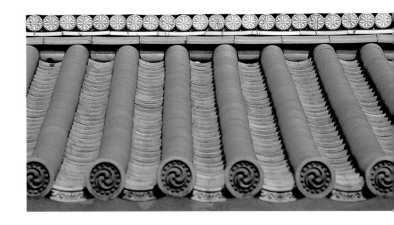

OPPOSITE: Bamboo, both wild and cultivated, grows in abundance throughout almost the entire Japanese archipelago. Close to five hundred different species exist here, including tree, bush, and grass varieties. Although bamboo is a simple and humble material, it is treated with honor and creativity, and is utilized in myriad ways in traditional Japanese architecture and gardening. Strips of bamboo may frame, screen, decorate, or highlight traditional windows. In its various forms, it is bent, woven, clustered, or tied to make walls and fences. It is also fashioned into water pipes, dippers, and other attractive and natural accessories commonly used in Japanese gardens.

Rustic and serene tea gardens arose in profound contrast to the otherwise opulent aesthetics of the following Momoyama period, while the later Edo period saw the culmination of magnificent stroll gardens, emphasizing ever-changing landscapes as viewers moved along a designated path.

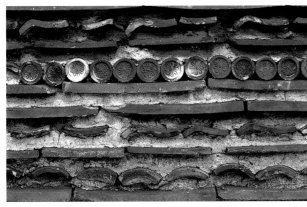

TOP: Fired clay tiles cover and ornament traditional temple roofs, as well as those of houses and castles. LEFT: Old tiles are occasionally reused in the creation of new walls to infuse them with a sense of the past. CENTER: Crested and "demon" tiles crown ridge ends. RIGHT: The immense wooden gates of castles and certain important temples were once fortified with ornamental ironwork.

Architecture offers its own impressive contributions to the national cultural treasury. Only natural materials are utilized in truly traditional Japanese architectural design, and they are treated therein with reverence by craftsmen of often formidable skill.

The Japanese have a history of living in accord with nature, or at least with nature as they have tamed it. Living spaces evolved to accommodate the long hot and humid summers, with materials cool

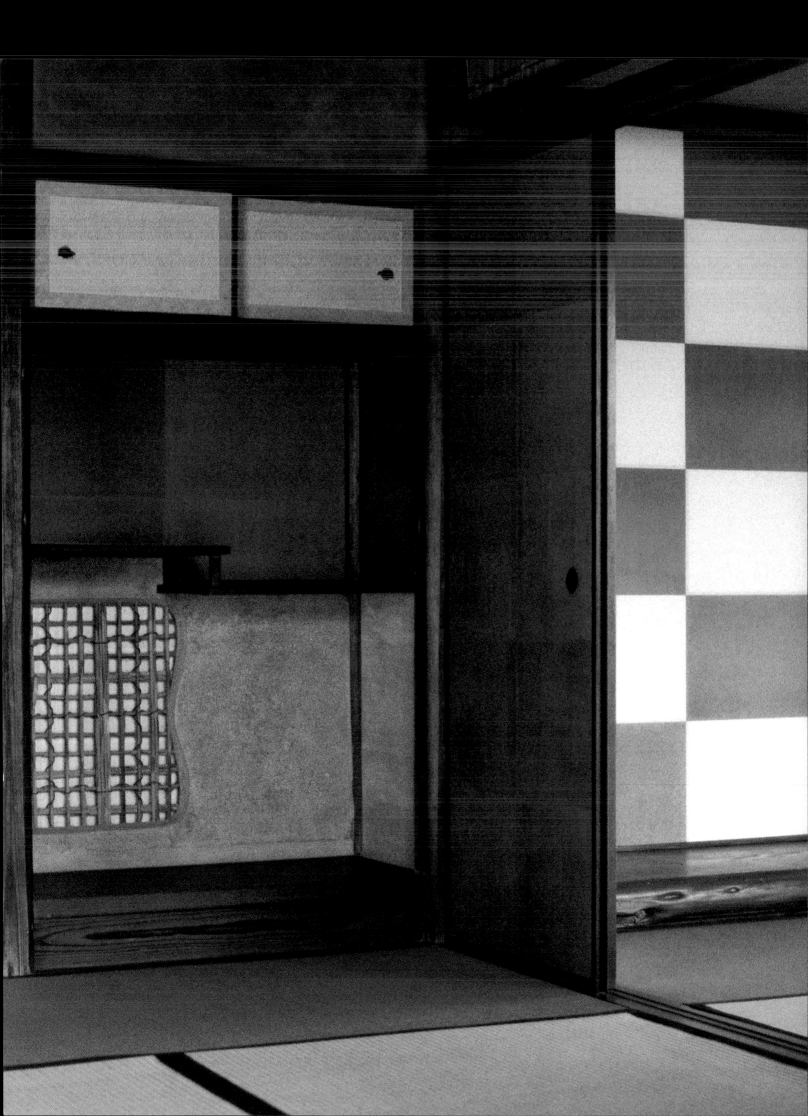

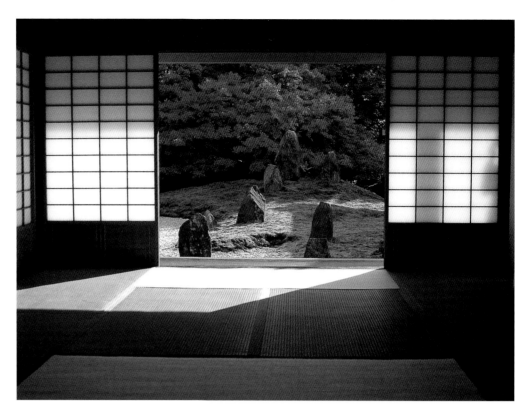

and comfortable to the touch. Stone, wood, clay, straw, and paper are worked in unique ways to create structures and auxiliary elements of spare beauty and subtle ornamentation.

Stone can be used for lanterns which light the way through darkened gardens, or for stepping stones leading tea ceremony guests along a path created to suggest a rustic way into the remote wilds. Stone waterbasins, called *tsukubai*, serve for ritual cleansing of hands and mouth before guests enter the teahouse itself.

Bamboo has been long appreciated for its living beauty. However, it is also handsomely employed as a versatile material for fences to contain or screen, for garden gates, and in the austere ornamentation of teahouses, temple pavilions, and, in the past, even palaces. Other woods find their place as the most suitable material for the construction of buildings,

The spare geometry of *shoji* design imparts a completely contemporary impression to foreign eyes, although it has existed in Japan for hundreds of years.

Bold rectilinear patterns—in the papered decorative alcove, the bamboo-and-vine latticed window, and the tatami-mat floor—dominate the interior of a pavilion at Katsura Rikyu, a villa built in the seventeenth century as an imperial retreat.

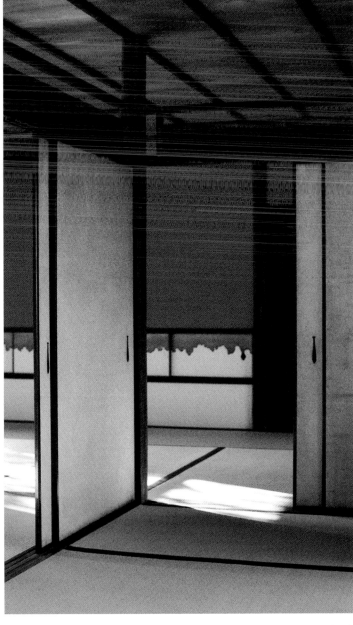

Traditional architecture evolved to accommodate the long, hot, and humid Japanese summers through the use of comfortable and cool natural materials, such as wood, paper, and straw. An innovative system of lightweight sliding or removable panels both facilitated the movement of air and visually linked the inside with the outside.

while clay is formed, sometimes glazed, and then fired for utilitarian and ornamental roof tiles.

Traditional interiors are almost always floored with tatami, thick mats of rice straw covered with woven rushes and edged with silk brocade. Paper, traditionally hand-crafted of mulberry bark fibers, is yet one more material incomparably utilized in Japan. In its translucent form, it continues to be used to construct *shoji* sliding doors and is sometimes employed in windows, bringing an ethereal light into traditional spaces. *Fusuma*, opaquely papered panels, divide or enclose spaces. The inherent beauty of the paper is at times their only decoration, although often they are simply or profusely patterned, or enhanced with original paintings.

A stone tied with rope is placed on a garden path to gently remind visitors that they may not proceed beyond that point.

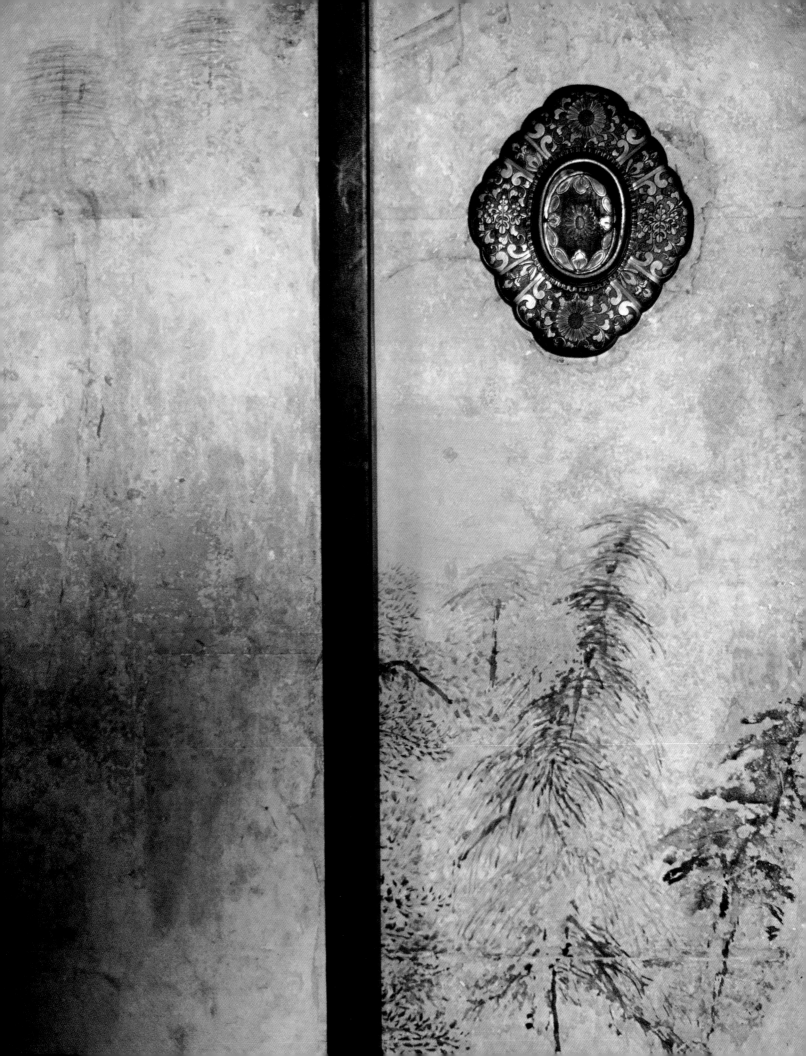

CAME TO FULL FLOWER IN KYOTO. EVEN

TODAY, THE JAPANESE

PEOPLE CONSIDER

Peaked patterns painted in the white
makeup of the "flower and willow
world" emphasize the beauty and eroti-
cism of the neck, a part of the female
body much favored in Japanese culture.

THIS ANCIENT CITY TO

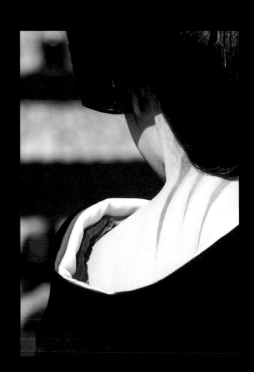

BE THE REPOSITORY

OF THEIR NATION'S

CULTURE AND TRADITION, AND NATIVE

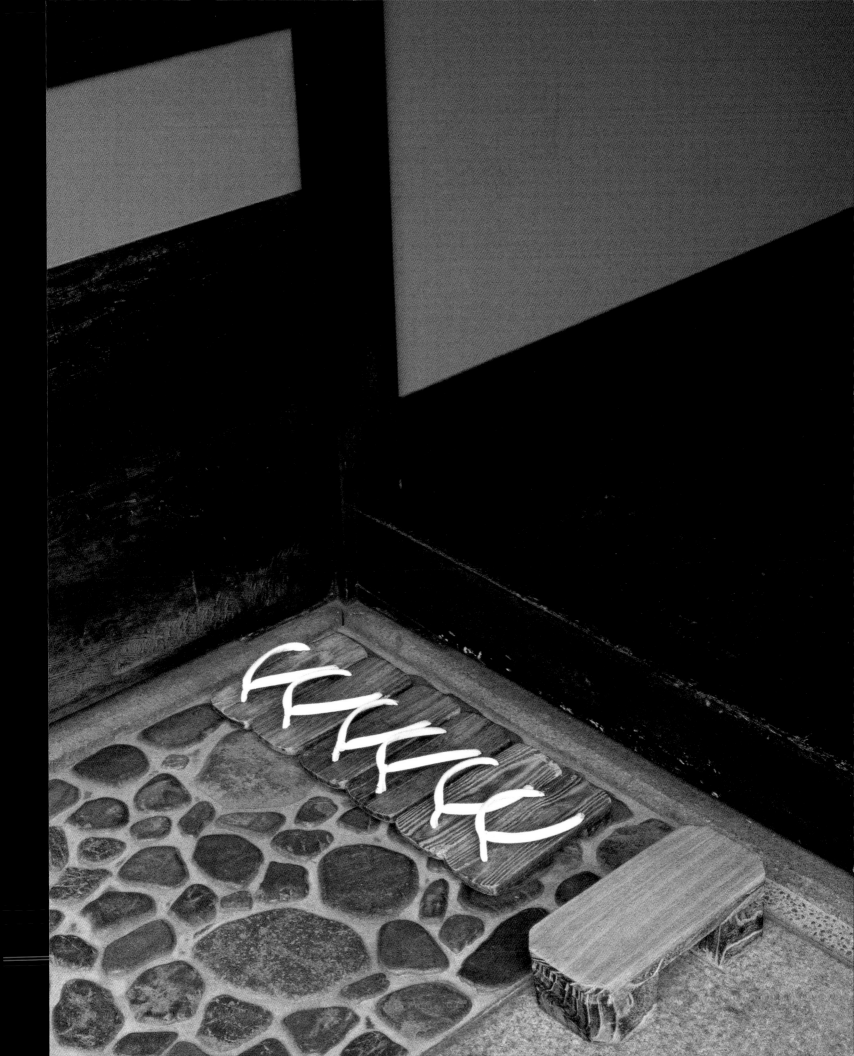

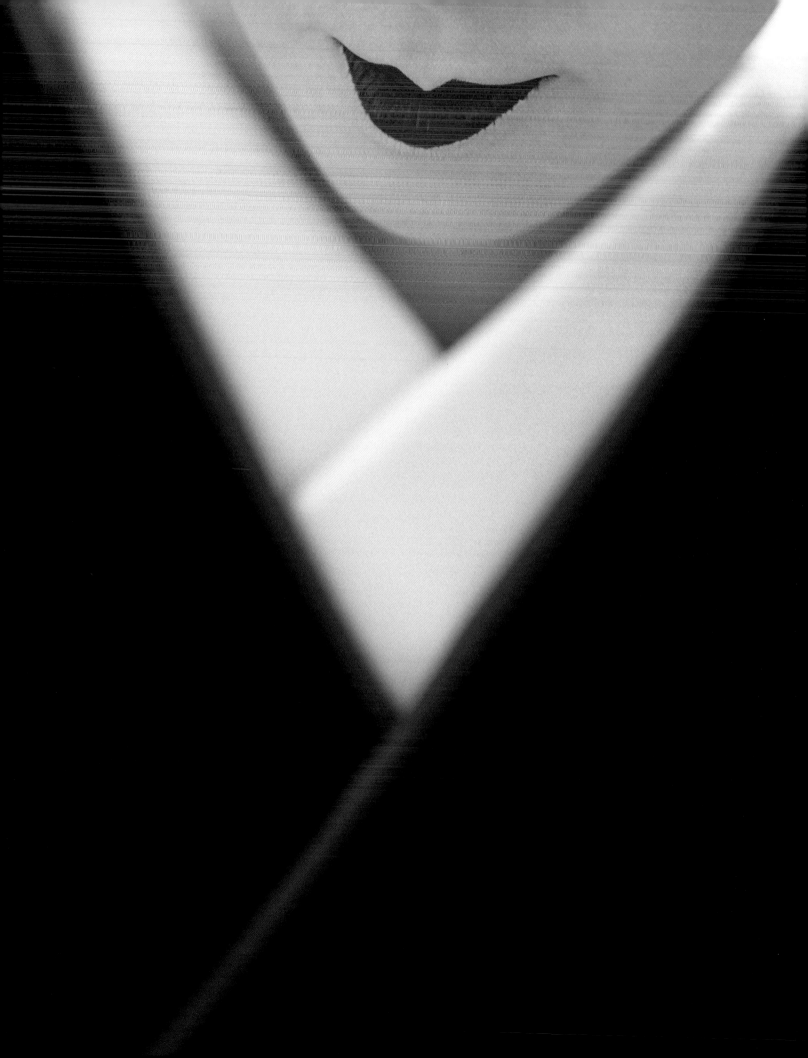

Sun and shadow meet at the edge of a Kyoto garden where *sudare* reed shades are rolled down to shield the veranda. They are a typical sight around the city in summertime, particularly in the old quarters, where simply the sight of them seems to evoke a feeling of coolness.

Kyotoites take great pride in their singular heritage. Among Japan's foreign admirers, it seems that Kyoto is the place that proves to be most like the Japan of their imaginations.

Kyoto held the eminent positions of both capital and imperial seat for more than a millennium, evidenced today by its superb palaces and villas which have been carefully preserved as a cultural patrimony. The city became the center of Buddhism as the new religion tied itself to the halls of power and gained ascendancy. Today there are nearly sixteen hundred Buddhist temples in Kyoto alone, and they possess a wealth of sacred art passed down through the centuries. A number of these treasures have been officially designated by the government as National Treasures or Important Cultural Properties.

The spirit of the past infuses the present in Kyoto. Traditional values continue to hold sway, and customs long practiced endure. In spite of sometimes disturbing intrusions of the contemporary world, a richer and more gracious way of life still seems to abide here. But beyond its impressive imperial and spiritual legacies, the city possesses an ardent dedication to the cultivated beauties and pleasures of life.

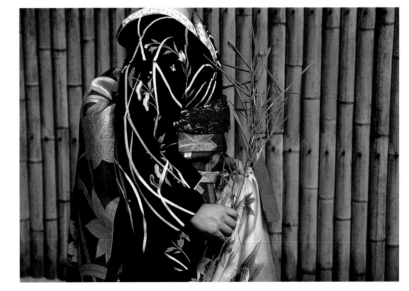

A *maiko,* or apprentice geisha, walks in a procession at Kushi Matsuri, the Comb Festival, held every autumn at Konpira Shrine in Kyoto, to comfort the souls of old and broken combs.

One vision unquestionably tied to Kyoto is that of the geisha, known by the term *geiko* in this city which has long sustained them. These highly ornamental and stylized women of the traditional arts—experts in music, dance, and witty conversation—live out the precious dreams of a passing age as they

Black, white, and red are the primary colors of the highly stylized geisha beauty: the raven black of hair and eyes, the stark white of a painted face and neck, and crimson-red lips.

Split bamboo forms a decorative quarter-round protector at the base of a traditional Kyoto townhouse. The so-called *inuyarai* protects the wall not only from soiling by *inu* (dogs) but also from stains of splashing rain and mud.

and their young *maiko* apprentices entertain their wealthy male clientele in the traditional teahouses, *o-chaya*, of famed Gion or other entertainment quarters of the city.

On occasion the geisha communities engage in certain public events connected to the *karyukai*, their so-called "flower and willow world." At annual performances, they exhibit their skills in music and dance. Every spring during cherry blossom season the geisha of Kyoto commemorate a famous courtesan of the past at the temple where she is buried. They also gather to honor a poet, who sometimes wrote of beloved Gion, and participate in a memorial service for worn-out combs, important tools of their trade. At Kyoto's greatest festivals, geisha often don fabulous historical costumes to participate in stately processions.

A *maiko*, wearing a dangling *obi*, makes a customary biannual courtesy call with an "elder sister" geisha to a teahouse to formally thank the owner for her patronage.

For the most part, however, theirs is a private realm, lived out behind the *sudare*, hanging reed shades, of their neighborhood geisha houses. Out on the city streets, their exotic beauty and extravagant dress cause a stir as they wend their way to and from their professional engagements. For most Japanese today, geisha are as intriguing, romantic, and nearly as unfamiliar as they are to any foreign visitor. Yet they stand as a resonant symbol of the prodigious wealth of traditions that contribute to Japan's cultural identity.

OVERLEAF: Following a patterned walkway between lush plantings, a *maiko* returns to her geisha house following a courtesy call in the entertainment quarter of Gion.

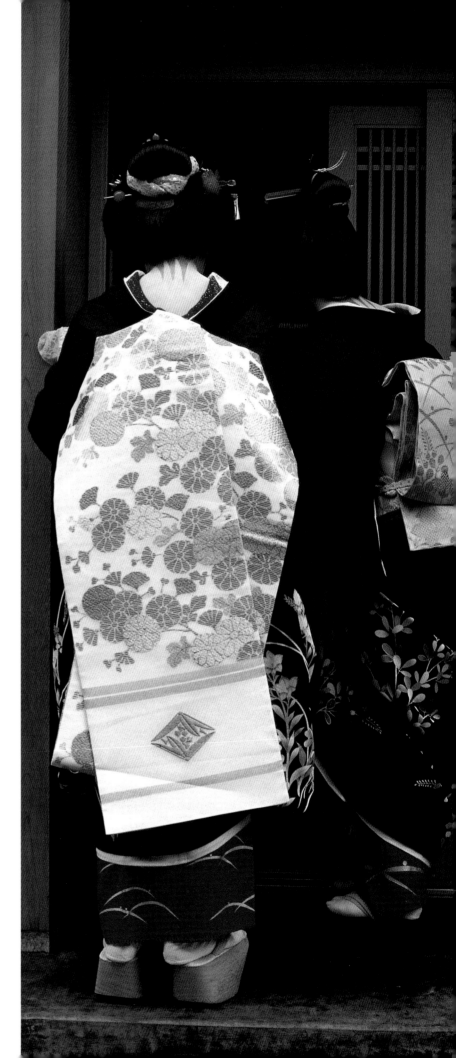

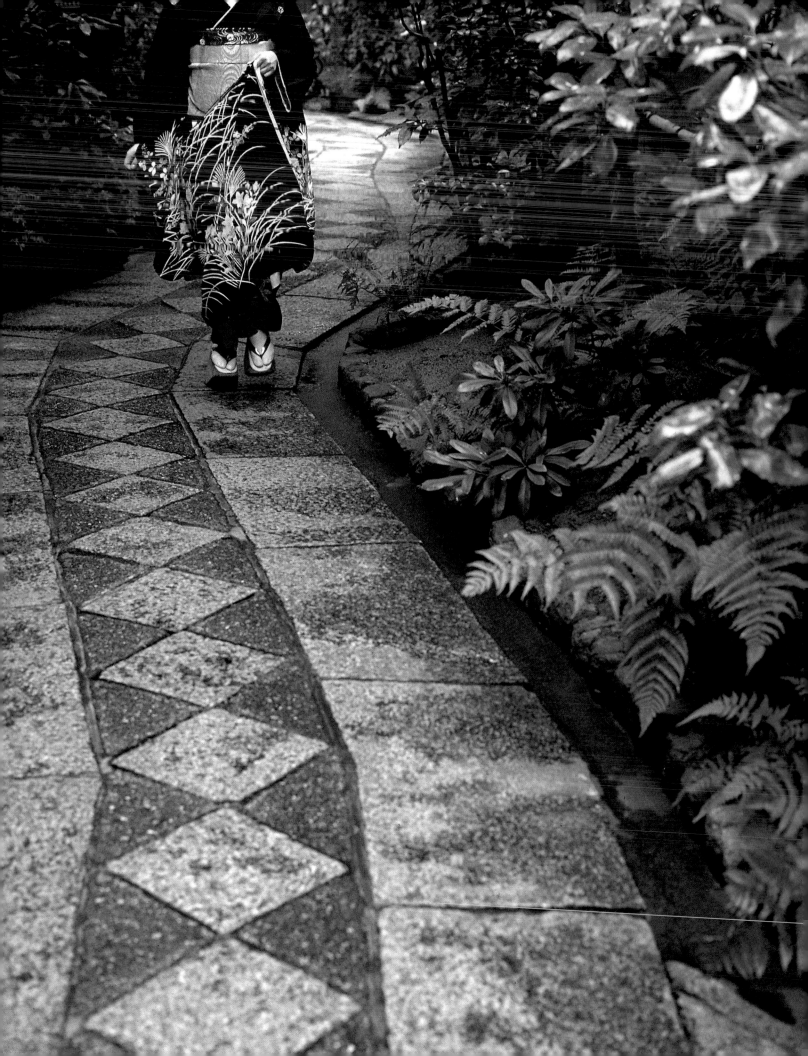